# THE ART OF LEGO®
# SCALE MODELING

DENNIS GLAASKER AND DENNIS BOSMAN

no starch
press

**The Art of LEGO Scale Modeling**. Copyright © 2015 by Dennis Glaasker and Dennis Bosman

Printed in China

First Printing

19 18 17 16 15    1 2 3 4 5 6 7 8 9

ISBN-10: 1-59327-615-X
ISBN-13: 978-1-59327-615-7

Publisher: William Pollock
Production Editor: Riley Hoffman
Cover Design: Beth Middleworth
Cover Photographs: Dennis Bosman (front) and Dennis Glaasker (back)
Developmental Editor: Tyler Ortman
Copyeditor: Anne Marie Walker
Compositor: Riley Hoffman
Proofreader: Paula L. Fleming

For information on distribution, translations, or bulk sales,
please contact No Starch Press, Inc. directly:

No Starch Press, Inc.
245 8th Street, San Francisco, CA 94103
phone: 415.863.9900; info@nostarch.com
www.nostarch.com

*Library of Congress Cataloging-in-Publication Data*

Glaasker, Dennis.
  The art of LEGO scale modeling / by Dennis Glaasker and Dennis Bosman.
     pages cm
  Summary: "Features four-color photographs of LEGO scale models of real vehicles from builders around the world. Includes tips and tricks that describe the design and building process"-- Provided by publisher.
  ISBN 978-1-59327-615-7 -- ISBN 1-59327-615-X
  1.  Motor vehicles--Models--Pictorial works. 2.  LEGO toys--Pictorial works. 3.  Motor vehicles--Models--Design and construction.  I. Bosman, Dennis.
II. Title.
  TL237.G57 2015
  629.22'1--dc23
                          2015014124

Production Date: 5/18/2015
Plant & Location: Printed by Everbest Printing (Guangzhou, China), Co. Ltd
Job / Batch #: 42106-0 / 702920.4

# About the Authors

Dennis Glaasker has been scale modeling all his life, mostly focusing on cars and trucks. He started by building plastic kits but now works exclusively on LEGO models. His work can be found online under the name *Bricksonwheels*, and his models have been featured in many magazines, including *Truckstar*, *10-4*, *BrickJournal*, *Hispabrick*, and *Towtruck*. He lives in the Netherlands with his wife and twin daughters.

Dennis Bosman is a pioneer in the art of LEGO scale modeling, specializing in large-scale models, which he has been building for more than 20 years. In the 1990s, he started one of the first LEGO-related websites, *www.dennisbosman.nl*, inspiring many people to build their own models. His work can also be found in magazines such as *Truckstar*, *Magazine Exceptionnel*, and *NAMAC*. He lives in the Netherlands with his girlfriend.

# Contents

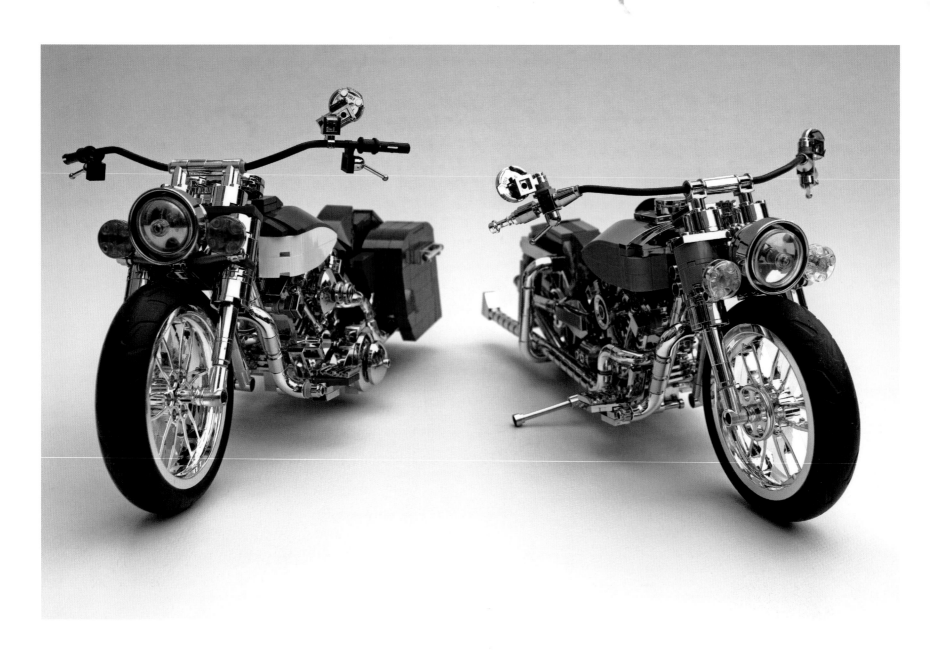

**Harley Davidson Classic and Cali Style Road Kings**
Dennis Glaasker

# Preface

We got our first taste of LEGO scale modeling as kids in the late 1970s. By that time, the LEGO Group had created the Technic theme and launched some functional models of classic cars, trains, and ships. These themes opened opportunities to create our own models. As our LEGO collections grew over the years, we were able to build bigger custom models of trucks and heavy equipment.

In the 1990s, LEGO introduced the more realistic Model Team range, which encouraged us and many others to build more complex LEGO models. These sets were LEGO's first attempts at creating realistic scale models rather than just approximating the form of vehicles. At the same time, many new pieces were introduced that made more complex geometries achievable.

Some of our models were published in truck and scale-modeling magazines during that time. As we shared our work, we got to know many builders worldwide—those working with LEGO as well as traditional scale modelers.

Due to the growth of the Internet, sharing new models and ideas with others became very easy, and new friendships were made. With so many websites and events dedicated to this hobby, we have met many people with great building talent.

Only with the help of some of these enthusiastic builders were we able to create this book. Their building techniques are inspiring, and their professionalism and remarkable models have made this book possible.

This book aims to show the many facets of scale modeling by showcasing a range of vehicles. Trucks, cars, ships, and planes are all possible with LEGO bricks. But of course, no showcase of LEGO models is ever complete. The community of builders is always pushing the envelope and experimenting, with the goal of reaching the next level in beautiful scale modeling.

We hope this book inspires you to build as well!

Dennis Glaasker and Dennis Bosman

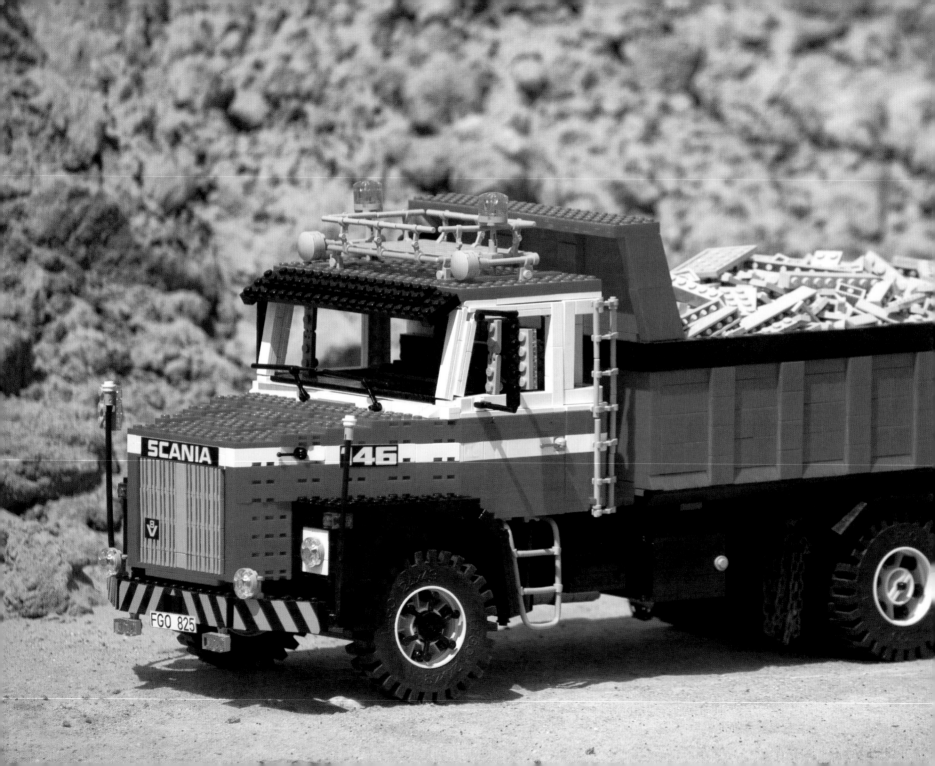

# Trucks

One theme that has always appealed to scale modeling aficionados is trucks. As a subject matter, trucks' popularity has its roots in the 1970s, when people started to build model kits of trucks inspired by road movies like *Duel*, *Convoy*, and *Smokey and the Bandit*.

When LEGO released its Model Team range in 1986, its goal was to introduce a line of LEGO sets that looked more like real vehicles, inspiring the fan community to do likewise. Over the ensuing years, LEGO has consistently produced trucks as part of its catalogue, including trucks from the Technic line, which opened up possibilities to create additional functioning parts.

Fans and enthusiasts have also created their own models completely from scratch, and some have mastered this art to achieve the highest level of realism possible with LEGO bricks. These builders work without any instructions and without using any extra unofficial parts. Every geometric relationship and technical detail is made using LEGO pieces.

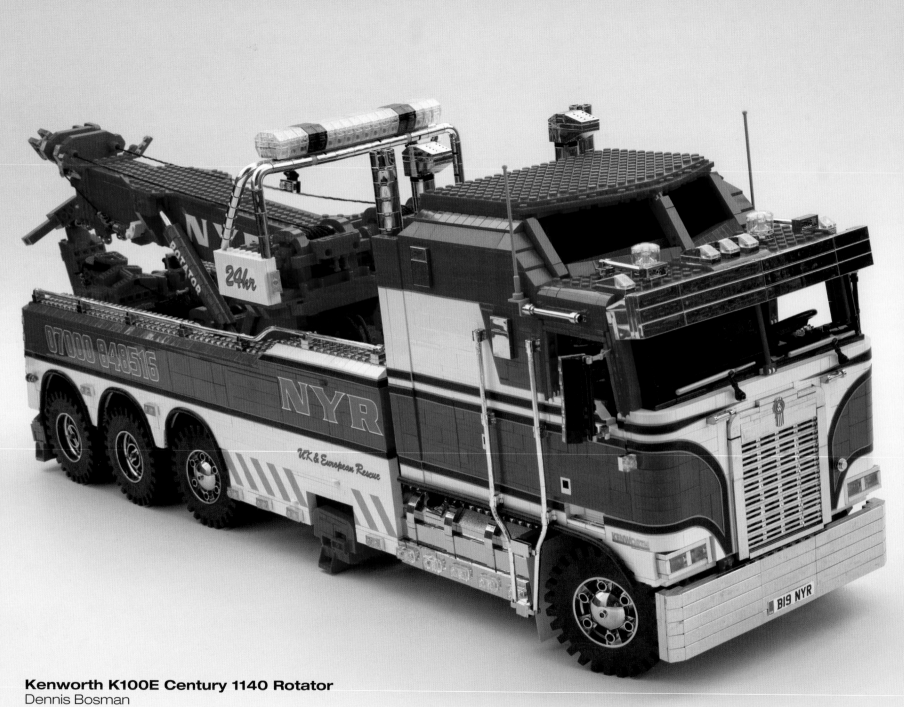

**Kenworth K100E Century 1140 Rotator**
Dennis Bosman

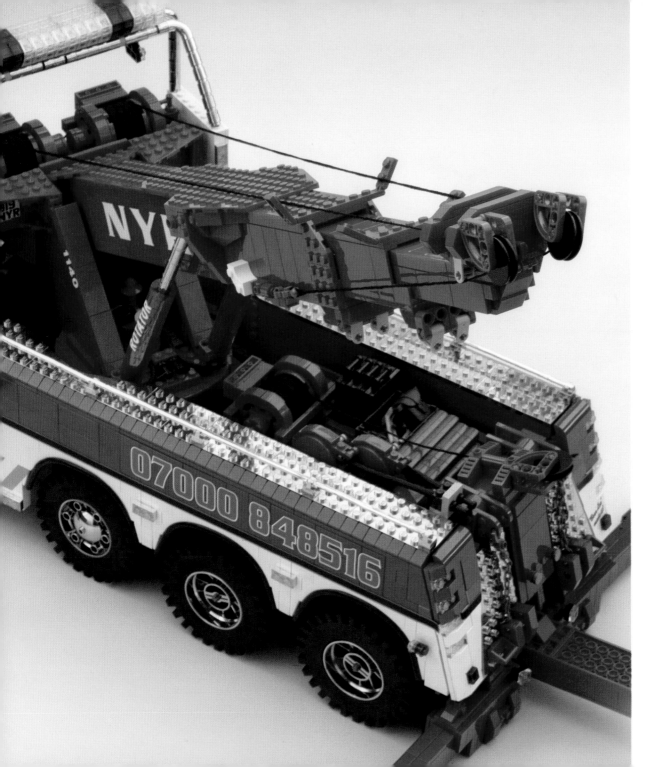

## Kenworth K100E Century 1140 Rotator

The Kenworth K100 is an American truck that found its way to Europe during the 1970s and 1980s. Nowadays, not many are left in Europe or America, but a few enthusiasts keep these classic trucks running. Neil Yates Recovery, a UK towing services company, has operated many US trucks over the years. This model is based on a large Kenworth K100E used by Yates, which is equipped with a Miller Industries–built Century Rotator 1140, suitable for heavy-duty towing jobs.

The 1:13 scaled LEGO version is a complex build at more than 2.6 feet (80 cm) long. The sheer length of the chassis made it challenging to construct, and as with the original, a secondary frame is used to support the rotator body.

The rotator crane has a working three-stage boom and two winches. In addition to the crane, the truck has an underlift at the rear.

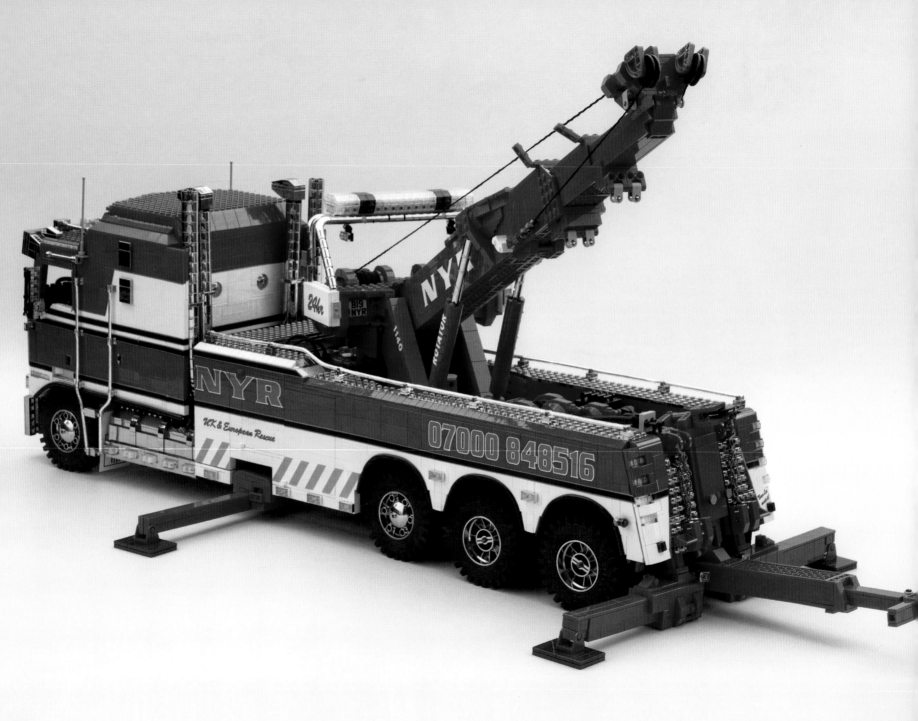

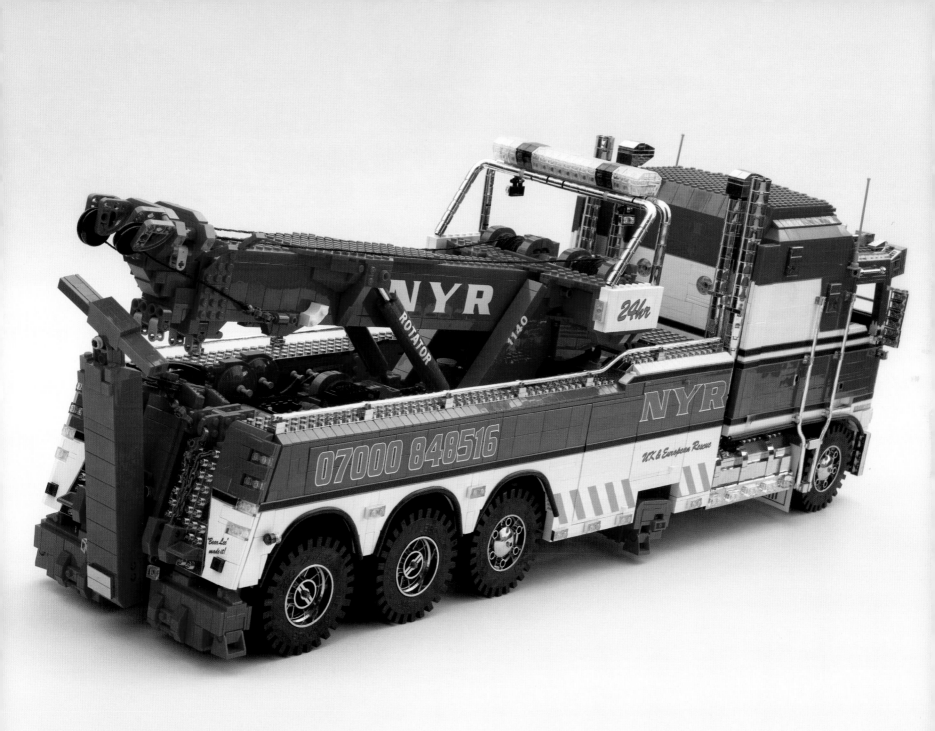

**Pegaso 1083 & Z-701**
Iván Vázquez

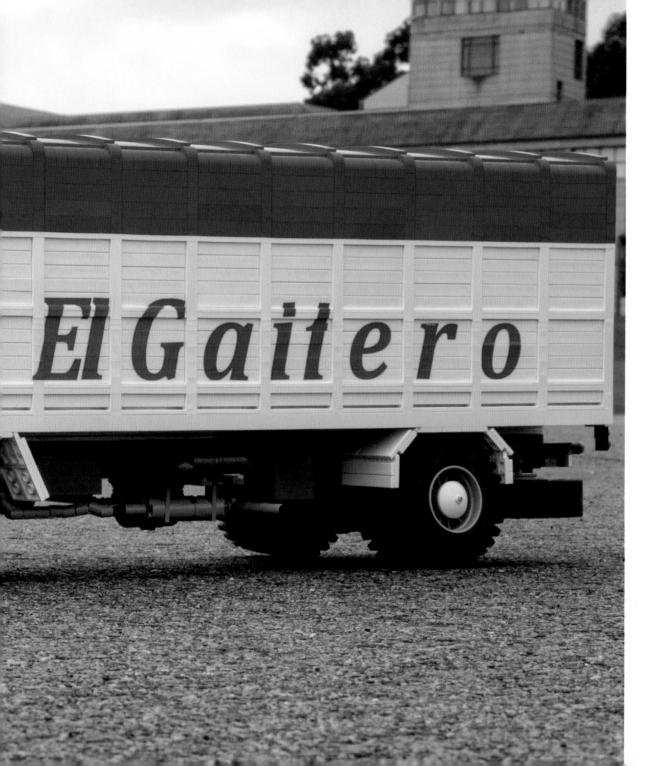

## Pegaso 1083 & Z-701

The Pegaso brand had largely disappeared by the time the Spanish company was bought by Italian giant Iveco in 1990; trucks using the name were no longer produced after 1994. Still, Pegaso has deep roots, having been owned by the same parent company as the classic Hispano-Suiza car brand.

The Pegaso 1083 featured here is a model of an apple-hauling truck made in 1972 for Sidra El Gaitero, a manufacturer of apple cider. Unfortunately, the original truck no longer exists. The 6×2 configuration with two steered axles, the so-called *Chinese Six*, was popular in Spain from the 1960s until the 1990s, and is replicated on this model.

The much older Pegaso Z-701, built to the same scale, can still be found on the road today. It was built in the 1950s, and as with other trucks built in Spain after the Spanish Civil War, the steering wheel is located on the right side.

Both models replicate a great deal of detail in a tribute to this classic brand.

## Scania L111 & Nooteboom Lowloader

Known for its distinctive European-style cabover designs, Scania has also built bonneted trucks for many decades. Two of the more popular models were the L110 and L111, which were produced from the late 1960s until 1980.

The L111 was used for many purposes but mostly for construction work and heavy haulage. One of its great advantages was the low cab, which made it possible to carry draglines with the boom still mounted, as in the combination featured here.

This large 1:13 scaled LEGO model of the L111 is connected to a Dutch-built Nooteboom lowloader with steered rear axles. In real life, this combination can carry about 45 tons. The LEGO version of the Menck M154 excavator fits the loading deck of the trailer nicely.

The model itself has nearly vintage status as well. It was built between 2002 and 2003, and it still exists today.

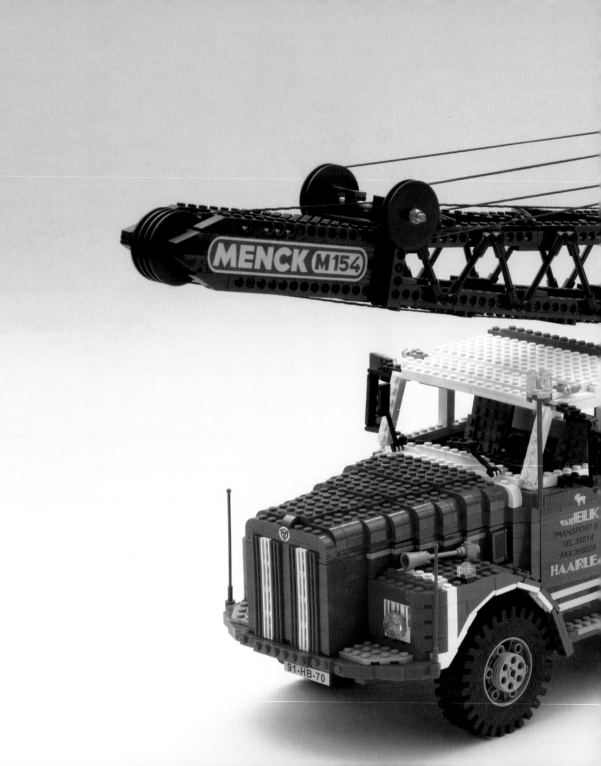

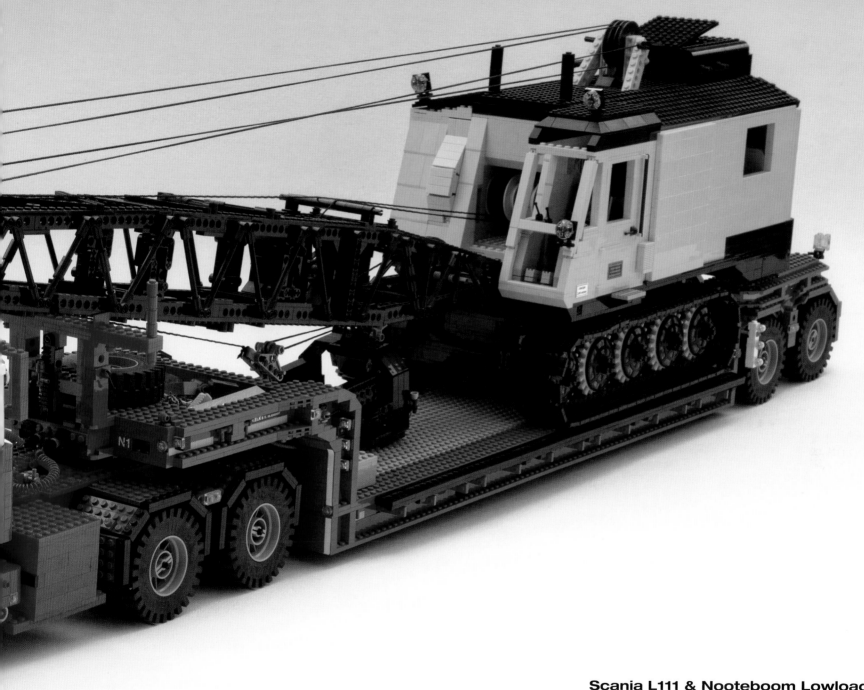

**Scania L111 & Nooteboom Lowloader**
Dennis Bosman

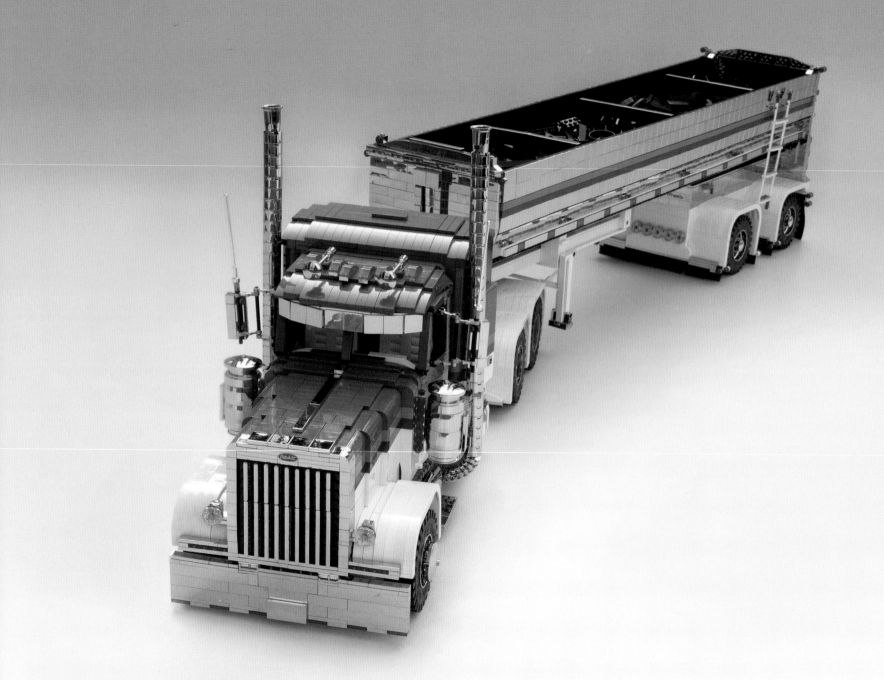

**Peterbilt 379 & MAC End Dump**
Dennis Glaasker

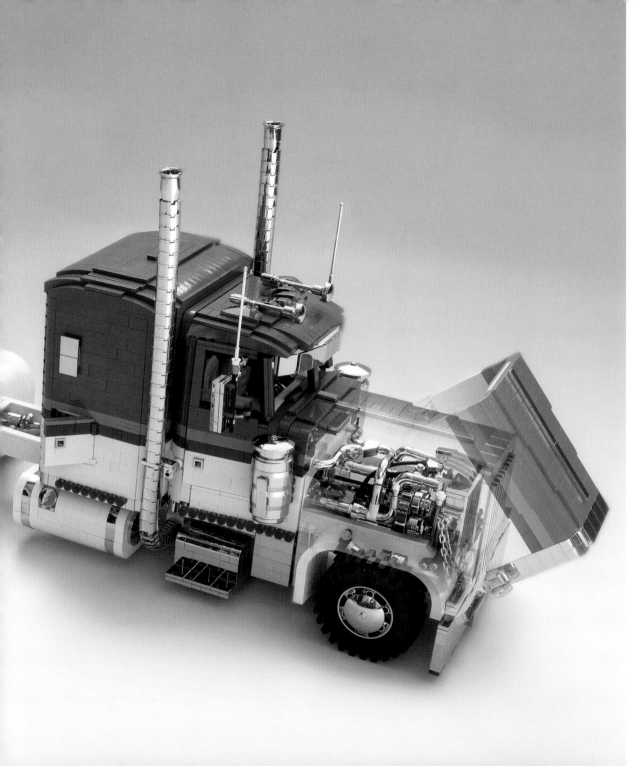

# Peterbilt 379 & MAC End Dump

The Peterbilt 379 series served as the company's flagship trucks between 1987 and 2007, and it remains popular among owners and operators for its classy looks and customizability. It is common to see a Peterbilt used as a working show truck, even when hauling dry bulk loads, like the example with the MAC end dump trailer featured.

This LEGO version is scaled at 1:13 and is about 5 feet (1.53 meters) in length. The level of realism is enhanced by the use of industrially chromed bricks that were electroplated especially for this model. These bricks are applied not only to the tractor but also to the trailer, where hundreds of tiles shine like the polished aluminum of the real thing.

As with the original MAC trailer, the model can tilt over the rear axle to unload. Instead of the 22.7 tons its real-life equivalent would haul, this model carries approximately 1,000 black bricks.

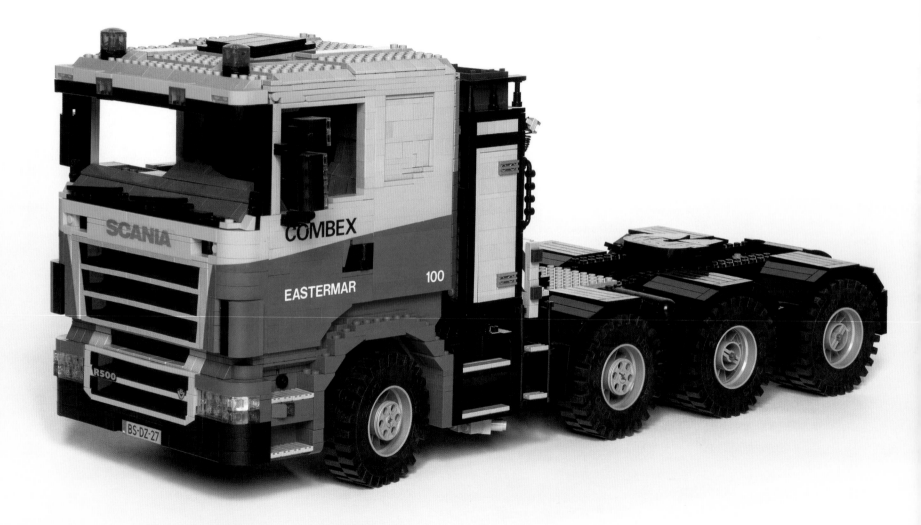

**Scania R500**
Dennis Bosman

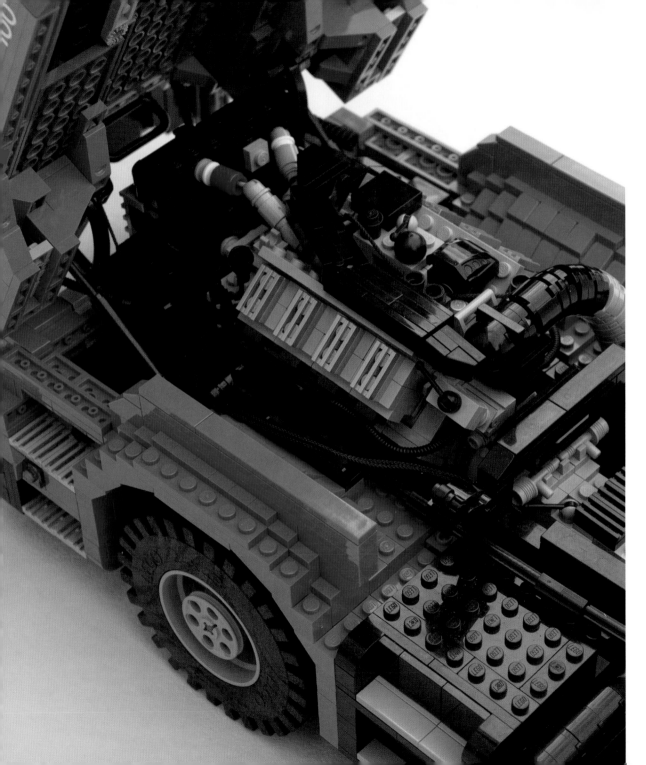

## Scania R500

Swedish truck manufacturer Scania is one of the most popular European truck brands, and much of its popularity comes from the big V8 engine that has been in Scania's delivery program since 1969. The engine is famous for both its power and its forceful rumbling sound.

Currently, this engine is available in Scania's R-Series and ranges from 500 to 730 hp. The R500 featured here is a four-axle prime mover that has the V8 engine under its tilted cab. This LEGO model is derived from the manufacturer's original blueprints and scaled down to 1:13.

Some of the most interesting components of this model are actually inside it. The detailed turbocharged V8 engine and the entire drivetrain, gearbox, and air suspension are all built to mimic the original. Oil gauges and air tanks make the model even more accurate, and a look into the massive cabin shows an interior reminiscent of the real thing.

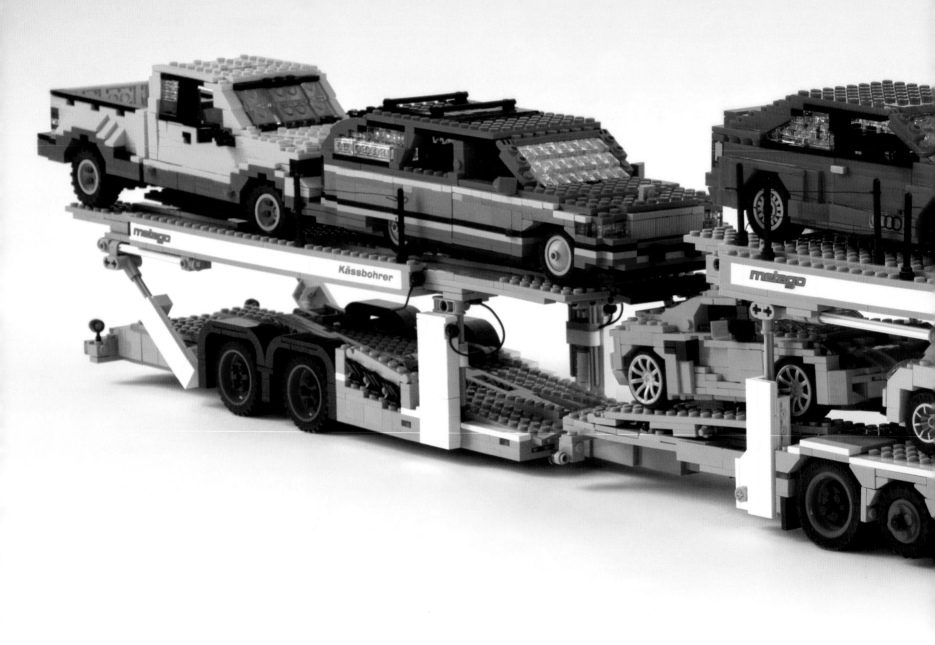

# Mercedes-Benz 2536 Actros Car Carrier
Ralph Savelsberg

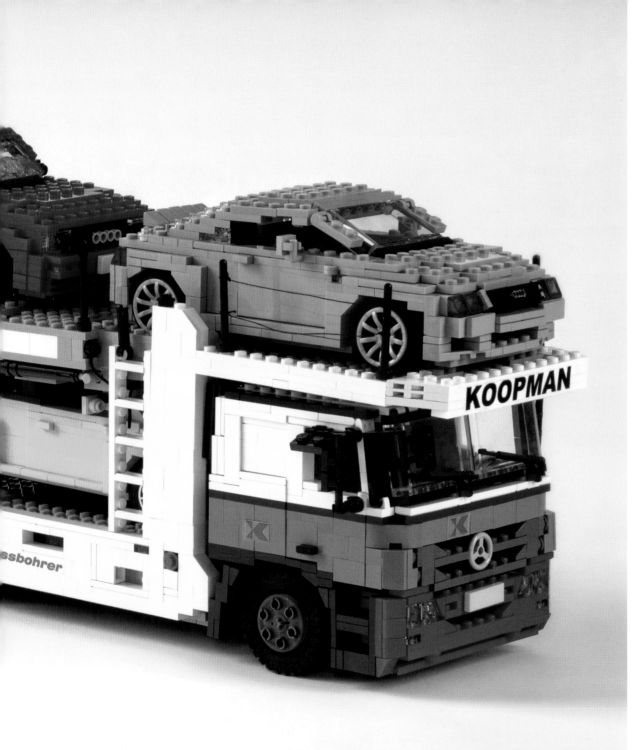

## Mercedes-Benz 2536 Actros Car Carrier

Car carriers like this Mercedes-Benz Actros with a German Kässbohrer Metago body must carry a variety of car types and facilitate efficient loading and unloading. Whether a customer orders a couple of vans or a load of sports cars, this versatile vehicle handles the job with ease due to its many adjustable components.

This versatility makes building a scale model a challenge. However, the 1:22 scaled model, shown here with a load of cars, reflects the details of the original. Besides the functional loading decks, it's full of eye-catching touches, such as the livery of the Mercedes-Benz cabin: the use of olive green LEGO bricks in combination with dark green exactly matches the livery of the hauling company, Koopman.

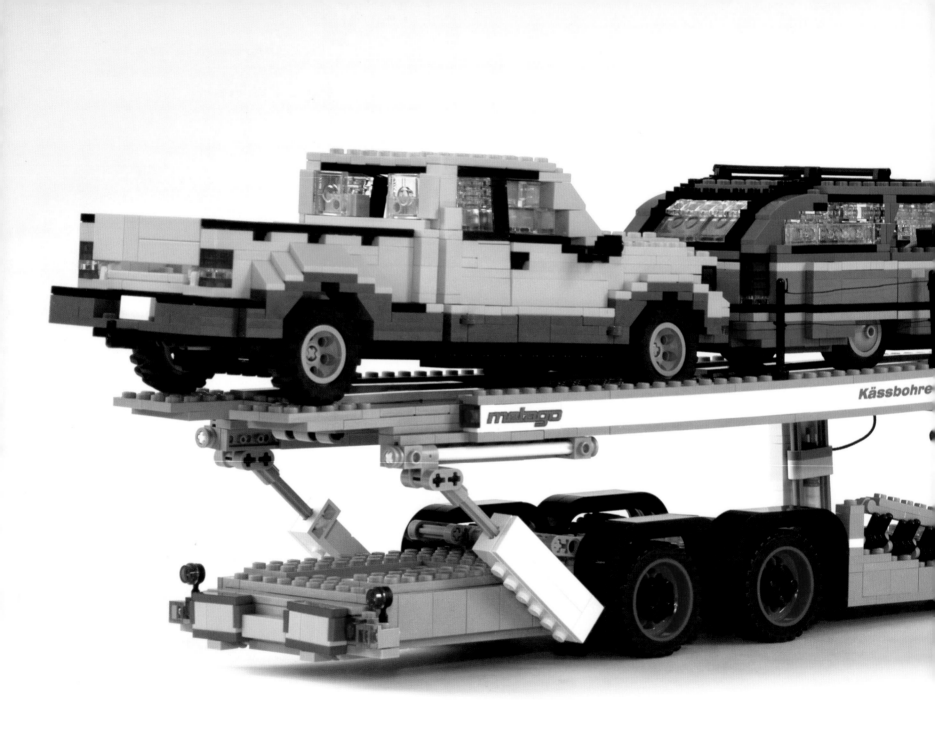

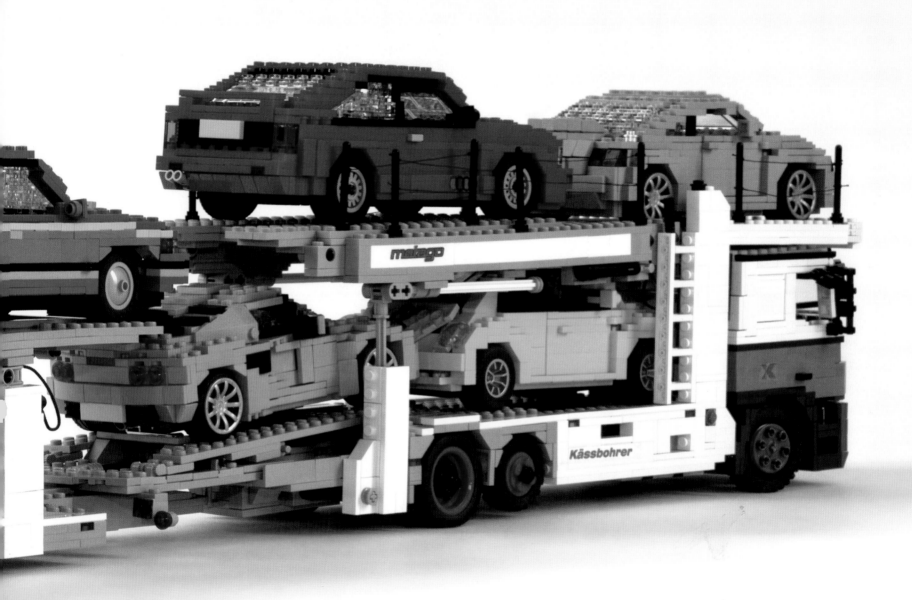

# Peterbilt 379 Century Rotator

A rotator is a heavy-duty towing vehicle, named for its recognizable rotating boom. The base of a rotator is a regular truck chassis that is extended, as shown in this model of a Peterbilt 379 with a Cat 550 hp engine.

The wrecker's body is built on top of the chassis and includes hydraulics for the outriggers and underlift. The Century 1075 system built by Miller Industries is capable of lifting 75 tons and has an additional winch capacity of 27.2 tons.

This 1:13 LEGO equivalent is also quite heavy. Composed of more than 10,000 LEGO bricks, this model weighs about 24 pounds (11 kg) and has a length of about 3 feet (94 cm). The extendable rotator boom can make a 360-degree turn, and the outriggers have full functionality as well. The model has a complete interior and detailed engine and is finished with custom decals and chromed bricks.

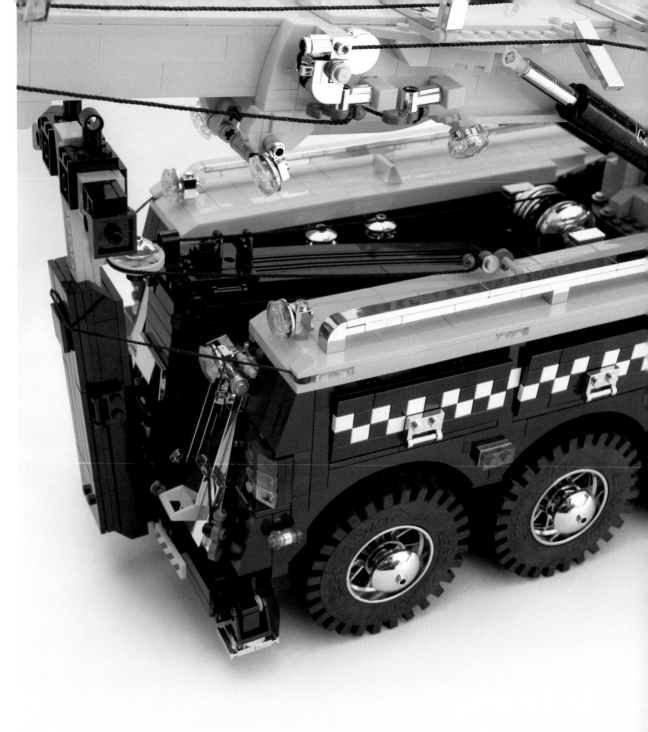

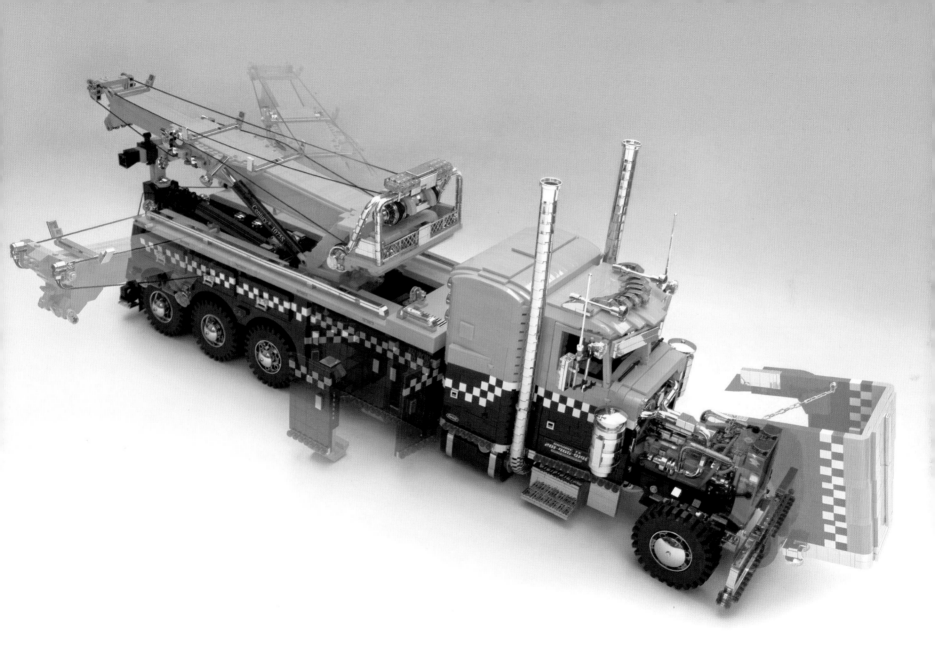

**Peterbilt 379 Century Rotator**
Dennis Glaasker

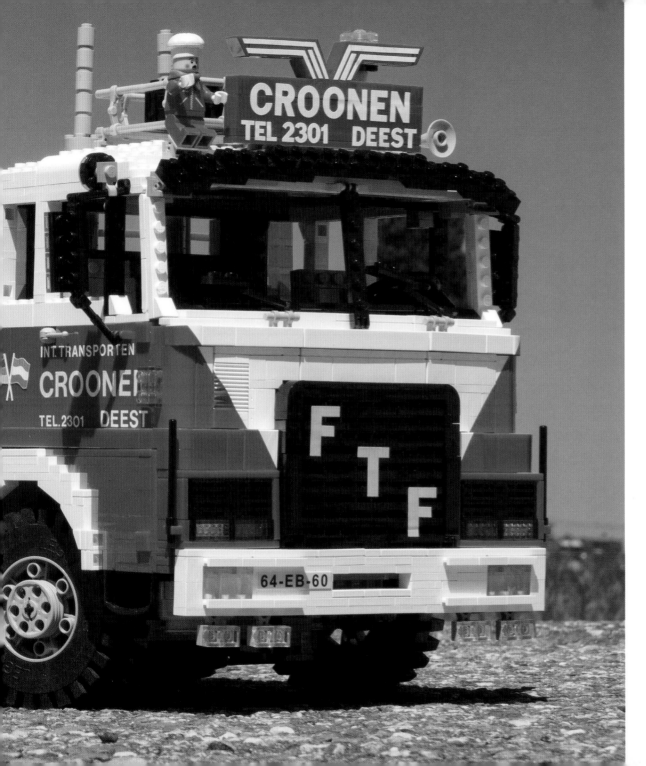

## FTF F-8.8 20D & Floor Trailer

During the mid-1960s, Dutch manufacturer FTF began building custom trucks designed for heavy haulage and construction. Unfortunately, FTF had to discontinue its truck production in 1995, but many of the original trucks have survived in the hands of enthusiasts.

The majority of FTF trucks were equipped with Detroit Diesel engines, and the cabs were produced in the UK. This example of a late-1970s FTF was also powered by a Detroit Diesel two-stroke engine. Seven axles were needed to carry the truck's maximum gross weight of 50 tons.

Under this LEGO model's tilted cab is a detailed V8 engine mounted to two vertical exhausts between the cab and bodywork. The crane is a typical 1960s design, and the top of the roof is decked out with characteristic 1970s accessories. Swinging the boom either to the right or left side enables you to pick up bricks and load them onto the truck.

# Scania T143M 500

The Scania 143 is part of the 3-Series family that came to market in 1987 as a successor to the popular 2-Series.

Bonneted trucks like this Australian T143, also called a torpedo, put the driver's cabin behind the engine, not over it. The engine in this T143, a big 14-liter, 500 hp V8, was the biggest available at that time.

This model is built roughly to a 1:17 scale and is based on the original Scania chassis drawings. But the model doesn't just look like the original; it also works. Controlled by remote, it's equipped with two motors from the LEGO Power Functions system. Finishing touches include custom chromed bricks, working lights, and a fully detailed engine and cabin interior.

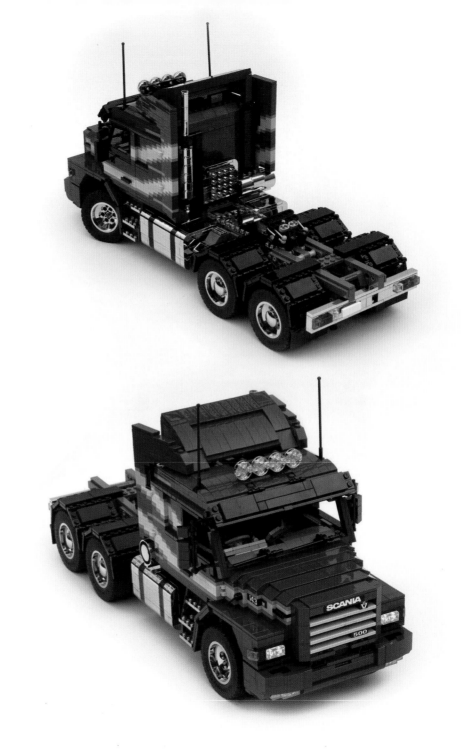

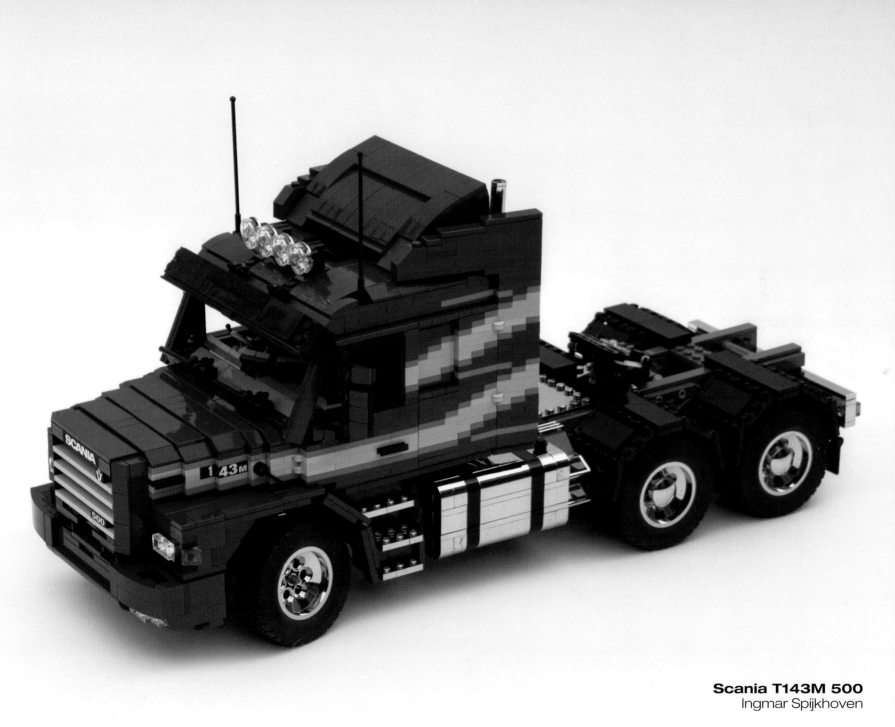

**Scania T143M 500**
Ingmar Spijkhoven

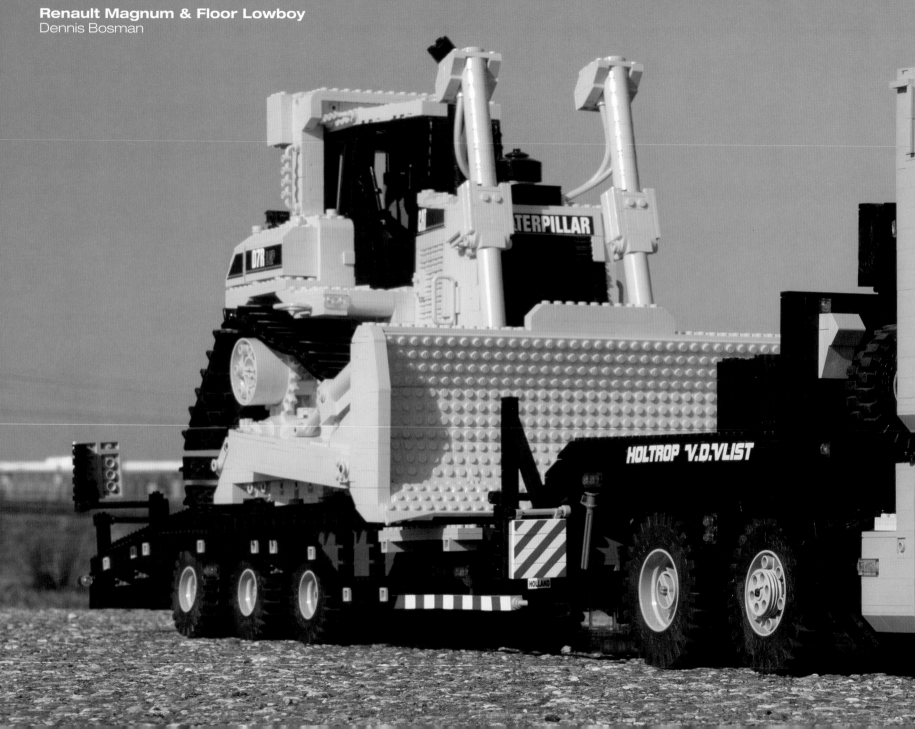

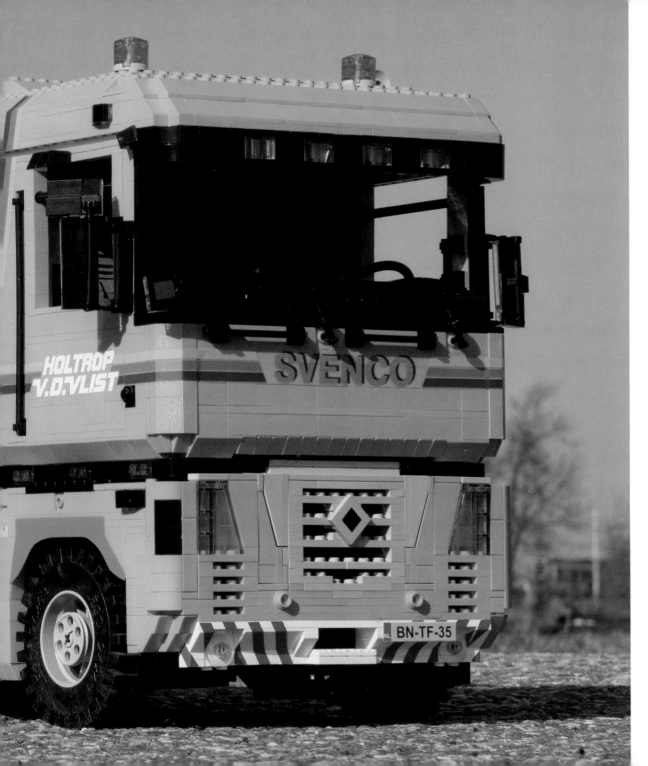

## Renault Magnum & Floor Lowboy

Renault's distinctive Magnum model was first introduced in 1990 and remained in production until 2013. Although it was not a common fleet unit, the height of the truck gave it a spacious cab, impressing many owners and drivers.

The Magnum's unique design made it a cult favorite and attracted many model builders. With its square cab, it might seem like an easy truck to re-create using LEGO bricks, but including every detail is a challenge. This model was built using as a reference an original Renault in the fleet of Dutch heavy hauler Van der Vlist. The unit is connected to an extendable step frame trailer carrying various kinds of equipment, such as a Cat D7R tracked dozer. To reproduce the vehicle accurately, measurements were taken from a Magnum in the hauler's yard.

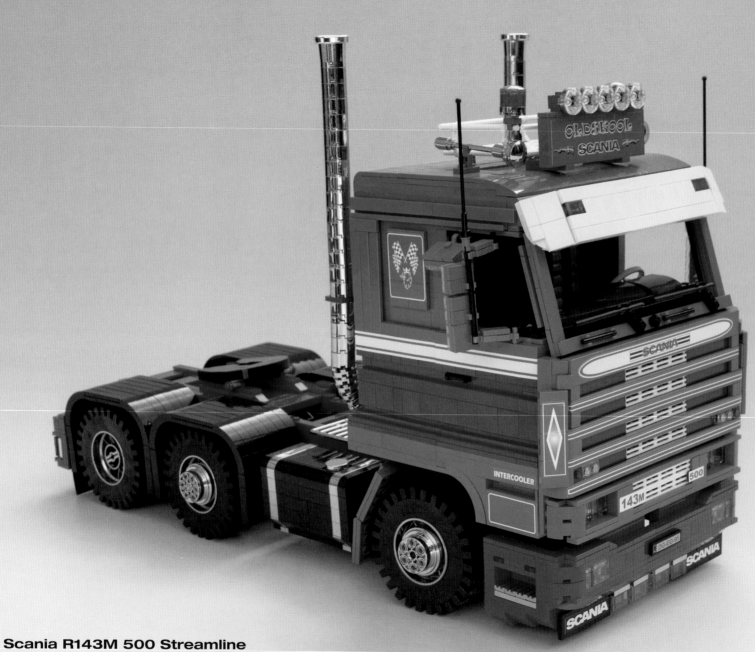

**Scania R143M 500 Streamline**
Dennis Glaasker

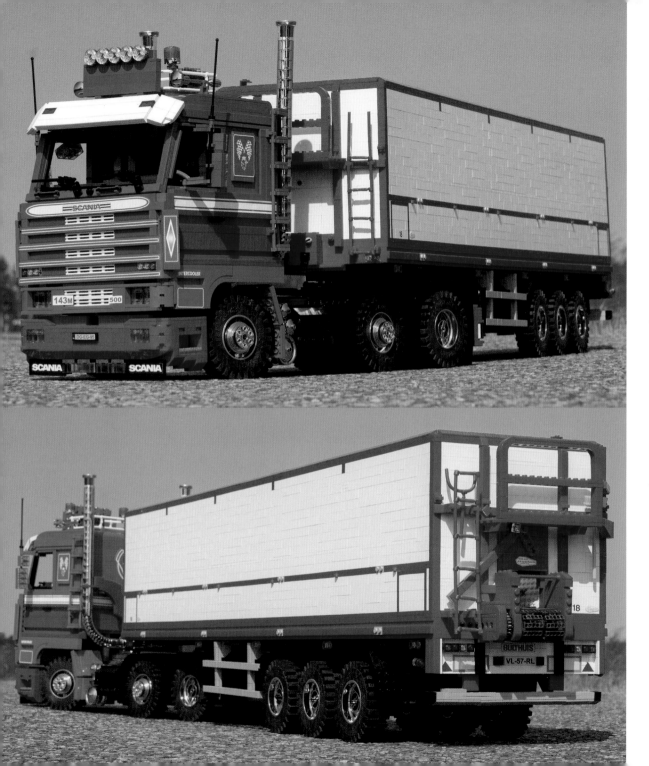

## Scania R143M 500 Streamline

The Swedish Scania Streamline was introduced in the early 1990s at the end of the Scania 3-Series production. (*Streamline* refers to an optional aerodynamic package.) The 143, which broke the 500 hp barrier for the first time, has become a cult classic among truck enthusiasts, especially because of the rough sound of its V8 engine.

Made from about 3,500 LEGO bricks, the 1:13 scaled model of the Streamline is a typical example of this Scandinavian-style truck, including its red and blue color scheme; twin rear axle setup; and several custom accessories, such as vertical exhausts, long-range lights, and a roof rack. Custom, electroplated chrome LEGO bricks and wheels, as well as color-matched stickers, complete this model.

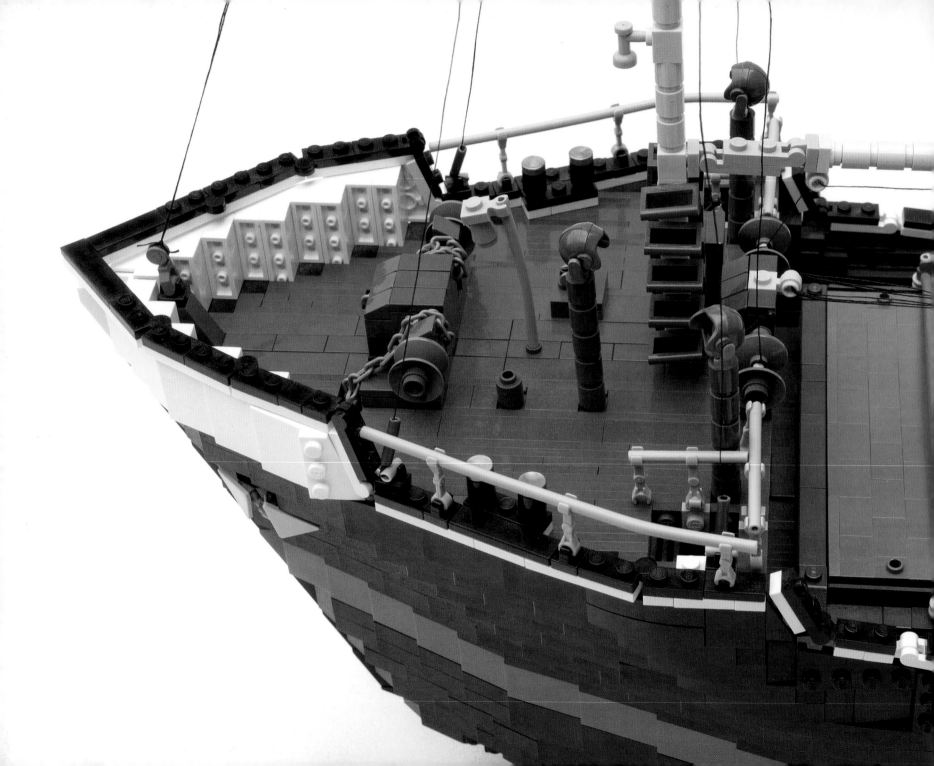

# Ships

Who would have thought it would be possible to build a replica of a ship out of LEGO bricks? The blocky shape of LEGO bricks makes this a complex task, especially when considering the smooth lines of most ships. Many ships' sheer size makes building to scale a serious challenge as well.

And yet ships have been part of the official LEGO catalogue for many years. From early marine vessels like the *USS Constellation* (1978) to the more recent Maersk Triple-E container ship (2014), LEGO ship models showcase an advanced building style. These large models also reflect the LEGO Group's attempts to appeal to the more serious builder.

But it's those fan-created models, built from scratch, that are most remarkable. Large-scale tugs, beam trawlers, aircraft carriers, and war cruisers—nothing is impossible.

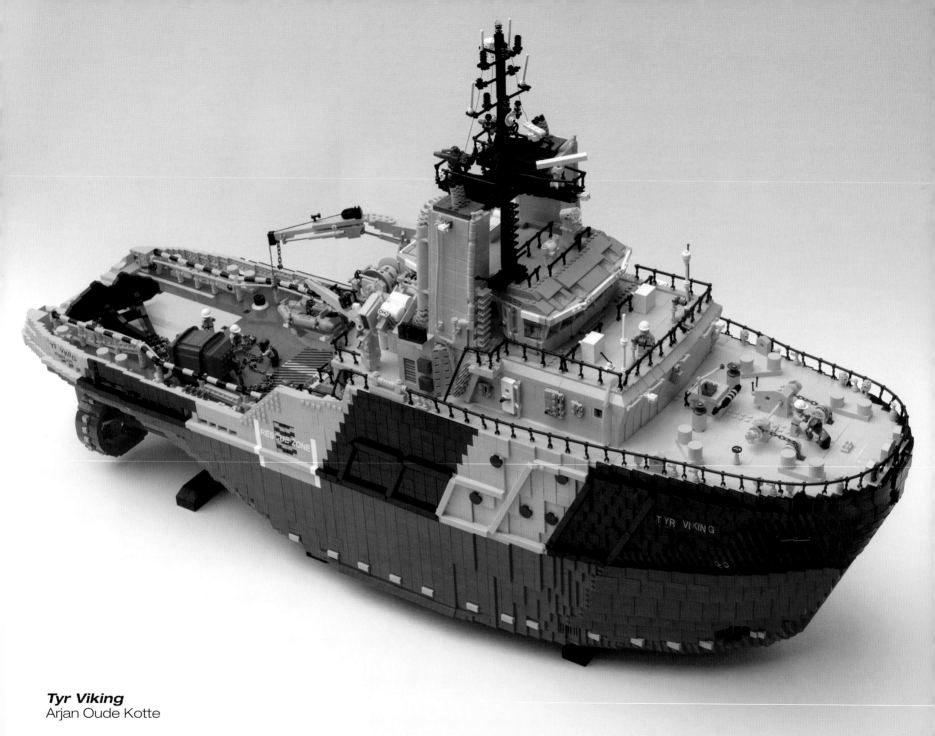

***Tyr Viking***
Arjan Oude Kotte

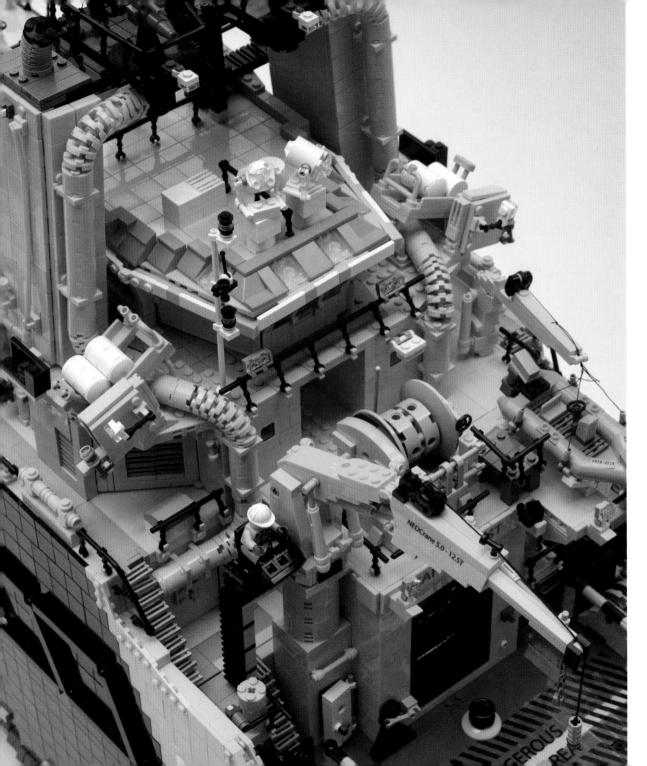

## Tyr Viking

Anchor Handling Tug Supply (AHTS) vessels, like the enormous *Tyr Viking*, are mainly used to handle anchors for oil rigs. The vessel can also tow the rig from one location to another or transport supplies to and from offshore rigging locations. Its open stern allows for the decking of a very large anchor. This ocean-going tug has an impressive gross tonnage of 1,374 tons.

This LEGO replica, including the massive hull section, is built from scratch out of bricks. A mast on top of the superstructure is fitted with water cannons and radar. Life rafts and cranes are mounted on both the port and starboard sides, and the starboard side supports a rescue boat as well. A knuckleboom crane on the port side is fitted to lift all kinds of supplies.

The tug, which is more than 4 feet long, 14 inches wide, and almost 2 1/2 feet tall (125 × 35 × 73 cm), is built from approximately 20,000 LEGO elements.

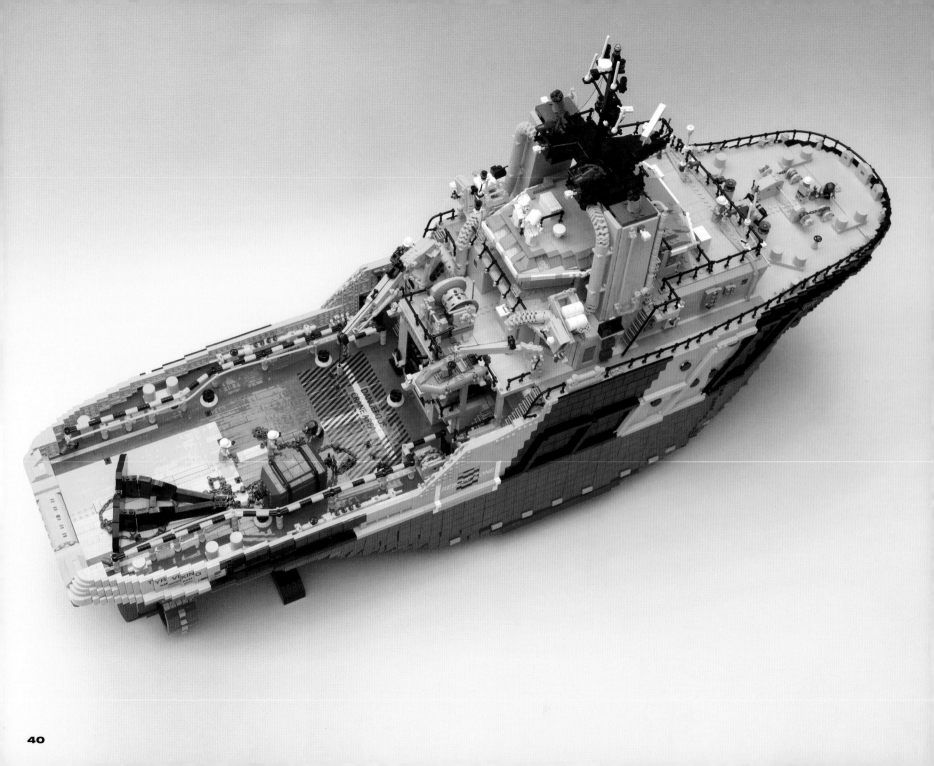

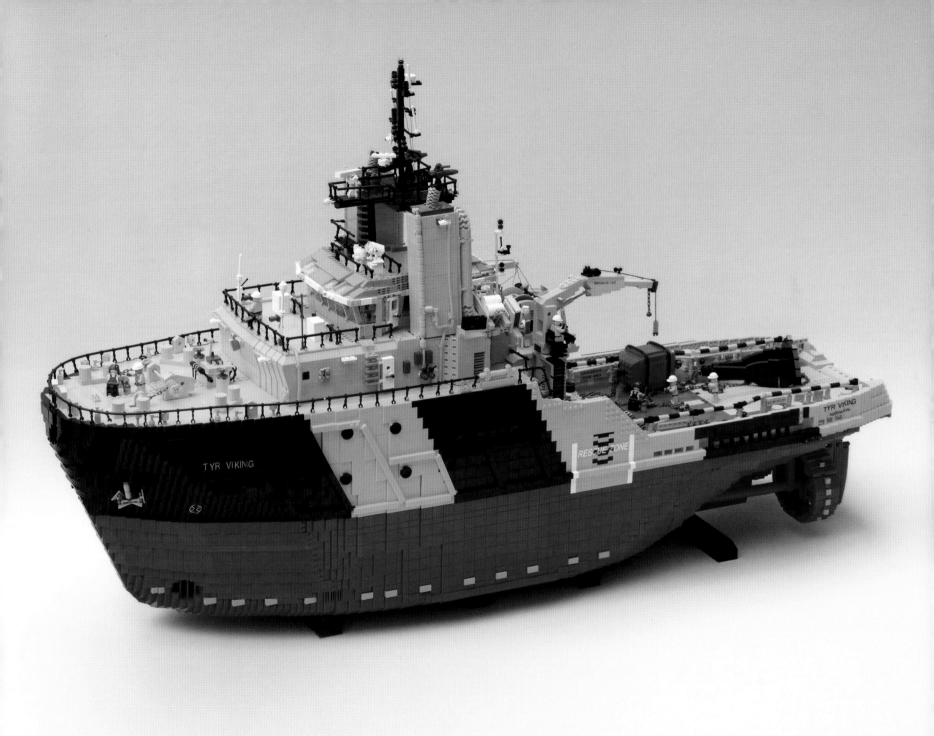

# Vietnamese Fishing Boat

This fishing boat is a modern motorized vessel used along the coast of Vietnam and Cambodia. Traditionally equipped with sails, these vessels started using imported diesel engines in the 1960s and 1970s.

Designed as a workhorse to carry heavy loads, this boat is built out of heavy timber and has a pilot house above the engine. It has little mechanical equipment on board; fishers rely on manual labor to bring in the catch.

On this replica, the ship's timbers are realistically re-created using 3,000 plastic bricks. The distinctive bright blue color matches the real boat's hue, and the ship is packed full of accessories.

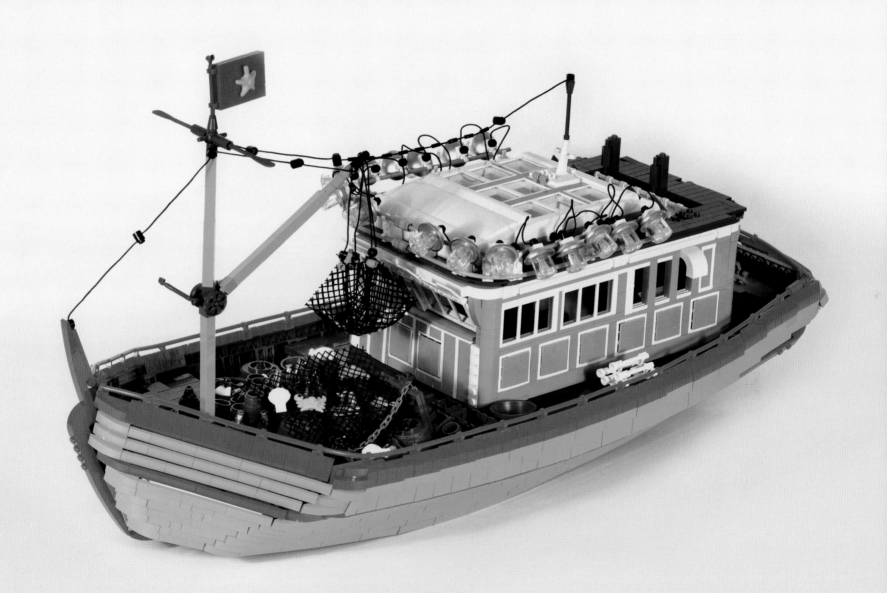

**Vietnamese Fishing Boat**
Hoang Huy Dang

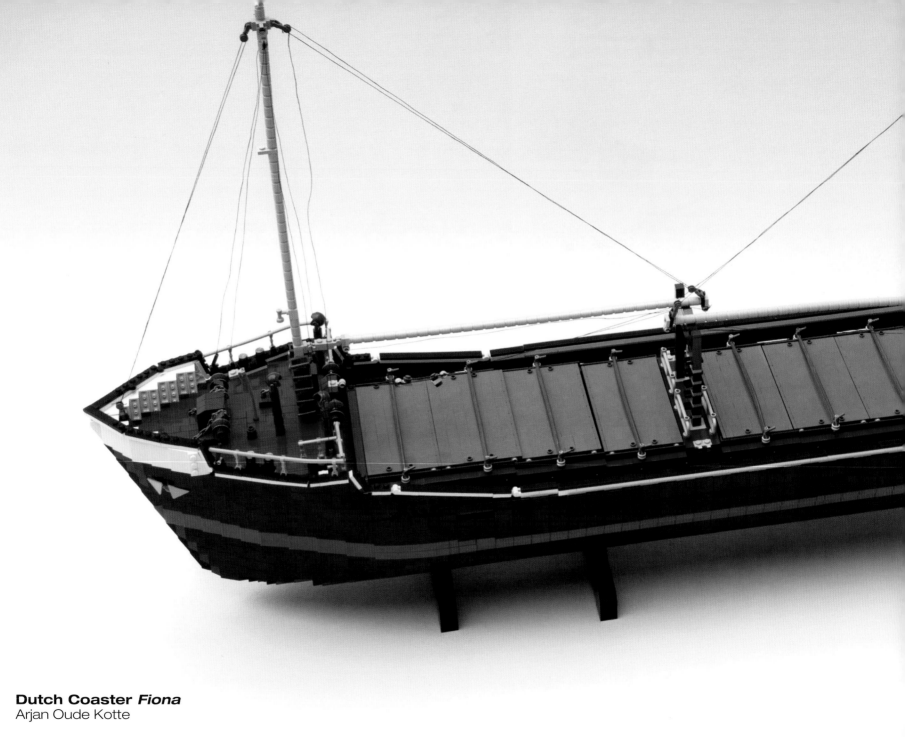

**Dutch Coaster *Fiona***
Arjan Oude Kotte

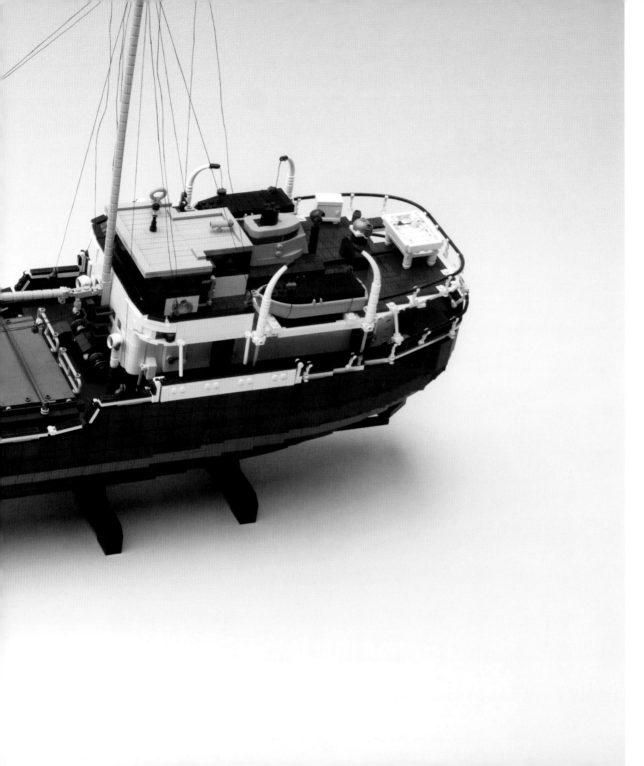

## Dutch Coaster *Fiona*

Used for trade between ports, a coaster is a shallow-hulled cargo ship.

The Dutch coaster *Fiona* was built in the Netherlands in 1953. A relatively small trading vessel, the *Fiona* had a dead weight of about 500 tons. It was in service off the coast of Finland for most of its career, until being dismantled a few years ago.

With a classic bridge and reddish brown decks, it is a typical vintage coaster. Built before the era of container ships, the vessel was designed to carry bulk cargo, usually stored in sacks and nets. Steel crossbeams above the deck hatches can be removed to access the cargo space.

The model of the *Fiona* is scaled to 1:40 and is approximately 4 feet (125 cm) in length. It took about three months to design and build.

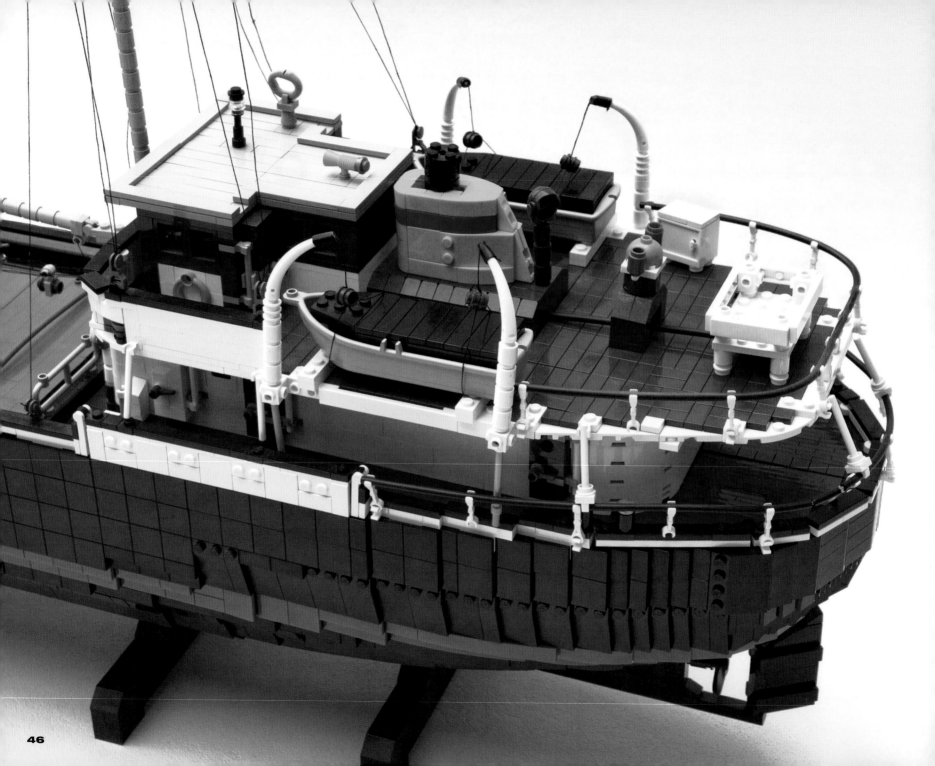

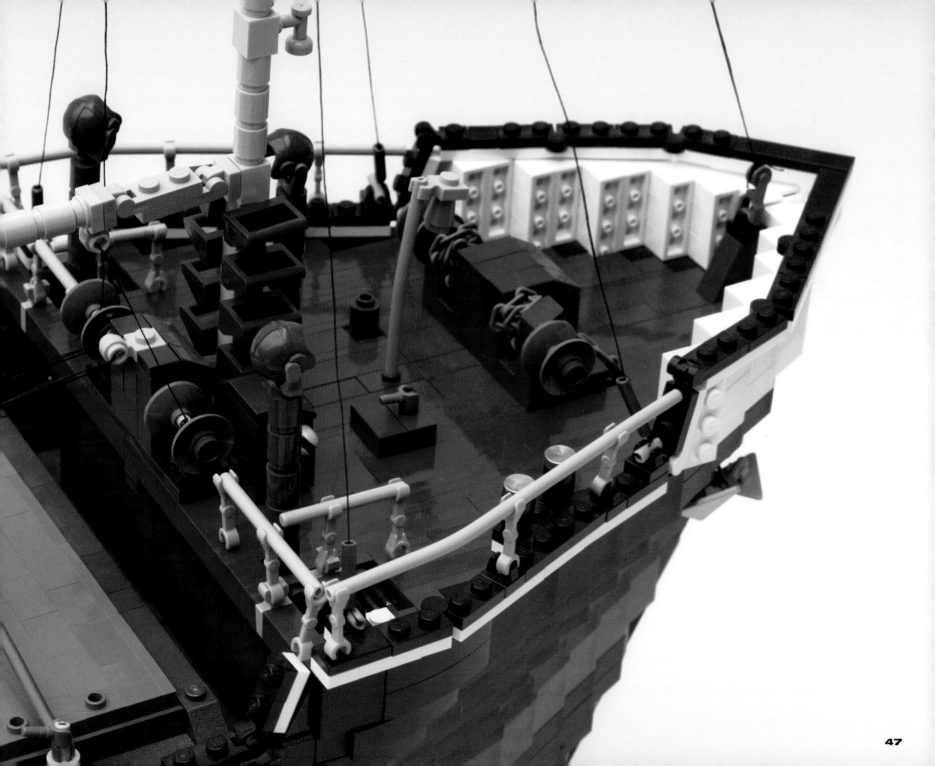

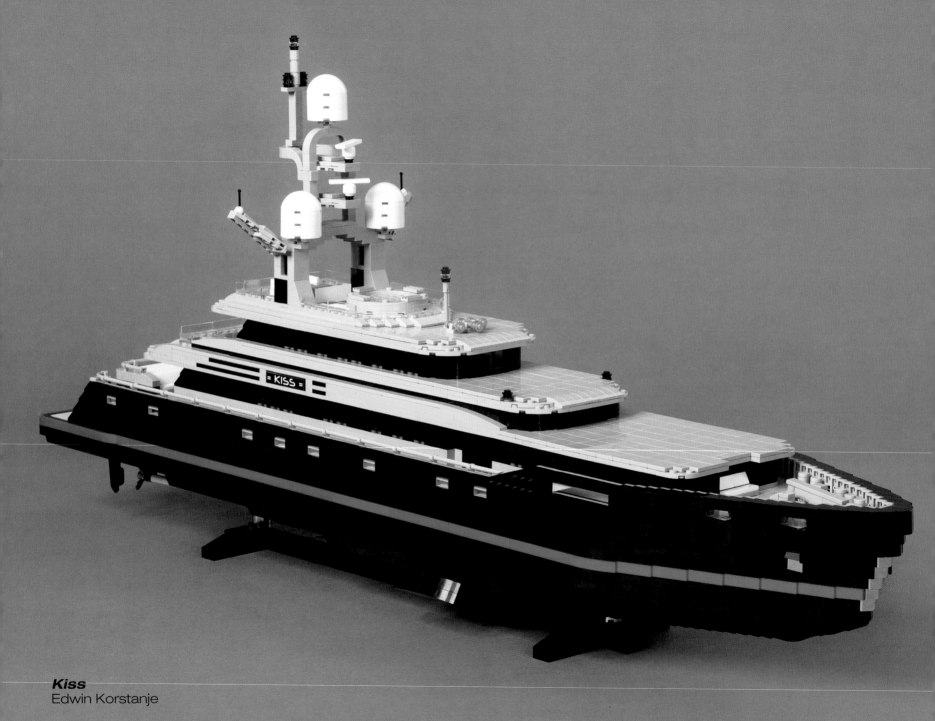

***Kiss***
Edwin Korstanje

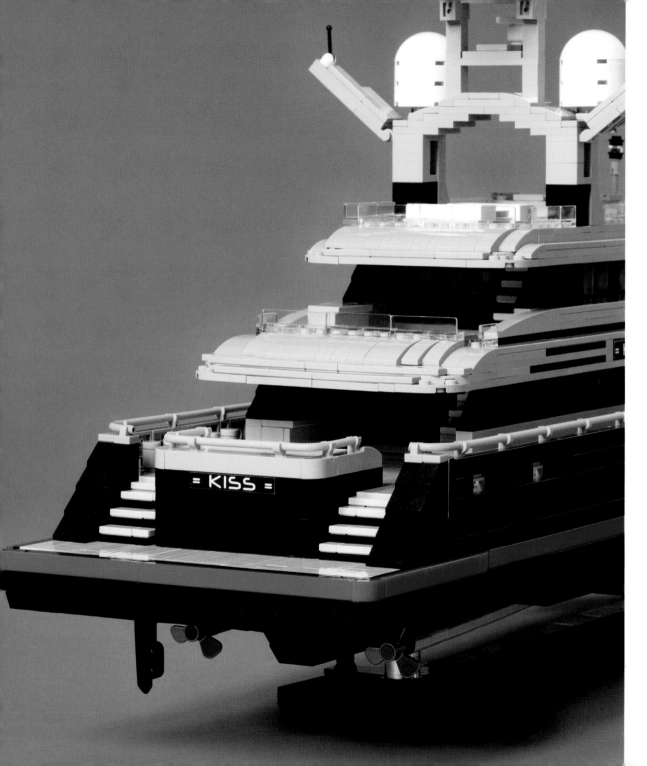

## Kiss

Feadship Royal Dutch Shipyards is known for designing high-end custom yachts like the *Kiss*, shown here.

A motor yacht with a transatlantic range, the *Kiss* was designed by Dubois Naval Architects. The 360-ton steel-constructed yacht is 152 feet (46.4 m) long and powered by two strong Caterpillar engines. An opulent interior and nine-person crew ensure the owner and guests travel in luxury.

The LEGO version of the *Kiss* was built especially for Feadship as a gift to the new owner of the yacht. The model was designed using blueprints and 3D renderings supplied by the shipyard.

The model is scaled down to 1:54 and is based on the size of the LEGO windows used for the upper deck. In total, about 12,000 LEGO elements were used in the model's construction.

# Grampian Don

The *Grampian Don* is an emergency response and rescue vessel (ERRV). It not only serves oil and gas operators in the North Sea but also monitors safety zones around offshore locations, as well as conducting recovery and rescue operations.

This large LEGO model of the *Grampian Don* has a unique hull construction composed of LEGO tiles rather than bricks. Slopes were used to create the impressive bow. Transparent panels mounted all around the large bridge deck give the crew good visibility. The vessel also comes equipped with a couple of cranes to carry and lift life rafts.

With a length of about 4 feet (125 cm), a height of almost 2 1/2 feet (74 cm), and a width of 1 foot (32 cm), this LEGO ship was built with more than 18,000 bricks.

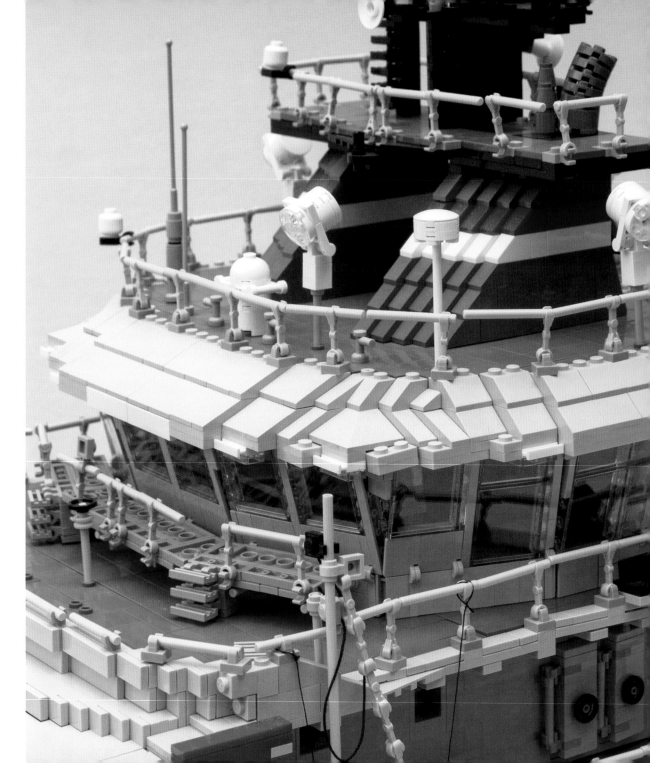

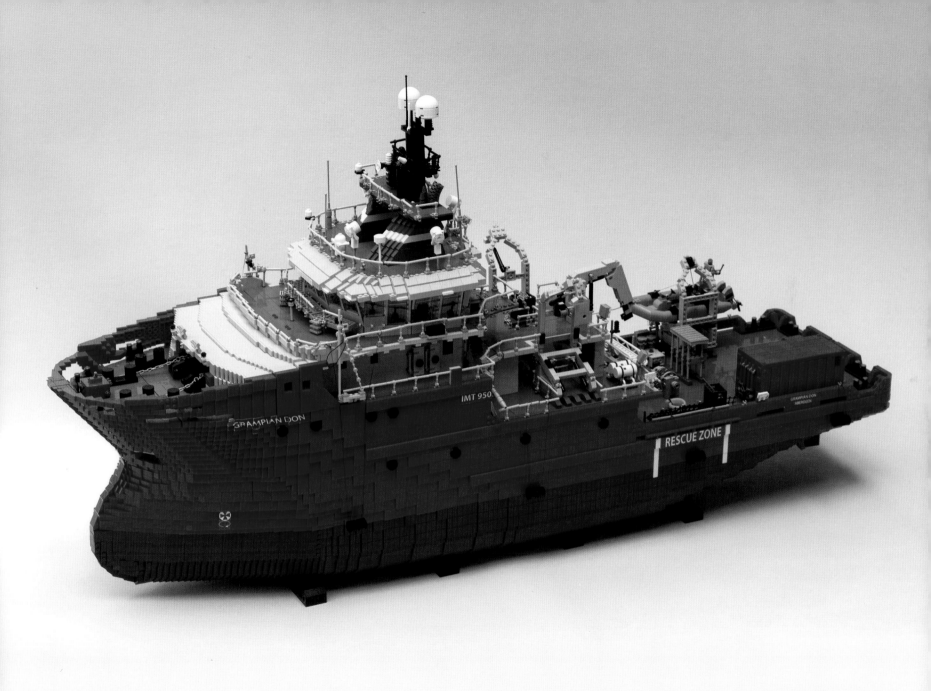

Text visible on the model:
GRAMPIAN DON
IMT 950
RESCUE ZONE
GRAMPIAN DON
ABERDEEN

***Grampian Don***
Arjan Oude Kotte

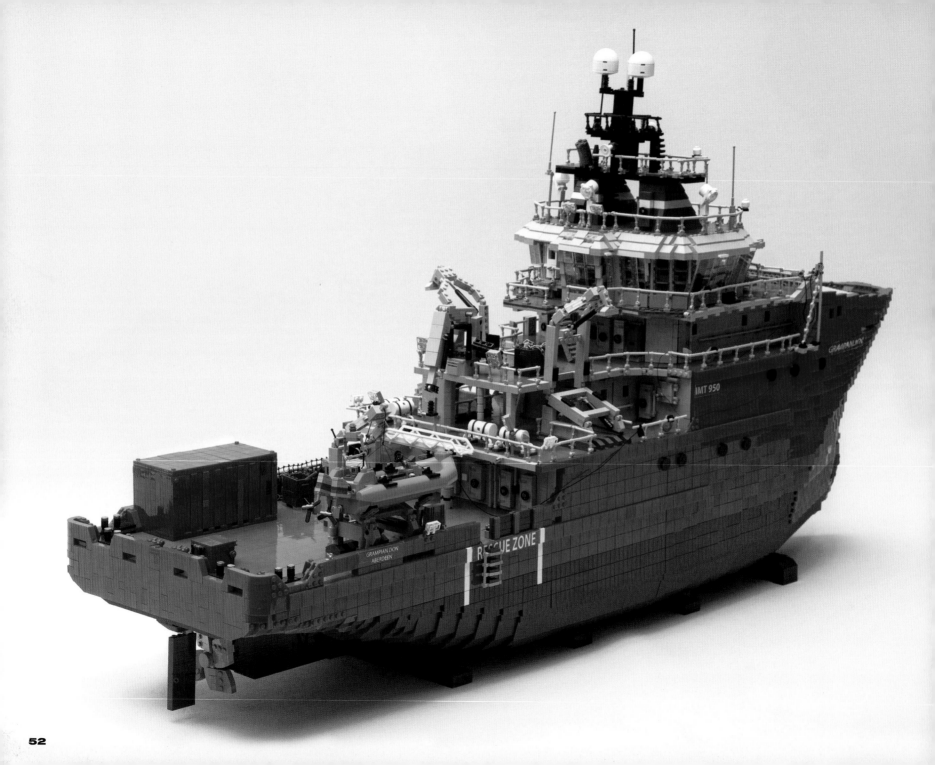

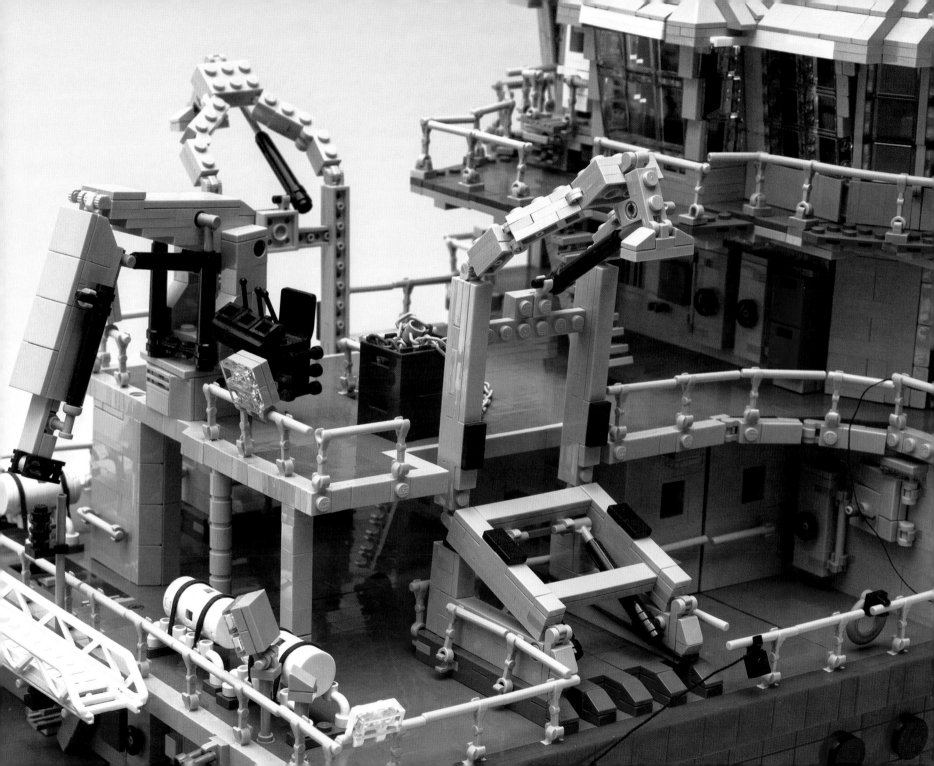

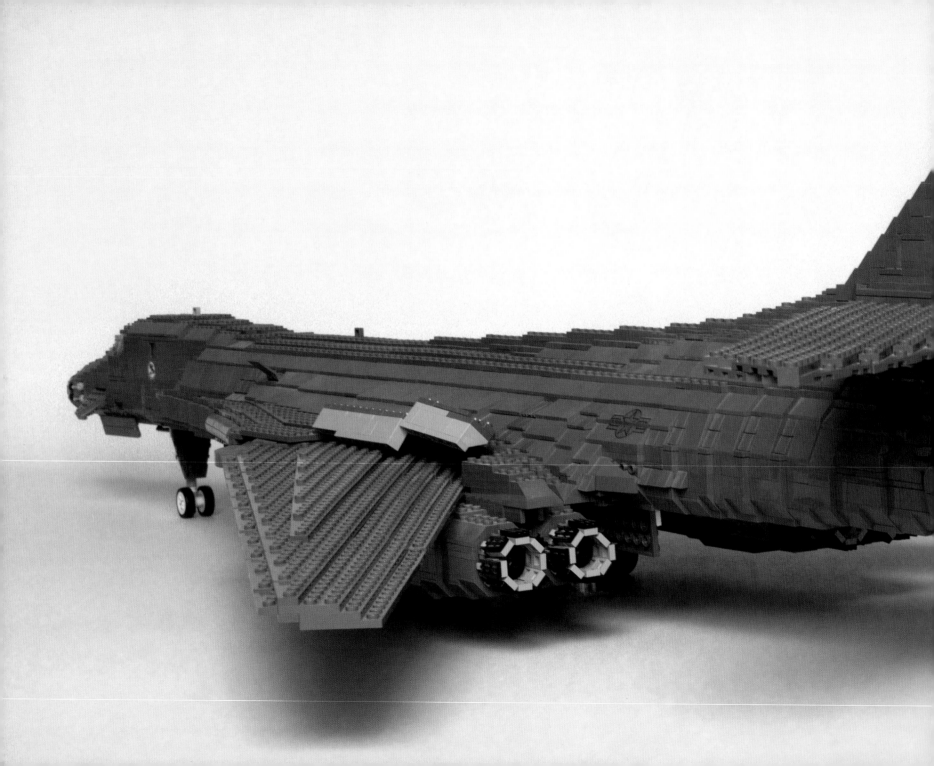

# Aircraft

Model planes have been on the market for more than a century, and aircraft represent a huge share of the commercially produced scale model kits to this day. As with cars, ships, and other vehicles, aircraft models may be either static or remotely controlled. LEGO aircraft models fall in the static category because they are too heavy and fragile to fly.

In the past, the LEGO Group released many official aircraft sets, most of which represented imaginary aircraft. But in more recent years, LEGO has released a number of realistic models of existing plane types, including the Wright Flyer and the Boeing 787 Dreamliner.

Fans and scale modelers have taken LEGO aircraft to the next level, creating authentic pieces in different scales using all types of available bricks and colors. Because the models are not designed to fly, modelers are free to disregard structural rigidity in favor of creating detailed reproductions of these aircraft.

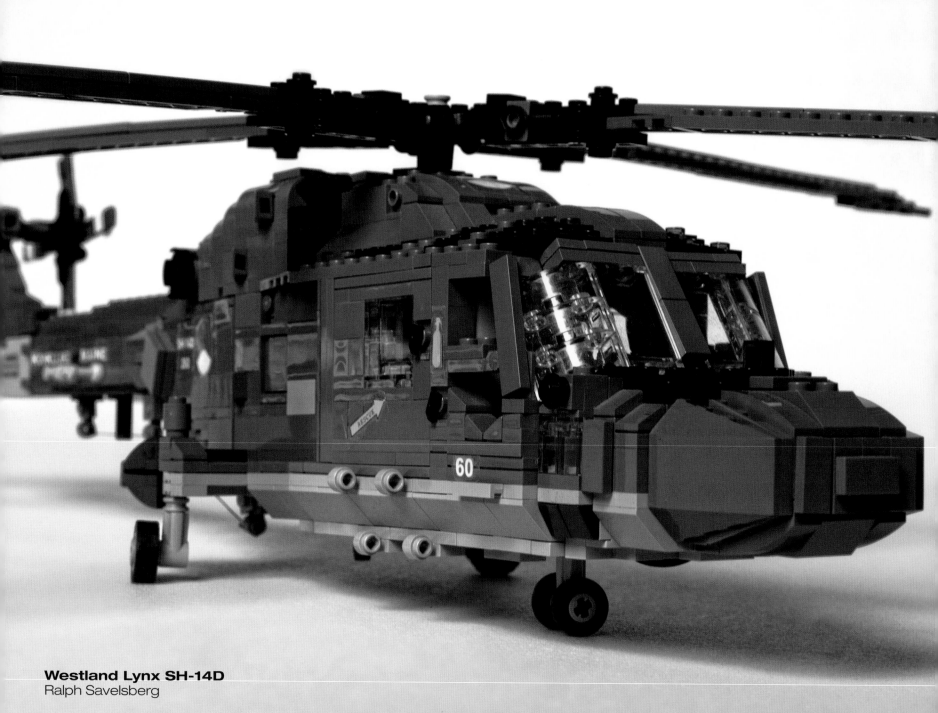

**Westland Lynx SH-14D**
Ralph Savelsberg

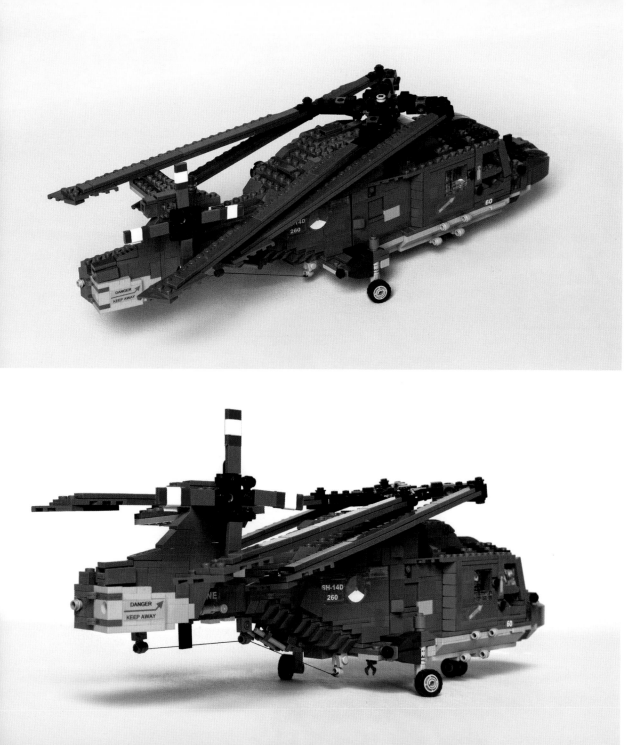

## Westland Lynx SH-14D

In Dutch Naval service until 2012, the British-built Westland Lynx was used for anti-submarine warfare, transport duties, and search-and-rescue missions.

The LEGO Lynx model was built to a scale of 1:22, using roughly 1,500 parts. No custom parts were used in the construction, but the model features custom-made decals that replicate the markings on one of the 24 helicopters that served with the Royal Dutch Navy.

With sliding doors in the cabin and operable cockpit doors, the model also incorporates features outfitting it for shipboard operations, including a rescue winch. Its unusual undercarriage, with pivoting struts on the rear wheels, is designed to prevent the helicopter from rolling off the deck. A folding tail boom and folding rotor blades enable the Lynx to fit inside the ship's small hangar.

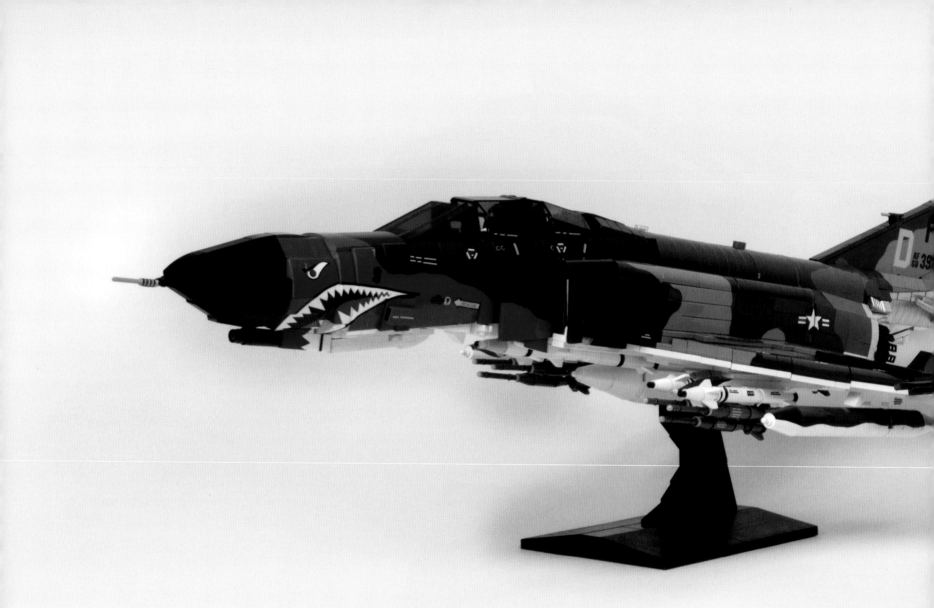

**McDonnell Douglas F-4E & F-4B Phantom II**
Carl Greatrix

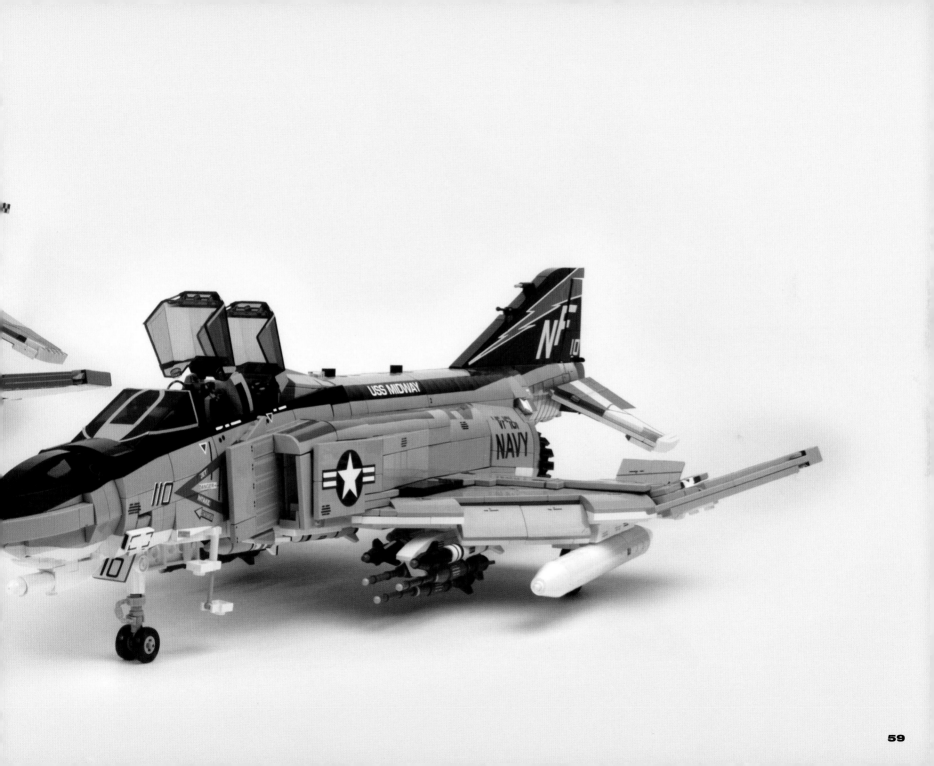

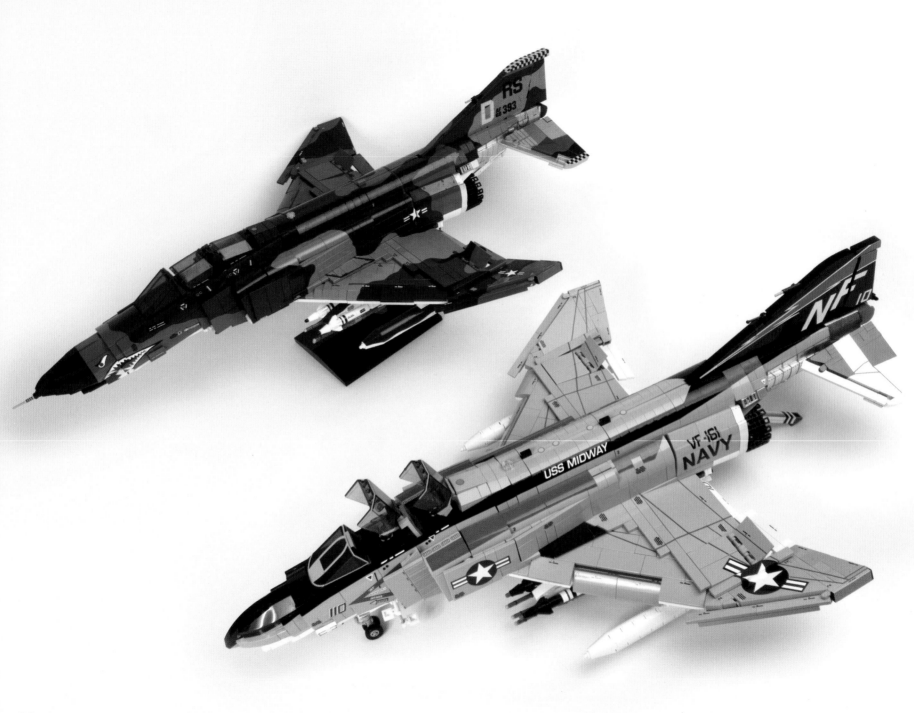

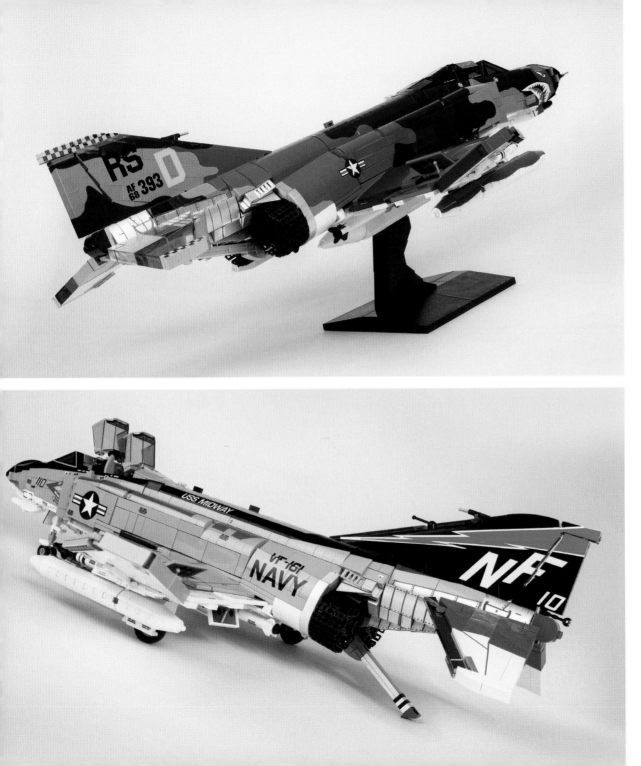

## McDonnell Douglas F-4E & F-4B Phantom II

The American McDonnell Douglas F-4 Phantom II is one of the most well-known military aircraft. Entering service in 1960, it was used by the US Navy, Marines, and Air Force for 36 years, and it is still in operational service in many other countries. During the time the Phantom was in production, 5,195 were built.

Both LEGO versions were built to a scale of 1:32. Each is about 24 inches (61 cm) long and weighs about 3.3 pounds (1.5 kg). The green camo model represents an F-4E that served the US Air Force in Europe at the Ramstein Air Base. The grey model is a US Navy F-4B. Distinguished by its unique landing gear and the tailhook between its engine exhausts, this aircraft served on the USS *Midway* aircraft carrier and was used by the VF-161 Chargers squadron.

These complex, highly detailed models are finished with custom decals that contribute to their realism.

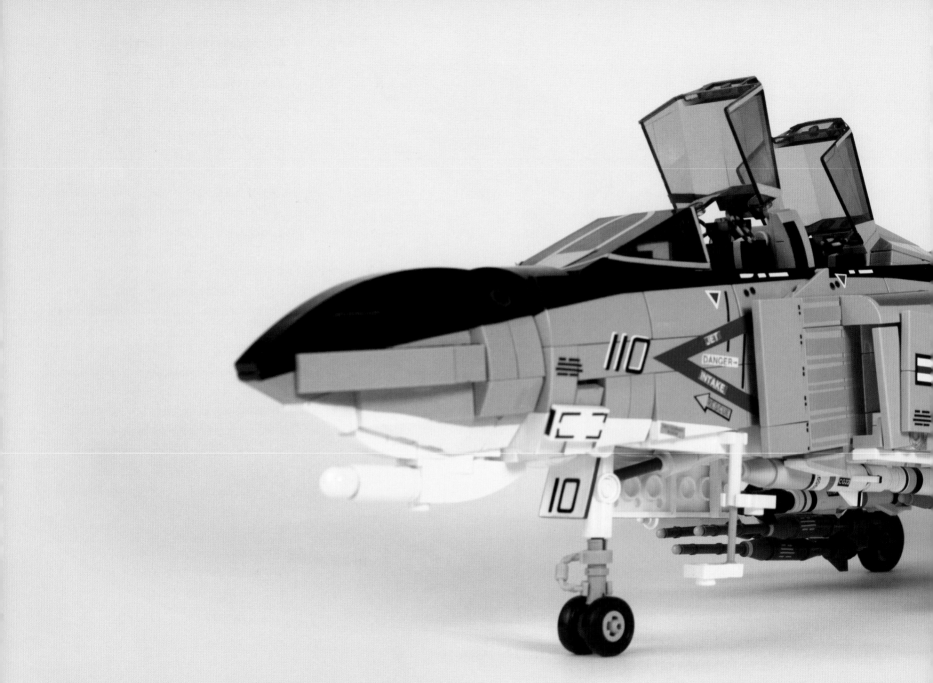

**McDonnell Douglas F-4B Phantom II**
Carl Greatrix

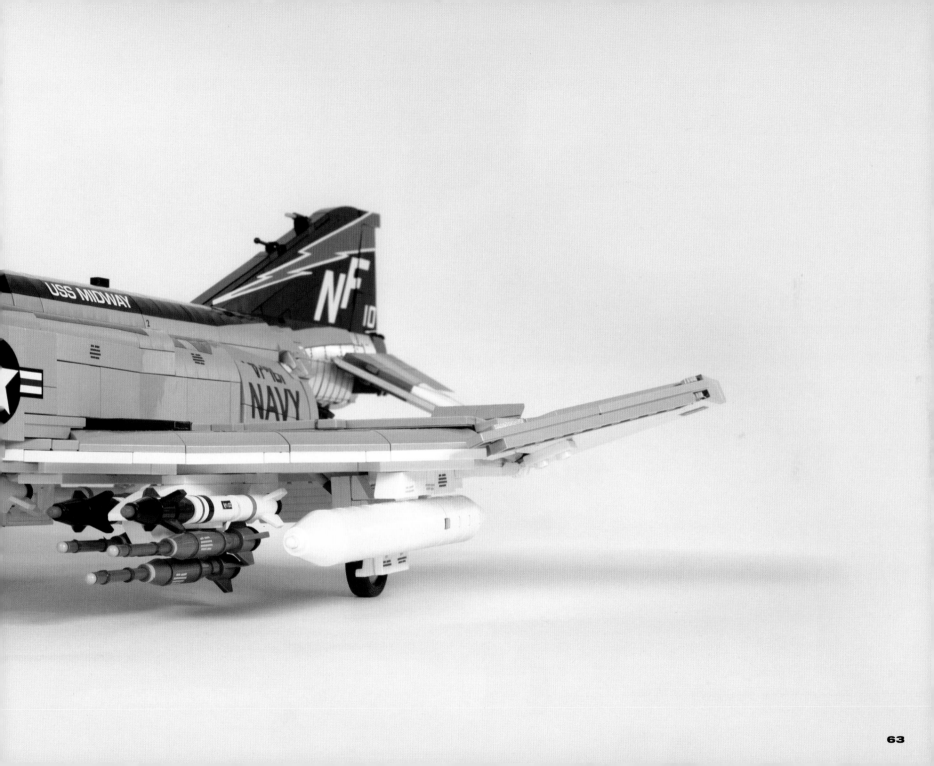

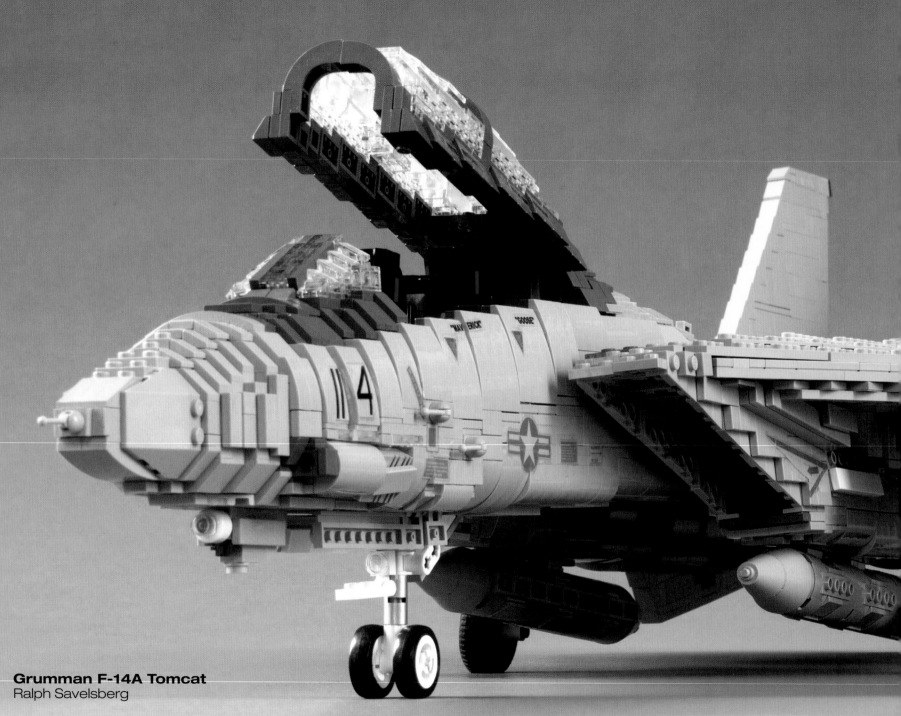

**Grumman F-14A Tomcat**
Ralph Savelsberg

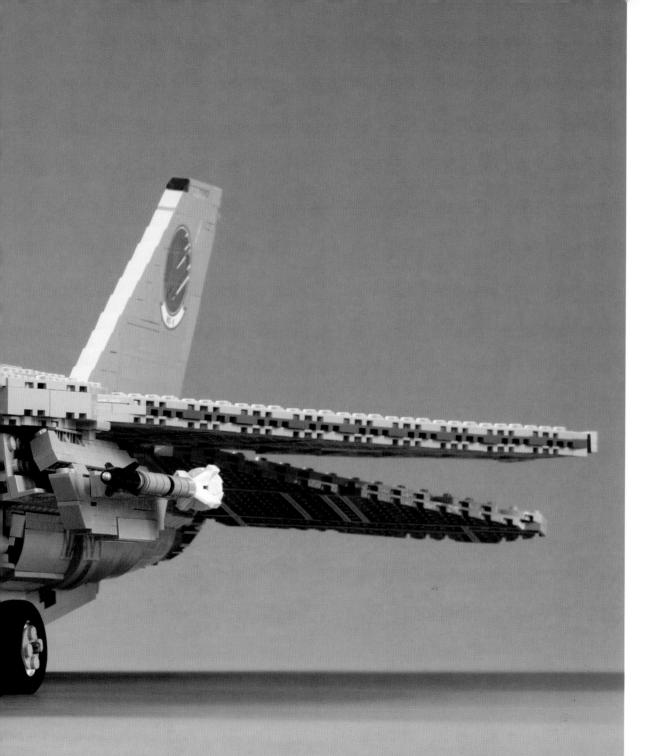

## Grumman F-14A Tomcat

From the mid-1970s until its retirement in 2006, the Grumman F-14 Tomcat was the US Navy's premier fighter, replacing the F-4 Phantom II on aircraft carriers.

With the size and weight of a WWII bomber, the F-14 was enormously expensive. But it could fly at more than twice the speed of sound and was both agile and heavily armed. A total of 712 were produced before production ended in 1991.

This LEGO Tomcat was built to a scale of 1:22 using roughly 6,000 parts. A copy of the jet used in the 1986 movie *Top Gun*, the model features custom decals. Other realistic touches include working variable-geometry wings with adjustable sweep angle, functioning flaps and ailerons, a cockpit canopy that opens to reveal a detailed cockpit, and fully retractable landing gear.

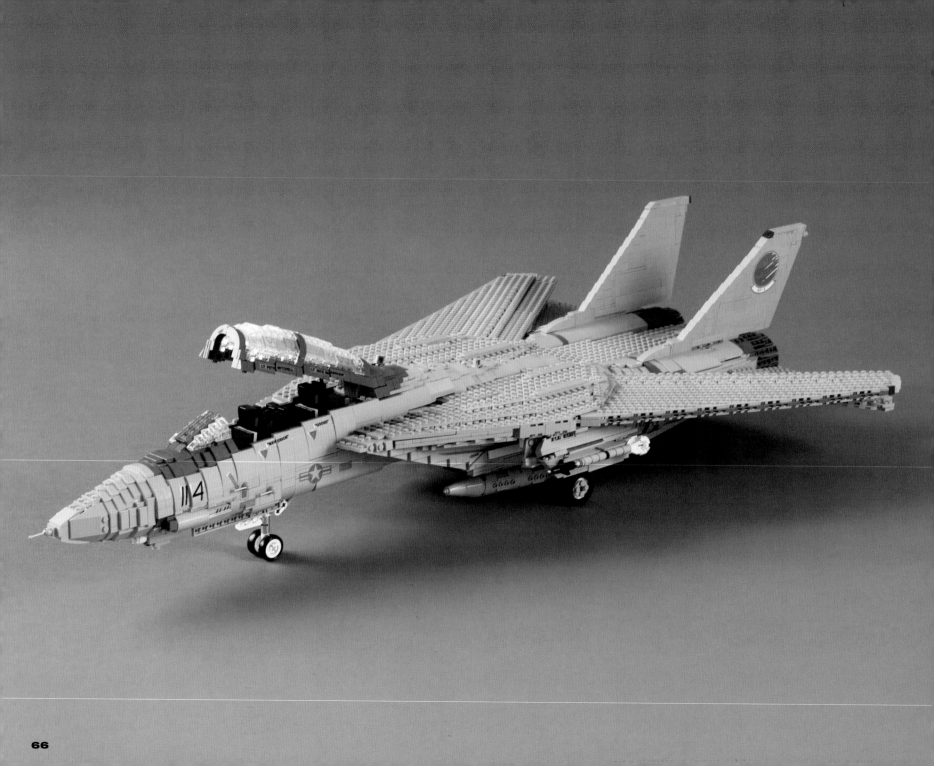

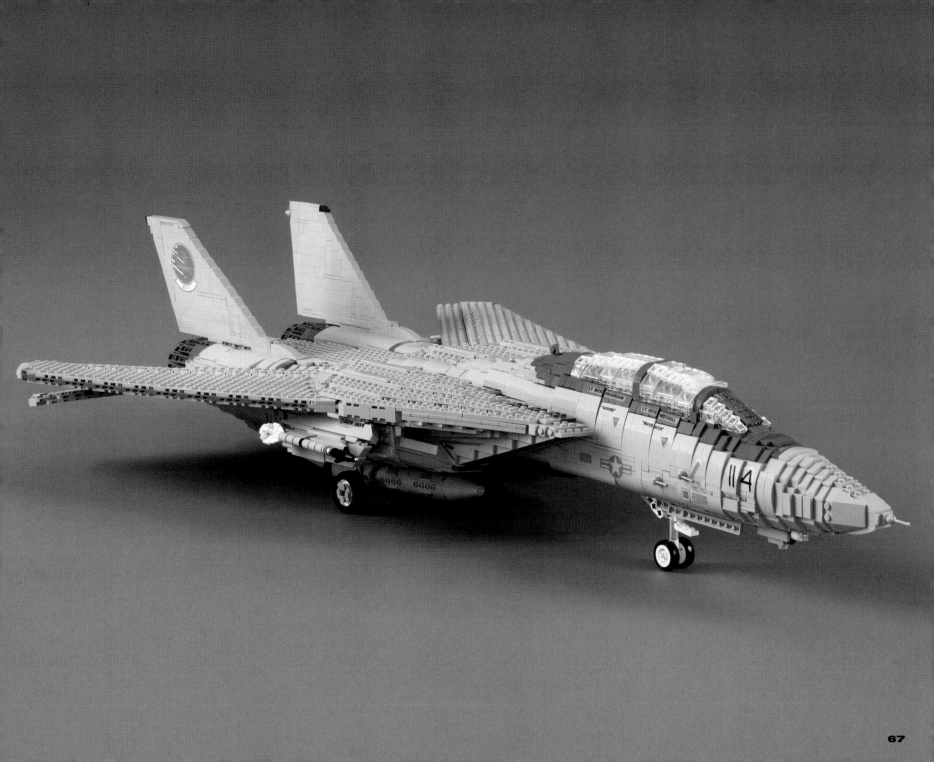

# Rockwell B-1B Lancer

The B-1 Bomber was originally developed as a long-range, supersonic nuclear bomber. First put into operation in 1974, the plane was redesigned in 1983, and a total of 100 of these newer B-1B aircraft were built. In the 1990s, after the Cold War ended, the B-1B was converted to the conventional weapons mission it currently performs.

The plane's four engines can produce a top speed of over 900 mph (1,448 km/h). Because 120 tons of its maximum takeoff weight of 216 tons can be fuel, the plane has a very long range of 7,500 miles (12,000 km).

This LEGO B-1B is built to a 1:36 scale and is approximately 4 feet (122 cm) long. Roughly 10,000 parts were used in its construction. Like the F-14A Tomcat on the previous pages, the B-1B has working variable-geometry wings, operational flaps, and retractable landing gear. In addition, it features detailed weapons bays and a functioning cockpit access ladder.

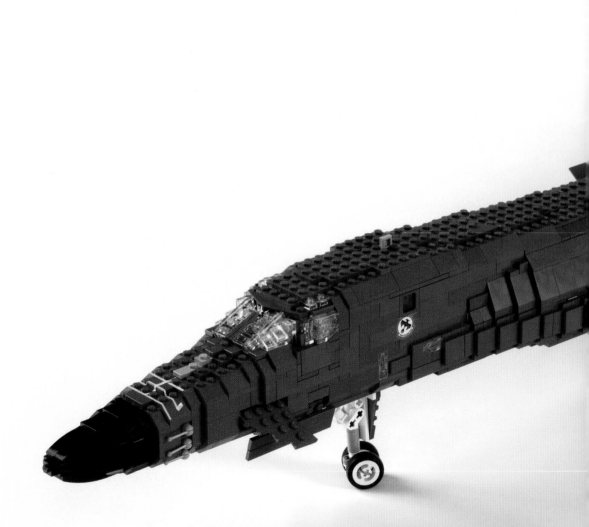

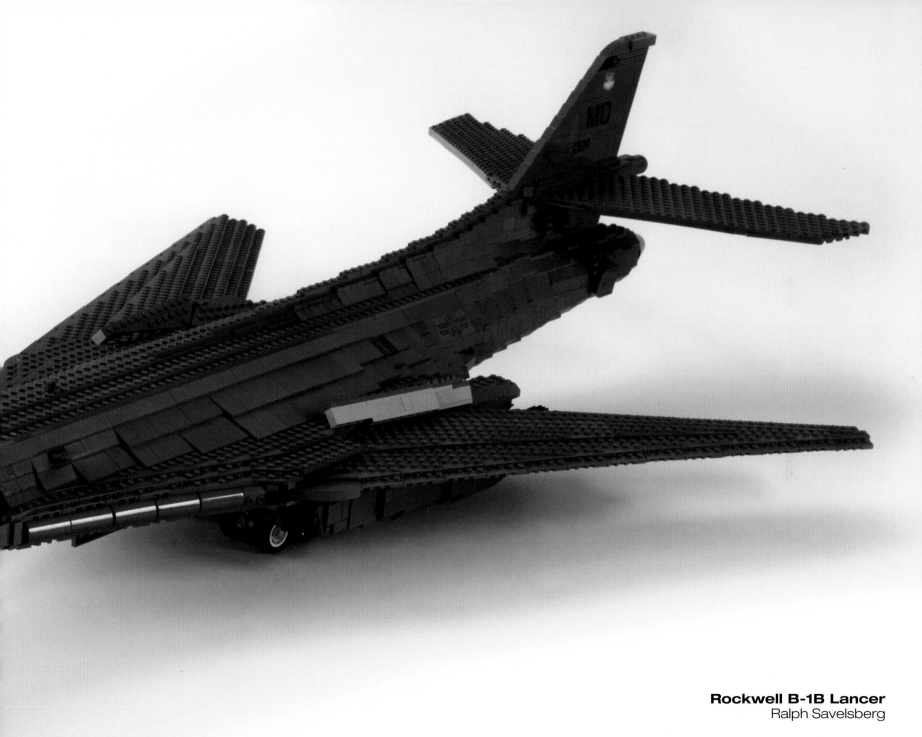

**Rockwell B-1B Lancer**
Ralph Savelsberg

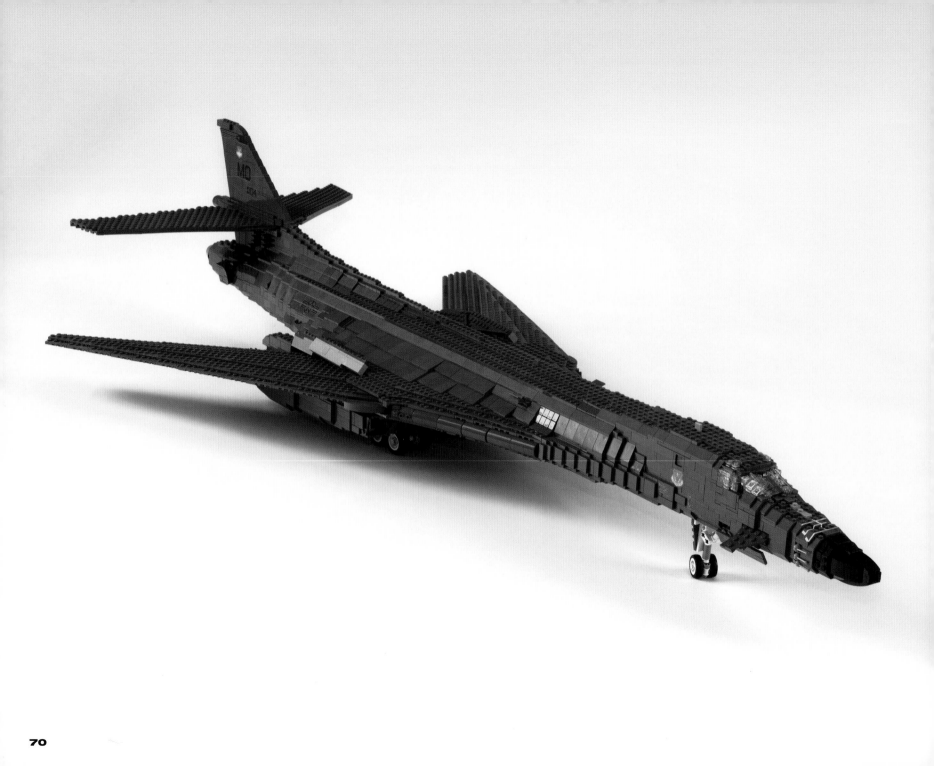

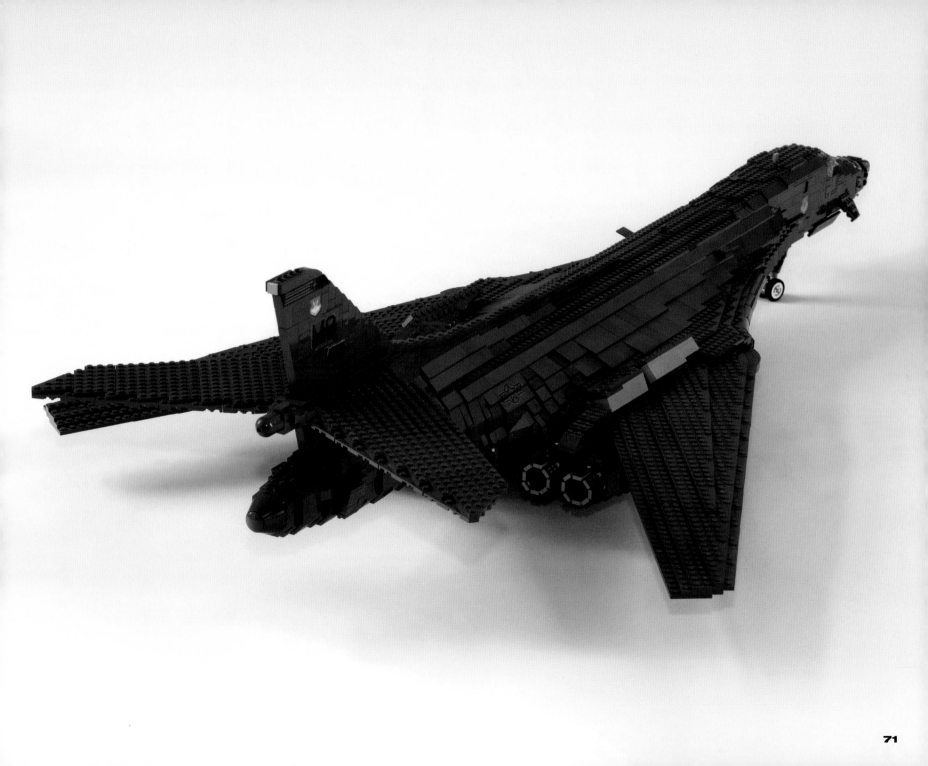

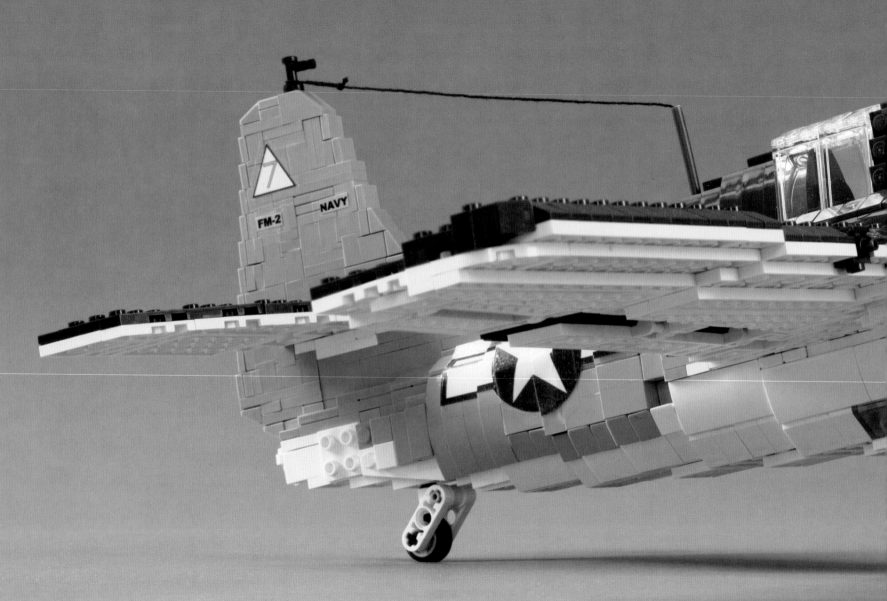

**FM-2 Wildcat**
Ralph Savelsberg

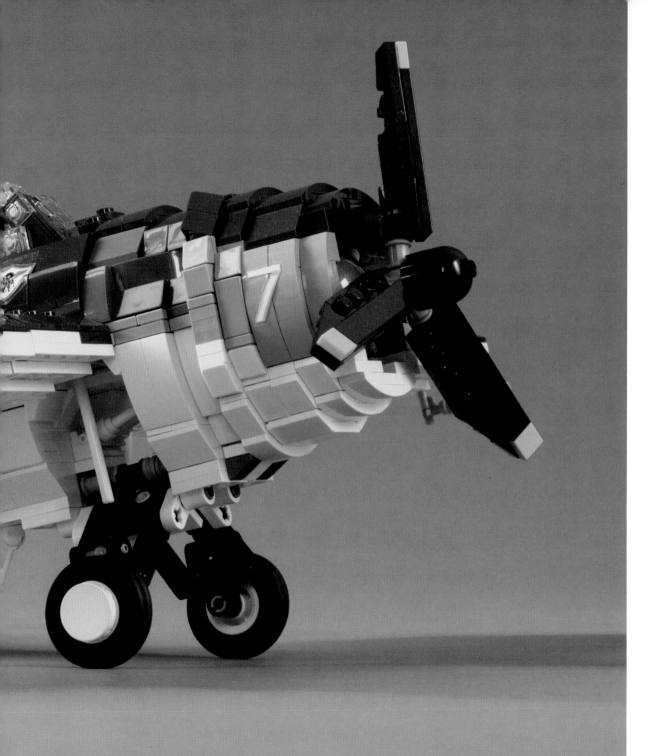

## FM-2 Wildcat

At the start of World War II, the Grumman Wildcat was the US Navy's main carrier-based fighter. It was one of the first Navy fighters to be equipped with retractable wheels and a fully enclosed cockpit. The plane's folding wings allowed it to be efficiently stowed on small carrier flight decks.

Later in the war, when Grumman began building more advanced planes, Wildcats continued to serve from the relatively small decks of escort carriers. Wildcat production was later transferred to a former car plant owned by General Motors. GM built the ultimate Wildcat version, the FM-2—nicknamed the *Wilder Wildcat*—which this LEGO model re-creates.

With a scale of 1:22, the model was built using roughly 2,500 parts. It features retractable landing gear and a working aft-sliding cockpit canopy. The folding wings reproduce the original Grumman Sto-Wing design.

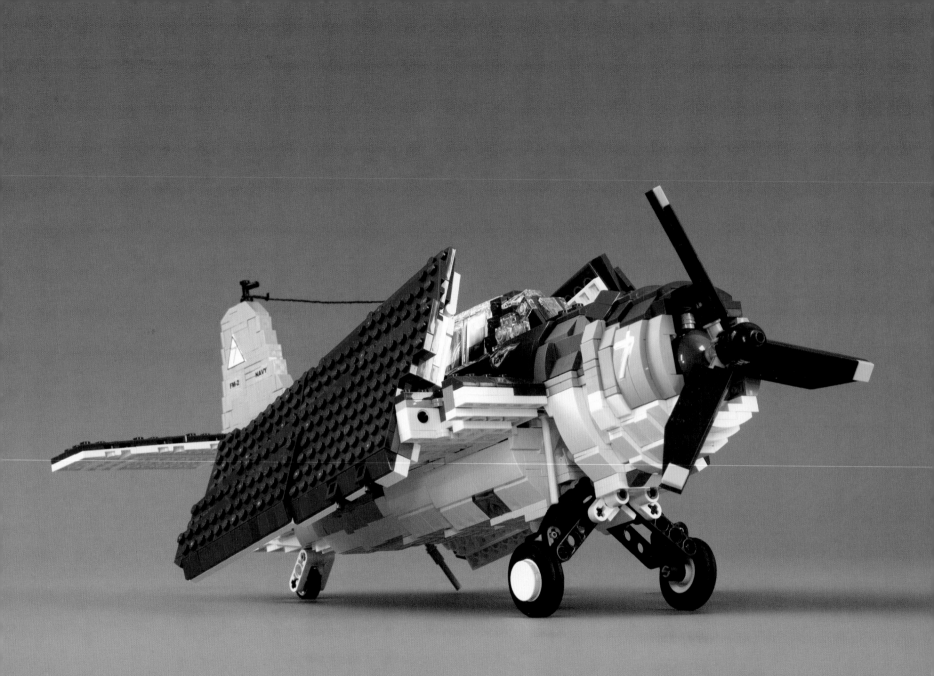

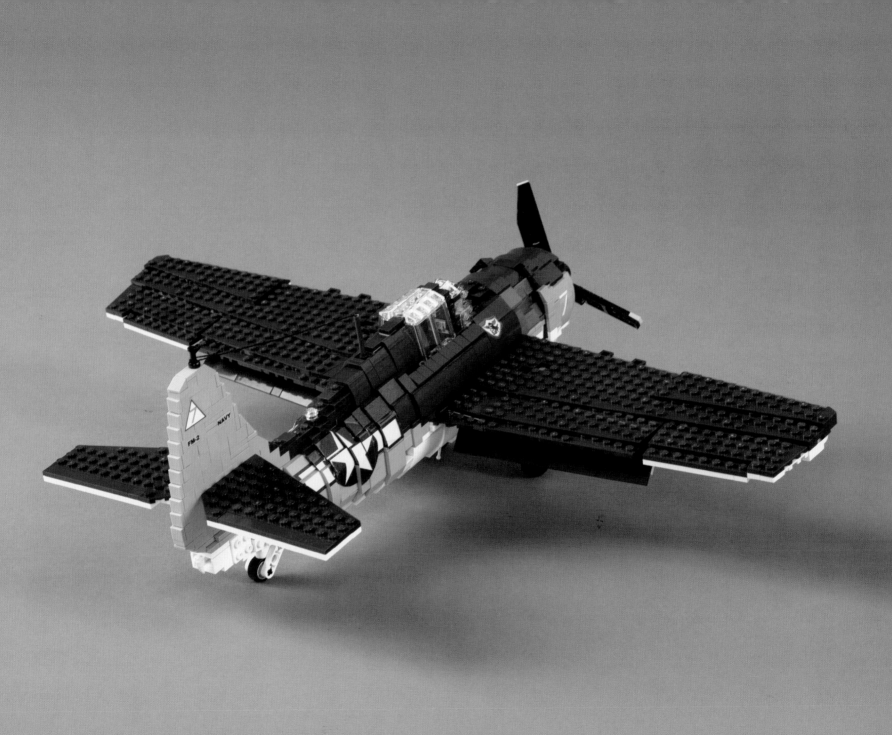

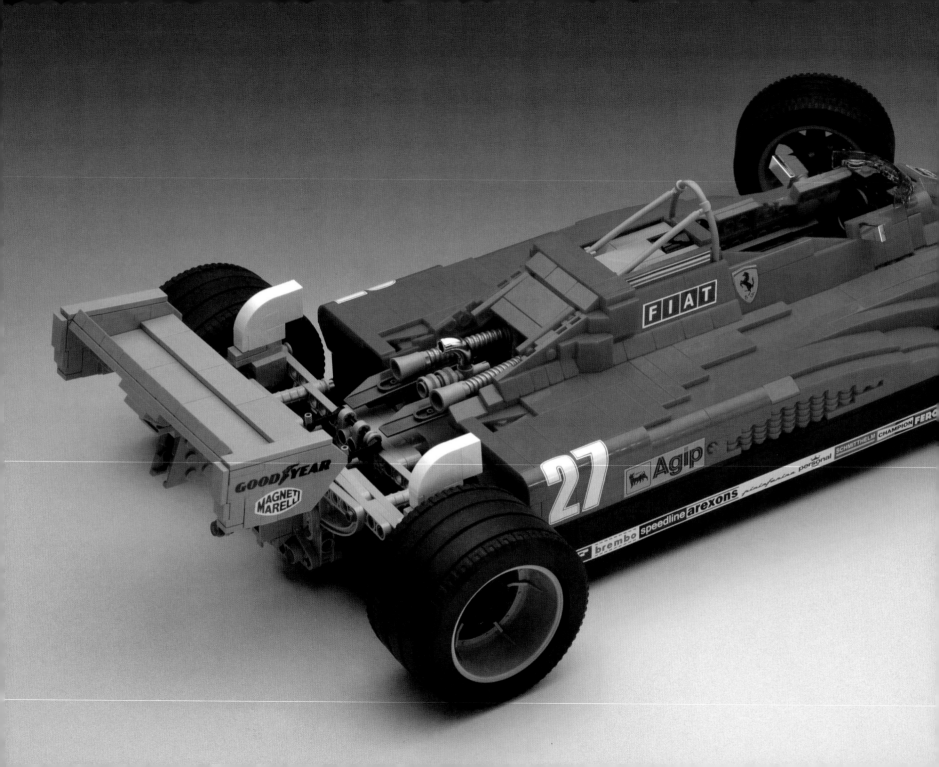

# Racing

Different races require different types of vehicles. But no matter what form racing takes, its speed and the noises from the engines and exhausts always attract big crowds. Whether modern high-tech machines or vintage racers are involved, the sport has enduring appeal.

Race cars have always been featured in the LEGO catalogue and remain a popular theme. One of the very first sets was a 1970s Formula 1 car (set #392), and many more came after it, such as the Ferrari and Williams F1 (sets #8386 and #8461).

Many LEGO builders make their own versions of favorite race cars, and some go the extra mile by building elaborate models of vintage and current racing vehicles. Some modelers specialize in certain areas, transforming their knowledge of teams, cars, and technology into lifelike models.

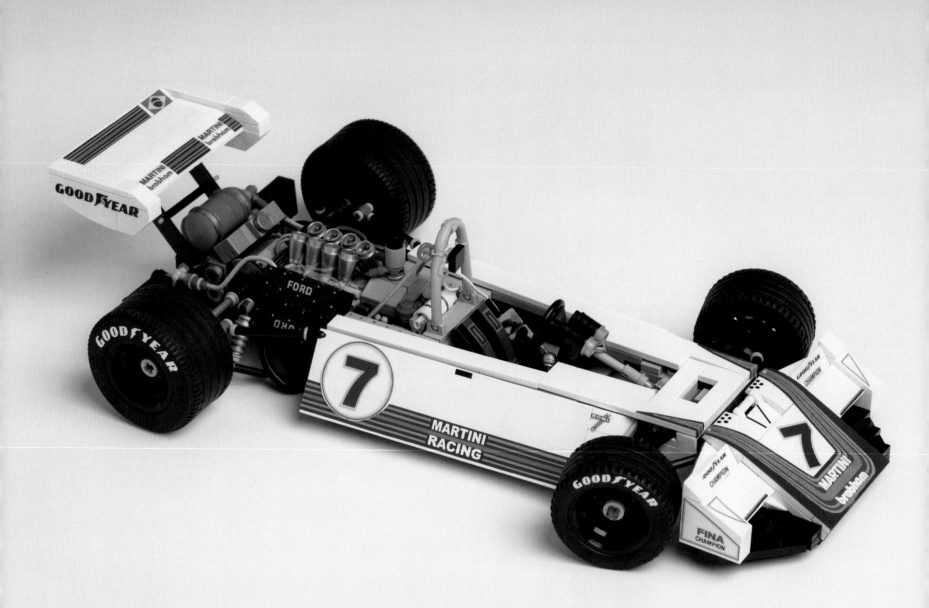

**Brabham BT44B**
Carl Greatrix

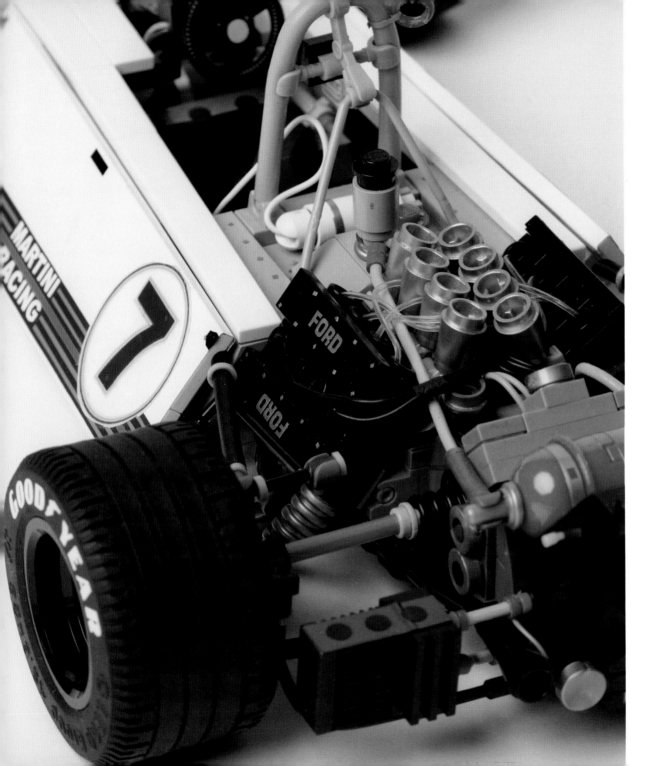

## Brabham BT44B

Brabham was a British racing car manufacturer and Formula 1 racing team. Its BT44 debuted at Argentina's Grand Prix in 1974, and Argentine driver Carlos Reutemann went on to net three wins for the team during that season. The car was modified in 1975, and the team drove the BT44B to win two Grand Prix, finishing the season by taking second place at the Constructors' Championship.

Sponsored by Martini & Rossi, the BT44B is powered by a Ford DFV V8 engine with 182.6 cubic inches (2,993 cc) of displacement and an output of approximately 460 hp at 10,500 rpm. The entire car weighs 1,269 pounds (576 kg). Its simple but aerodynamic body is a trademark of Brabham designs.

This LEGO model features linked steering; a removable nose cone; removable intake cowling; and a modular engine, gearbox, and rear wing—all of which expose the model's detailed internals.

## Porsche 962C

Endurance races, like the famous
24 Hours of Le Mans, have featured
many specialized race cars over the
years. In 1982, Porsche developed the
962, a car that could compete in both the
American IMSA GTP and European FISA
Group C endurance racing series.

The 962 accumulated more than 180
victories, starting in 1982 and continuing
well into the 1990s. Porsche built a total
of 73 of these vehicles, each equipped
with an air-cooled, 6-cylinder engine
rated at more than 600 hp.

This 962C replica is a 1:17 scaled version
of the official factory team cars that ran
from 1984 to 1987. The model's livery
is created using bricks, and its doors
open just like the original's. The rear area
in particular, including the engine and
suspension, shows what can be done
with LEGO.

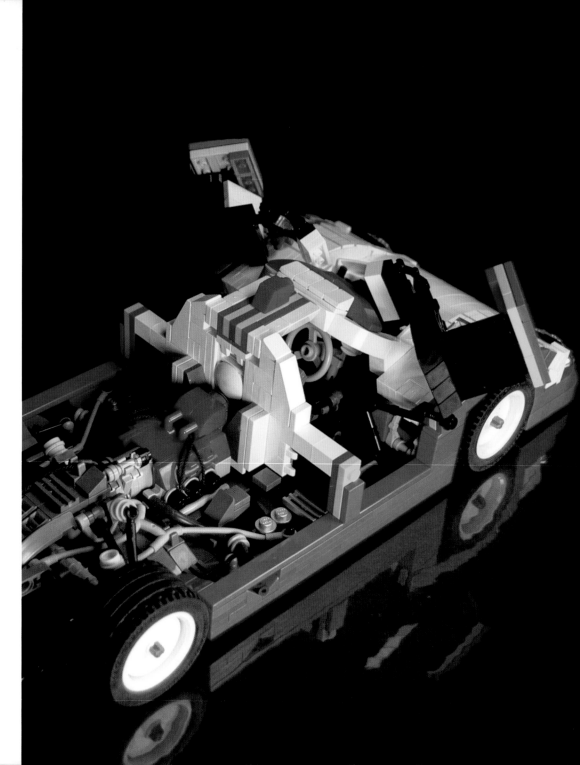

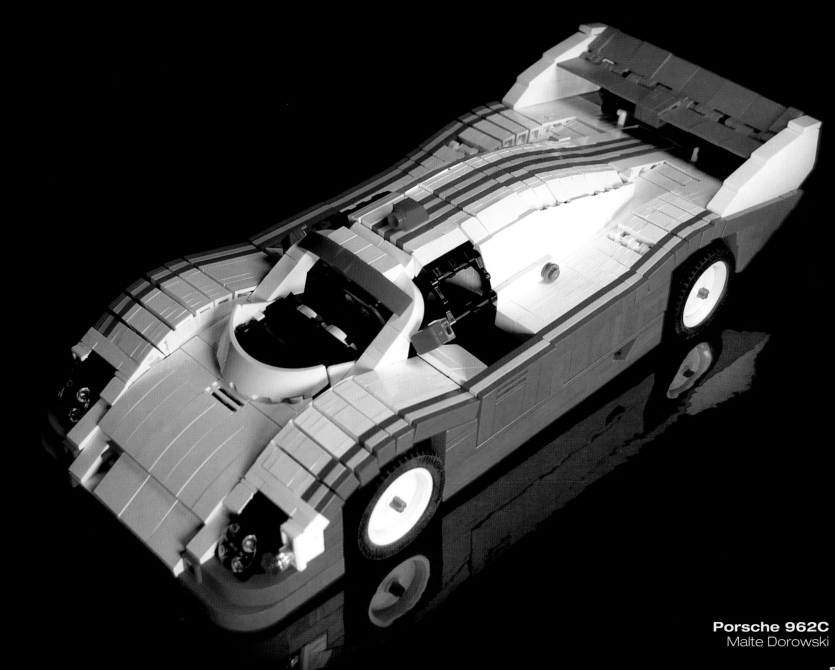

**Porsche 962C**
Malte Dorowski

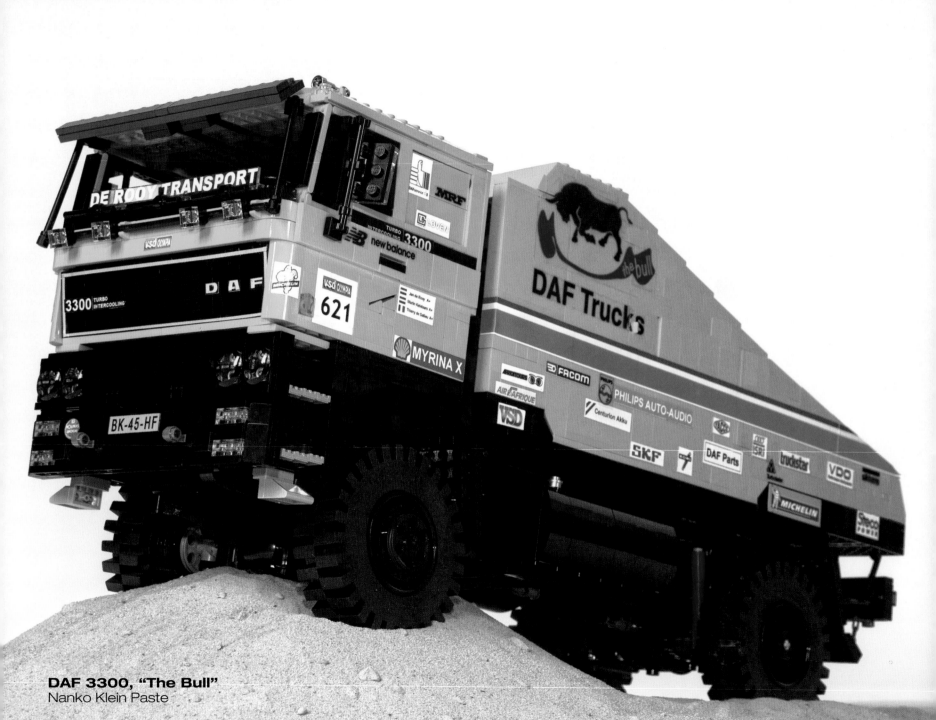

**DAF 3300, "The Bull"**
Nanko Klein Paste

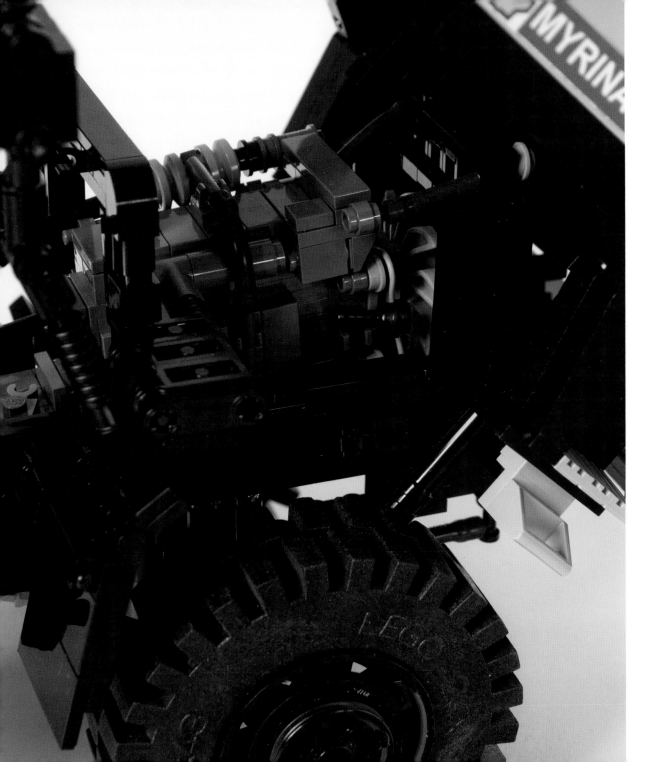

## DAF 3300, "The Bull"

The Dakar rally raid is one of the most challenging events for cars, motorcycles, and trucks. In 1981, Dutch truck manufacturer DAF entered for the first time but was unsuccessful. A year later, Dutchman Jan de Rooy, a well-known rallycross driver and owner of a transport company, led Team de Rooy to victory in the truck class.

In 1985, the team entered the rally with an innovative DAF truck called "The Bull." Powered by two engines delivering a combined 850 hp, the truck won its class.

The LEGO version, built to 1:16 scale, features large 24×43 Technic wheels, giving the truck a massive look and high ground clearance. Much attention was paid to the model's engines, drivetrain, and suspension. Decals representing the many rally team sponsors were made for the model as well.

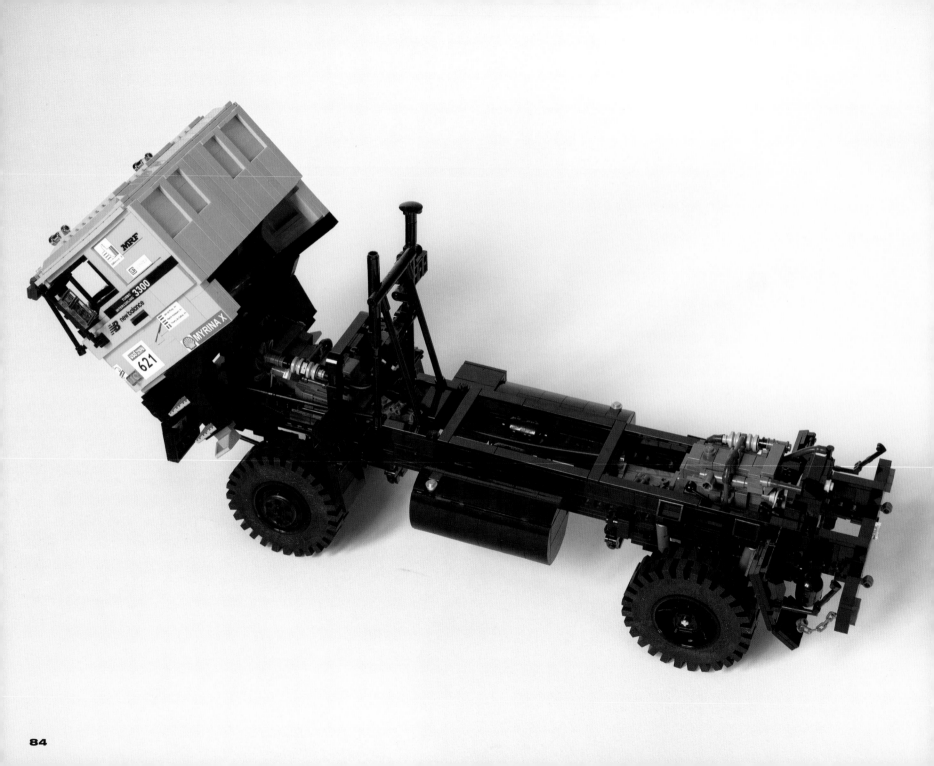

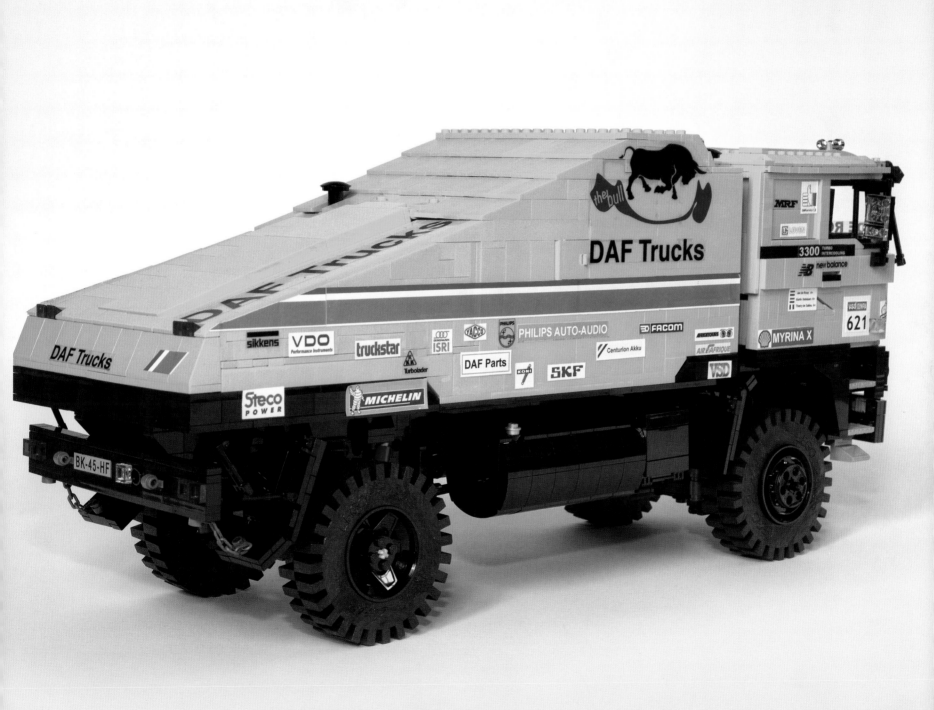

# Ferrari 312T4

The Ferrari 312T4 marked Ferrari's move to design cars with more aerodynamic ground effects, an innovation in Formula 1 racing introduced by Lotus in the late 1970s. The T4 proved to be a reliable race car and led to Scuderia Ferrari winning the 1979 Constructors' Championship, with Jody Scheckter and Gilles Villeneuve taking 1st and 2nd place, respectively, in the Drivers' Championship.

The scale of the featured 312T4 model was based on available LEGO wheels, and its design presented some challenges. The removable upper body panel, for example, needed to look realistic while still serving as a structural component. Featuring a removable nose cone, upper body panel, and side body panels, plus a removable modular engine and a separate gearbox and rear wing, this model can be stripped down to the driver's monocoque (protective shell).

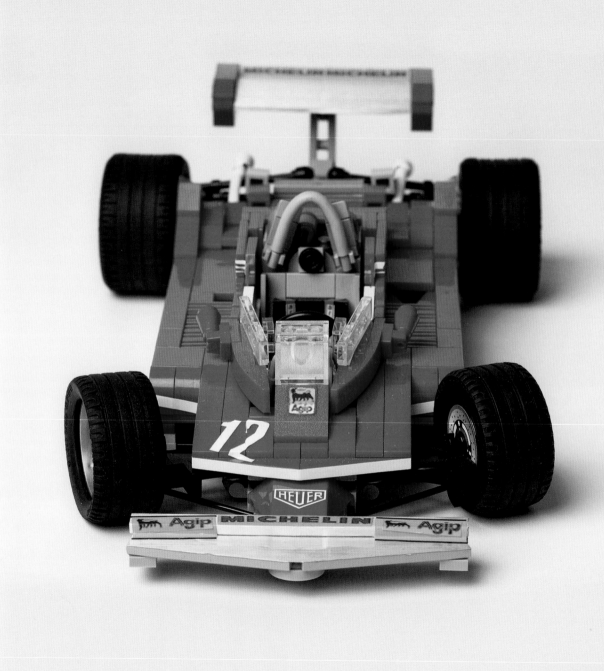

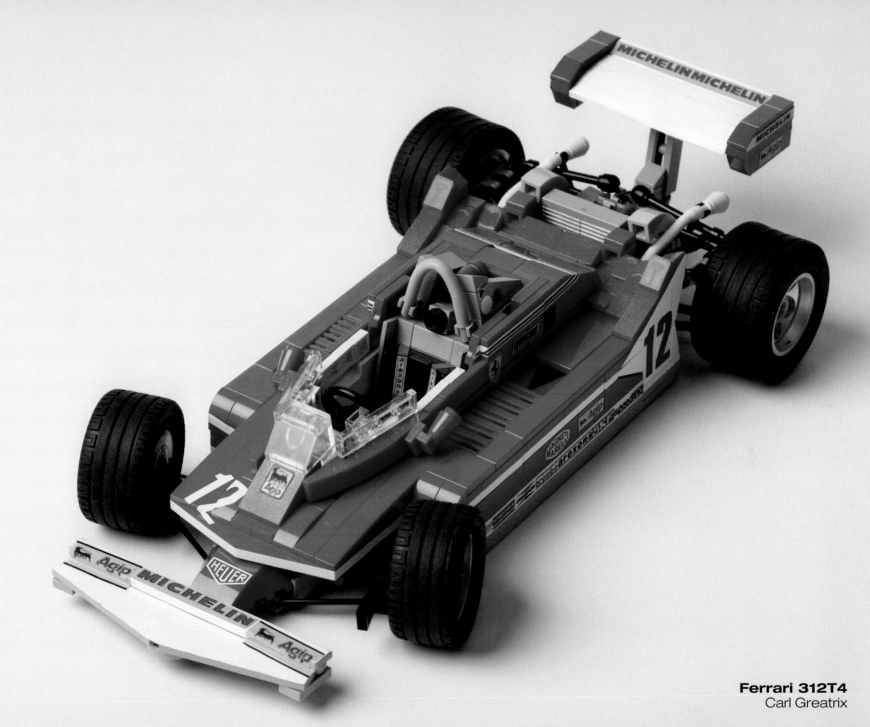

**Ferrari 312T4**
Carl Greatrix

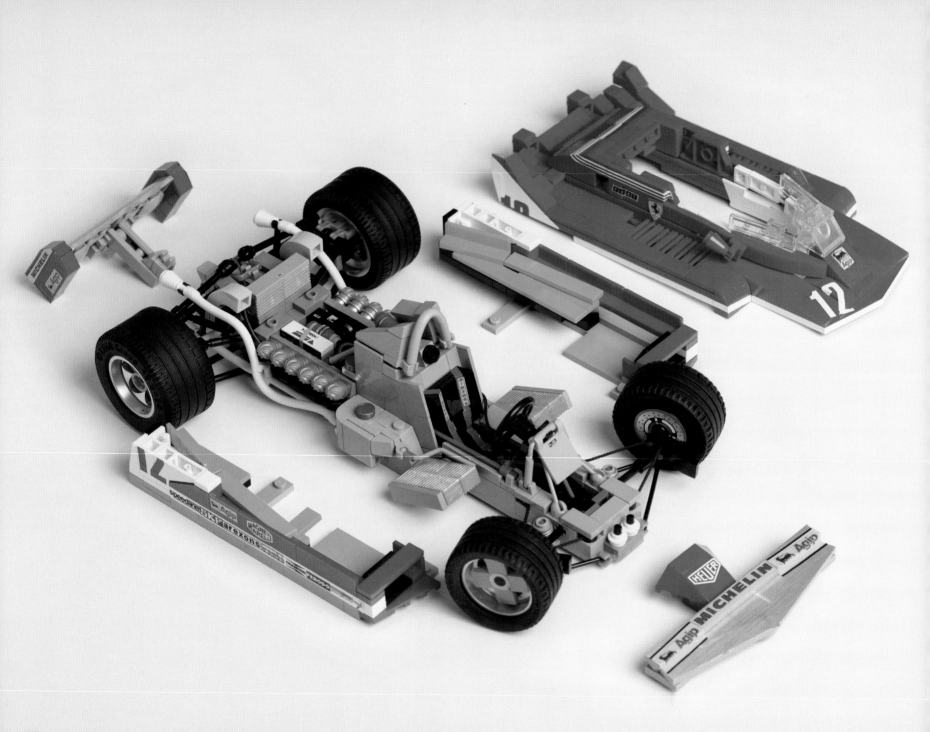

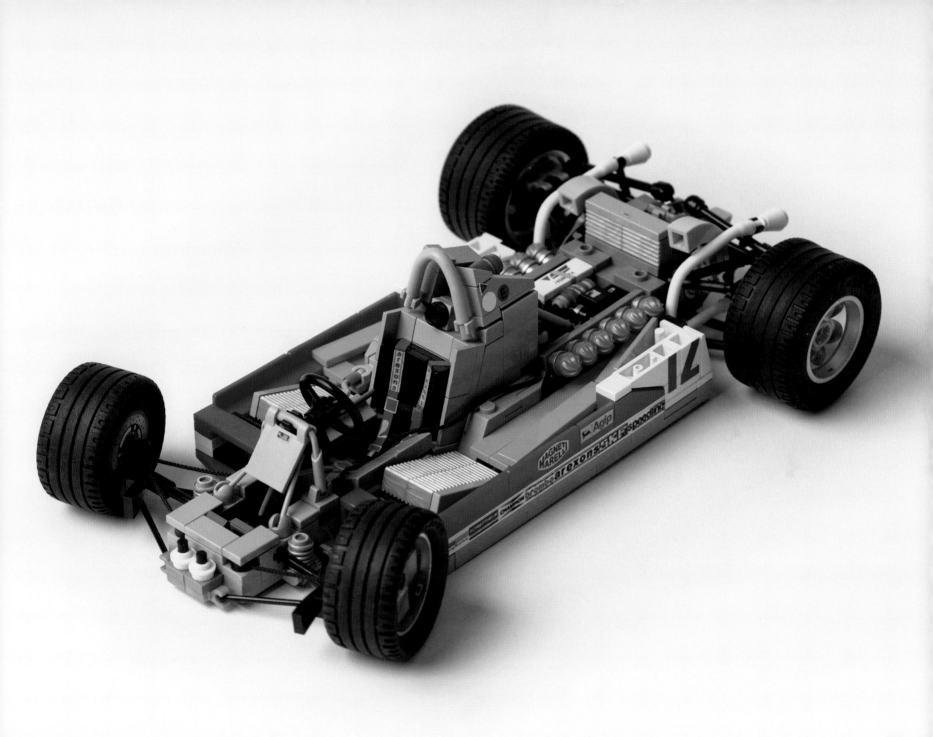

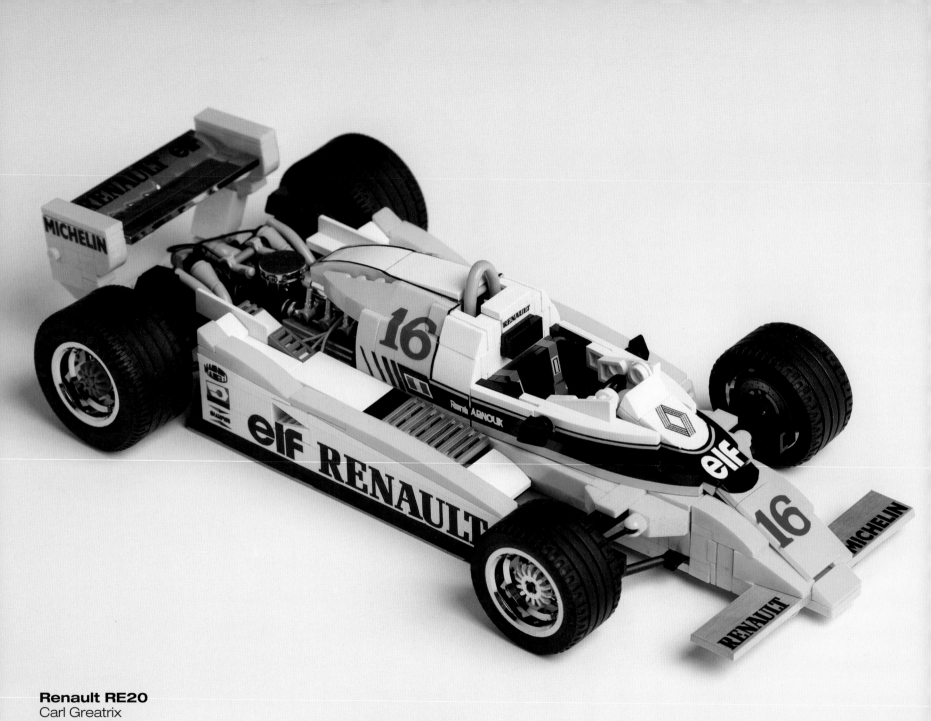

**Renault RE20**
Carl Greatrix

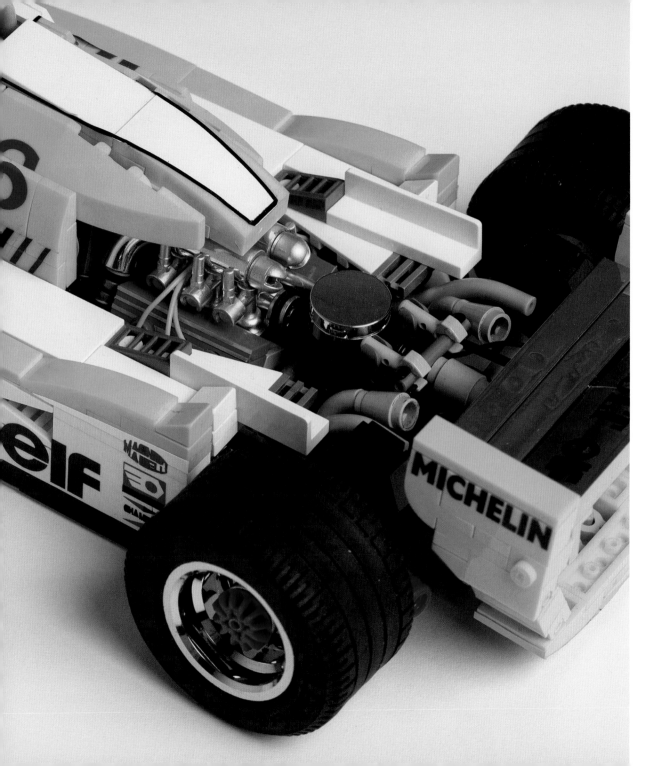

## Renault RE20

Renault pioneered turbo technology in Formula 1. In 1977, it developed its first turbo car, powered by a very small 1.5-liter V6 engine. Although quick, the car was not very reliable, and it did not win a victory until 1979.

The 1980 Renault RE20 was based on the same type of 1.5-liter engine. The car weighed 1,355 pounds (615 kg) and delivered about 520 hp. Developed entirely in France, it featured Michelin tires and used ELF fuel. The team, including drivers Jean-Pierre Jabouille, René Arnoux, and Alain Prost, finished fourth in the Constructors' Championship that year.

Because of the complex shape of the original bodywork, this LEGO model relies on the many angled and curved slopes now available. The model features a removable nose cone, upper body panel, side body panels, and rear wing so that it can be stripped down to the driver's protective capsule and the fuel cell.

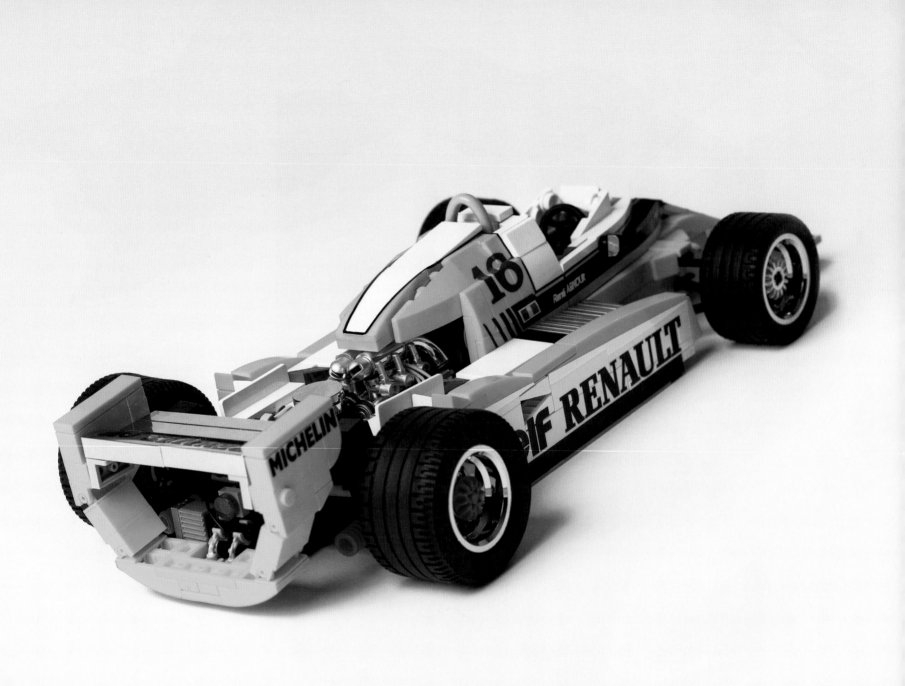

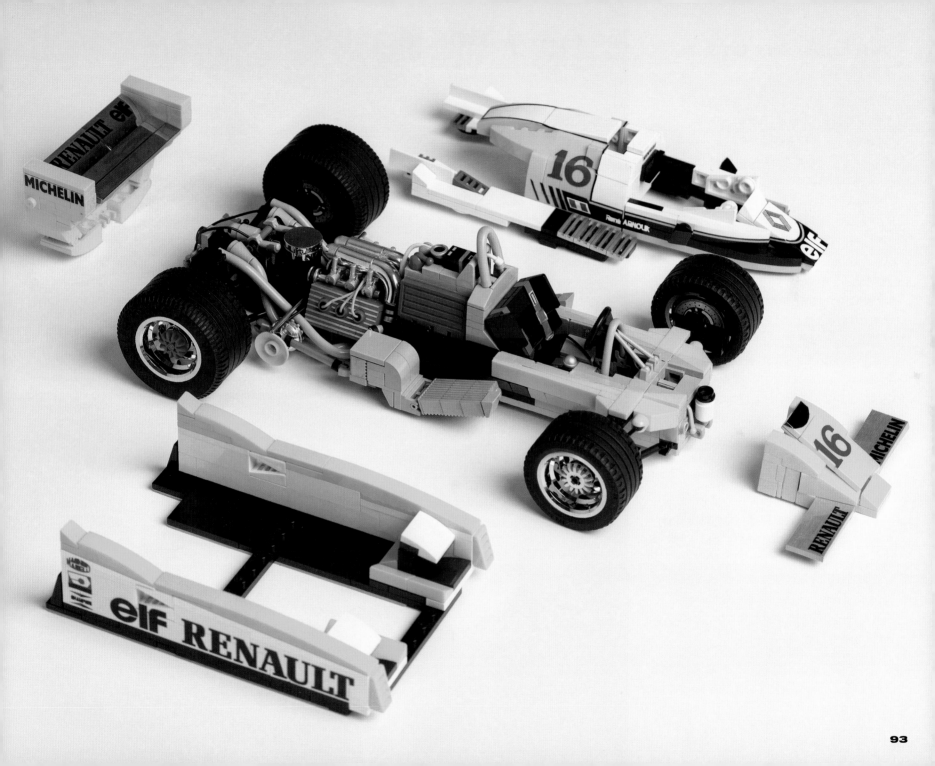

# Porsche 911 GT3-R Hybrid

Hybrid cars supplement a gas engine with a battery and an electric motor, allowing a mix of low-speed electric driving, as well as an electric power boost that reduces gasoline consumption. With the 911 GT3-R Hybrid, Porsche built a prototype that uses this technology for racing purposes.

Built in 2009, the car has a gasoline engine mounted at the back, powering its back wheels. A pair of electric motors over the front axle power the front wheels. Rather than storing power in batteries like a traditional hybrid, the Porsche stores power kinetically, in a flywheel, and redeploys it to the front wheels. All the power combined can deliver in excess of 630 hp.

While the LEGO version, scaled to 1:17, does not feature working engines, it does include plenty of functionality and detail. The classic shape of the 911 is tricky to create with bricks, but this example does so realistically—so much so that the builder was featured on the official Porsche media site.

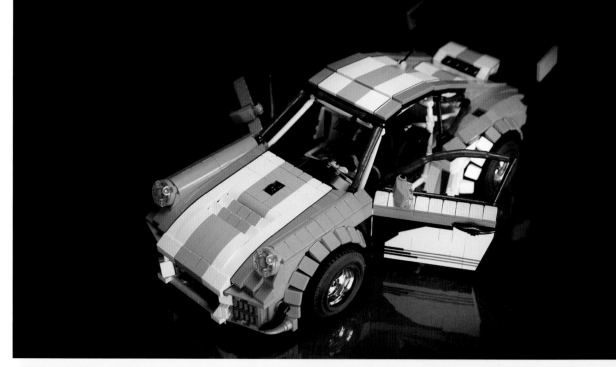

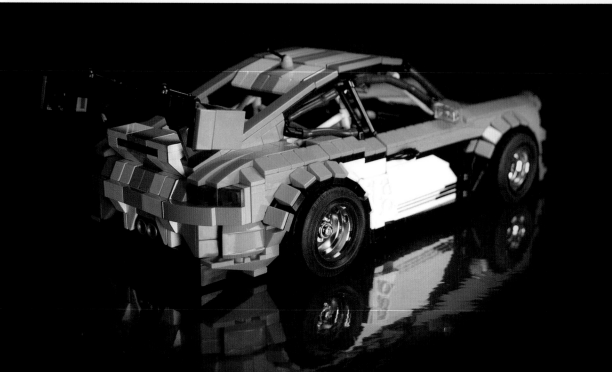

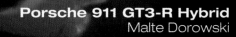

**Porsche 911 GT3-R Hybrid**
Malte Dorowski

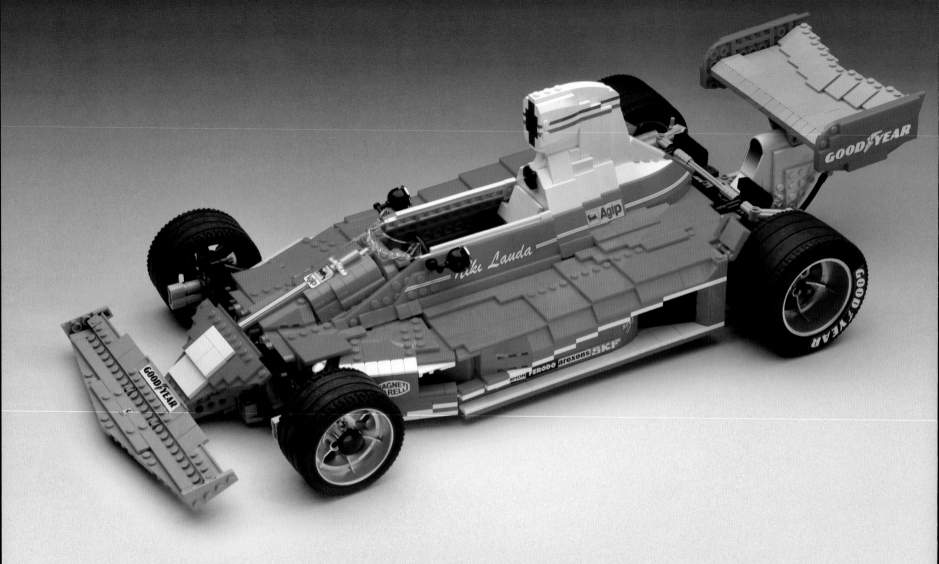

**Ferrari 312T**
Luca Rusconi

## Ferrari 312T

After two disappointing Formula 1 seasons in 1972 and 1973, the Ferrari team developed the 312T, which offered more power, less weight, and better performance. The flat 12-cylinder engine was heavily modified to deliver 485 hp, a superior amount of power at that time. The 312T name was derived from the use of a new transverse gearbox that was bolted directly onto the engine in an effort to improve the weight distribution.

Drivers Niki Lauda and Clay Regazzoni drove the car to success during its debut in 1975. Lauda brought the team five victories that year, and Regazzoni won at Monza on the same day his teammate became World Champion.

The LEGO model has a full working suspension, steerable front wheels, a 12-cylinder flat engine with a detailed set of exhaust pipes, a rear stabilizer bar, double radiators in the front and rear, an oil cooler integrated into the rear wing support, and brake-cooling ducts.

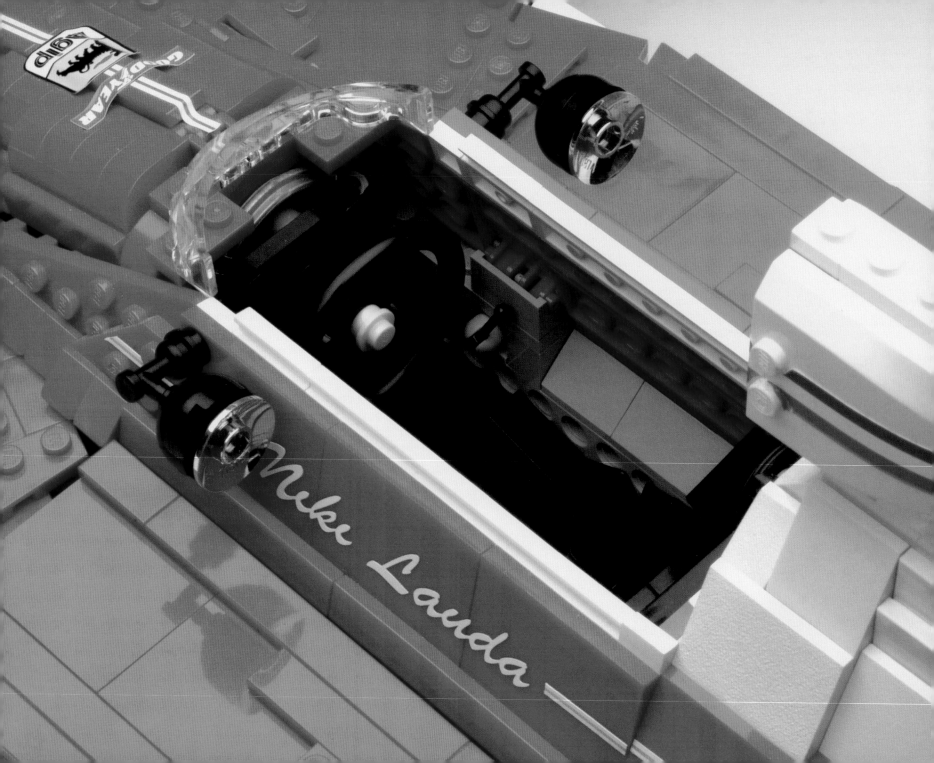

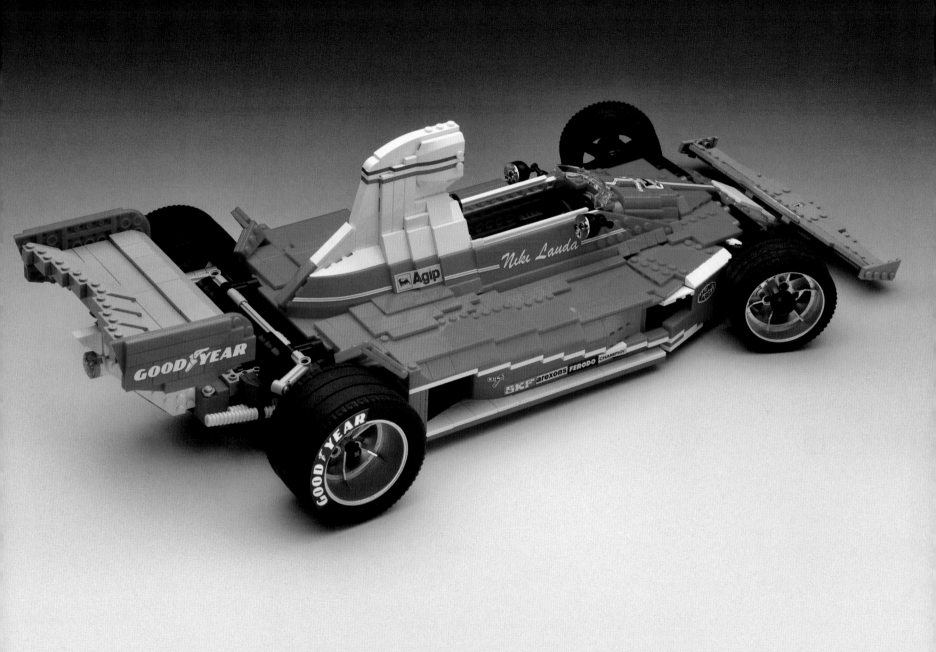

# Alfa Romeo 8C 2600

Histories of automotive design will always have a spot for the Alfa Romeo 8C. Designed in the early 1930s by Italian Vittorio Jano, the car is an engineering masterpiece.

Although the Alfa Romeo 8C was very successful in 1931 and 1932, economic troubles forced Alfa Romeo to drop its in-house racing team in 1933. The Scuderia Ferrari, led by none other than Enzo Ferrari, stepped in and became Alfa Romeo's acting racing team. One of the cars used by the Scuderia Ferrari was the 8C 2600, which was fitted with a super-charged 156-cubic-inch (2,556 cc) V8 engine.

Building an 8C LEGO model was a challenging task. The modeler used slopes, wedges, and tiles from many different LEGO themes to create curved body-work, the front and rear fenders, and the detailed interior and engine. Classic wagon wheels were used as car wheels for this model.

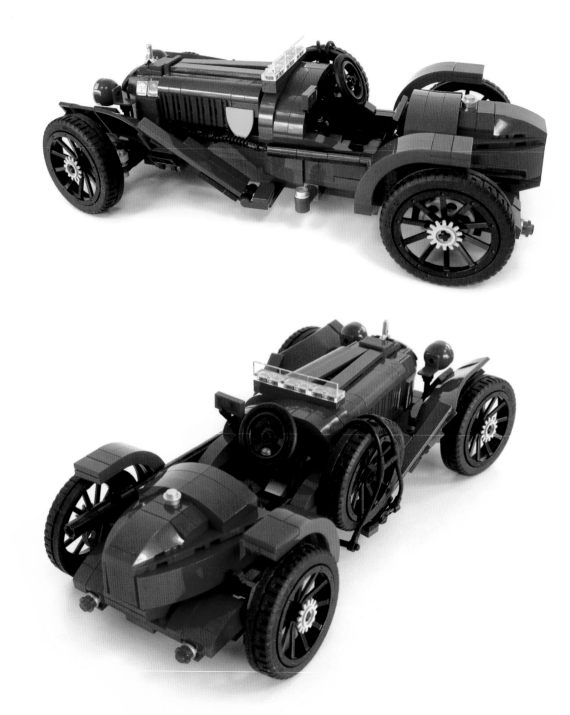

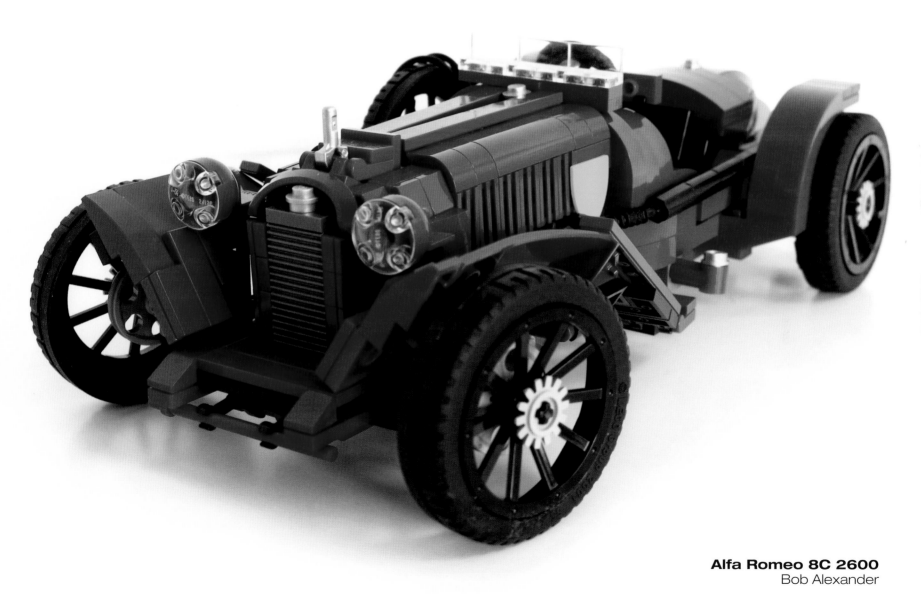

**Alfa Romeo 8C 2600**
Bob Alexander

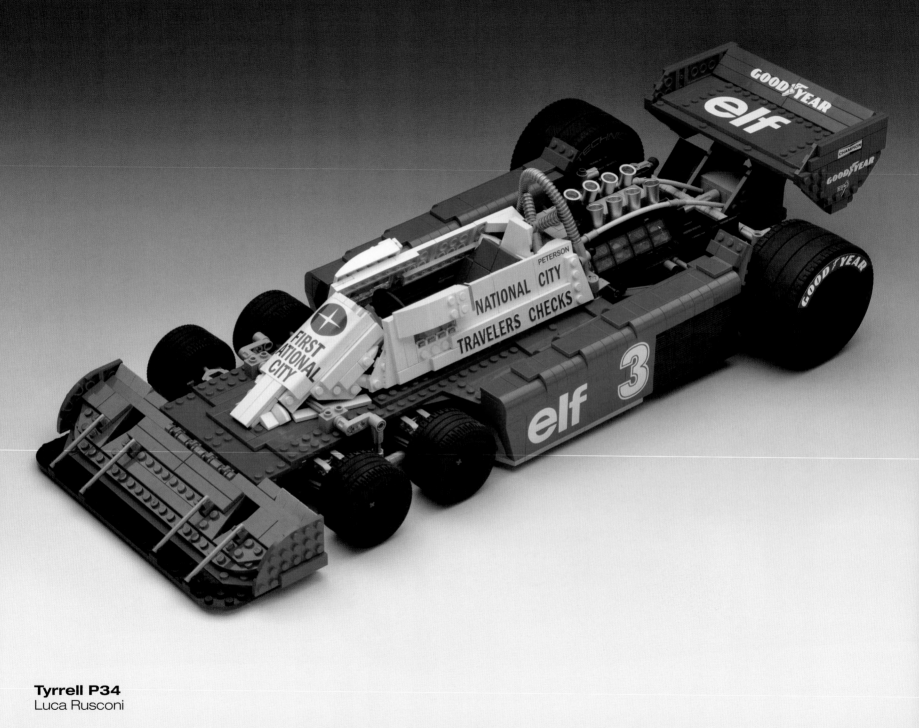

**Tyrrell P34**
Luca Rusconi

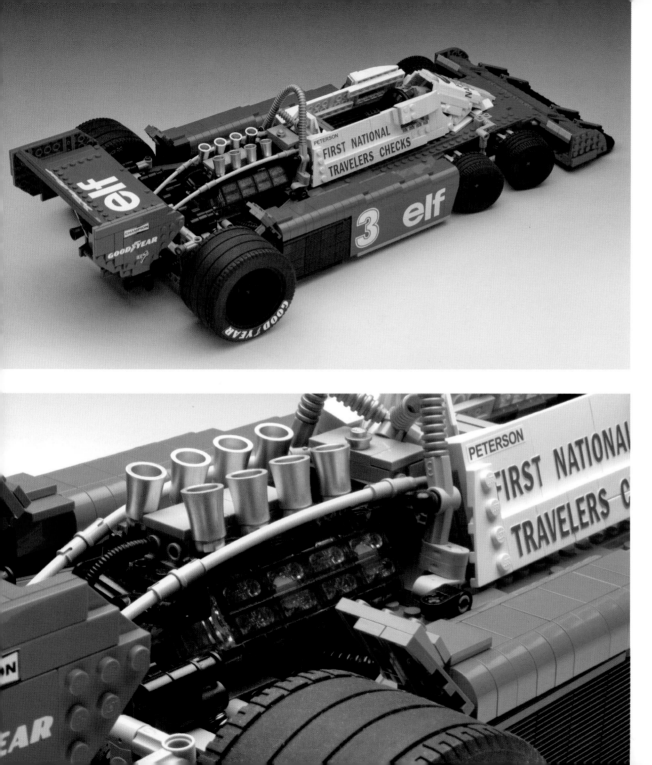

## Tyrrell P34

The 1976 Tyrrell P34 is the only six-wheeled Formula 1 car to win a Grand Prix. Designer Derek Gardner based his radical design on the idea that smaller front wheels would create less drag than that generated by a regular four-wheeled race car.

The P34 was fitted with a Ford Cosworth 182.6-cubic-inch (2,993 cc) V8 engine. Combined with the advantages of the six-wheel solution, this should have produced a competitive package. However, after just two seasons, it became clear that the small front tires made handling difficult, and although the design achieved some success, the concept was dropped in 1978.

This LEGO P34 model captures the powerful lines of the original. It has full working suspension, steerable front wheels, a V8 engine, front and rear stabilizer bars, radiators, and much more. It also re-creates the port holes placed in the side of the original car's cockpit, which allowed the driver to see the position of the front wheels.

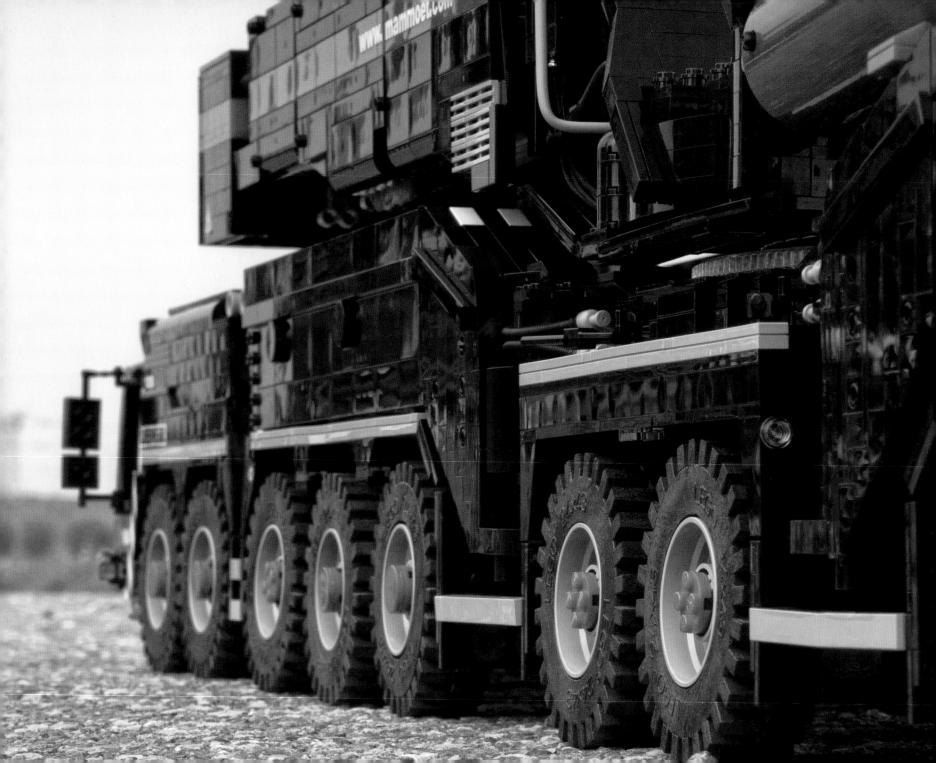

# Heavy Equipment

Cranes, excavators, and agricultural equipment—the variety of specialized machinery is immense. Many well-known brands, like Caterpillar and John Deere, offer their own range of die-cast and plastic models, as do companies that specialize in highly detailed models.

The technical complexity of special equipment leads many LEGO modelers to avoid the theme. Building such models requires a great deal of knowledge about the equipment—knowledge that's frequently hard to come by.

The LEGO Technic line offers a range of construction vehicles, such as excavators, bulldozers, and cranes, with moving parts and lifelike functions. Builders who enjoy tinkering with working parts and combining functionality with realistic aesthetics excel in this theme.

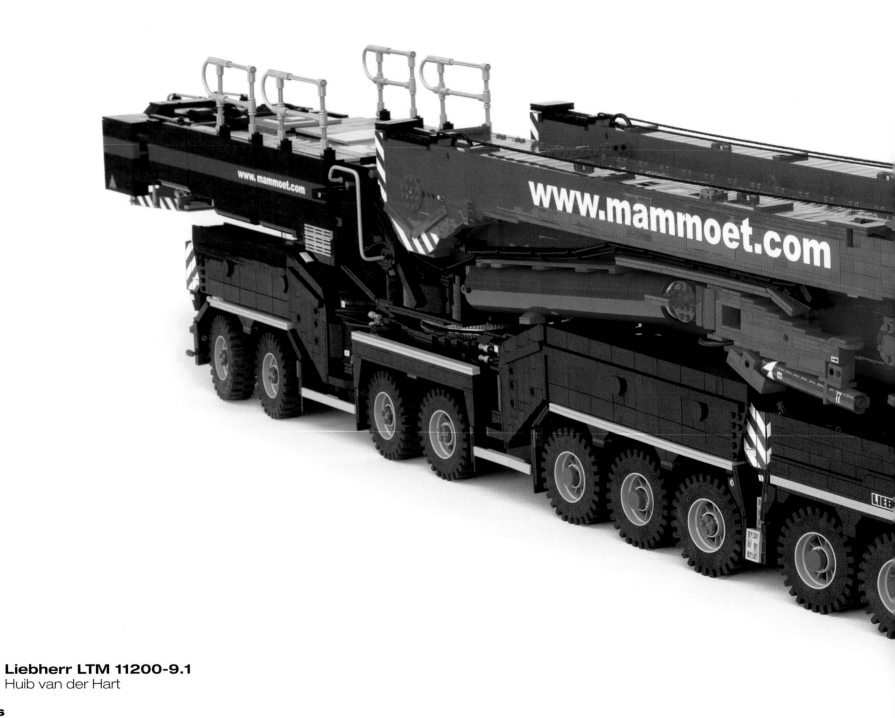

**Liebherr LTM 11200-9.1**
Huib van der Hart

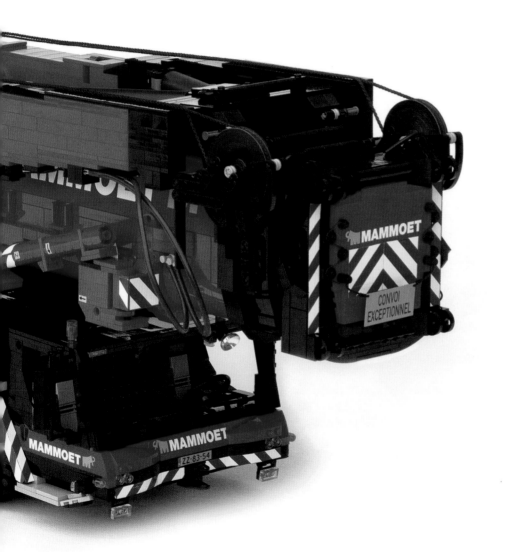

## Liebherr LTM 11200-9.1

The Liebherr LTM 11200 is the world's strongest mobile crane. Equipped with the largest telescopic boom in production, it has a lifting capacity of 1,200 tons.

The crane is fitted with two engines: a 500 kW (680 hp) output carrier engine and a separate 270 kW (367 hp) crane engine. The operational weight of this massive piece of equipment is 108 tons.

The LEGO model featured is both impressive and functional. Scaled to 1:16, it has a working drivetrain and eight steered axles. All lifting and balancing functions are powered by original LEGO motors. The crane body's heavy weight needs a custom-made turntable to support it. The telescopic boom weighs approximately 18 pounds (8 kg), requiring a counterweight to keep it in a lifted position.

The entire crane with boom sections and equipment weighs about 50 pounds (23 kg). Including the telescopic boom, it is about 4.25 feet (1.3 m) long, and when operating, its total height is almost 11.5 feet (3.5 m).

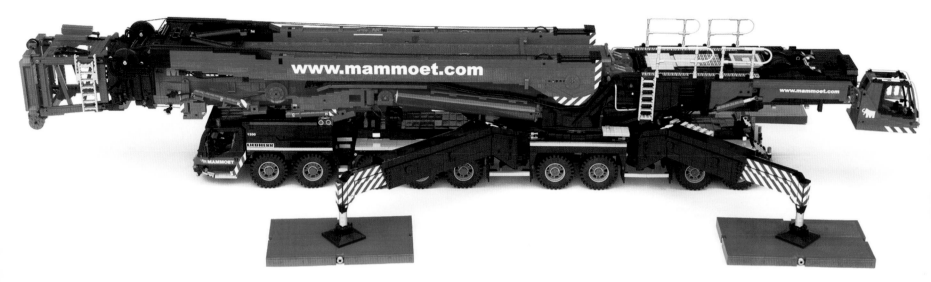

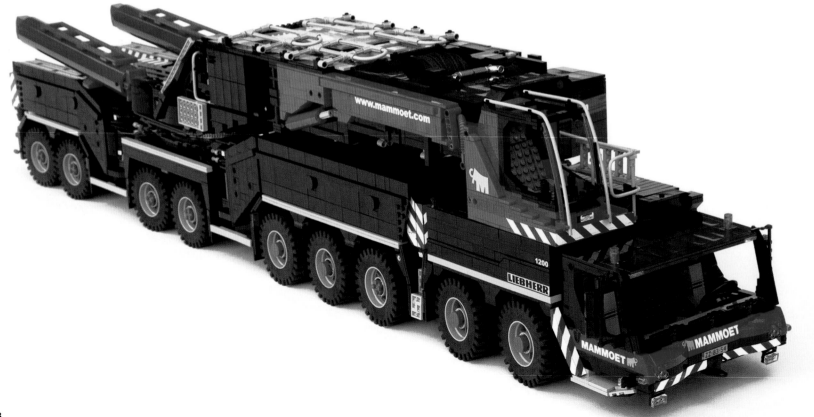

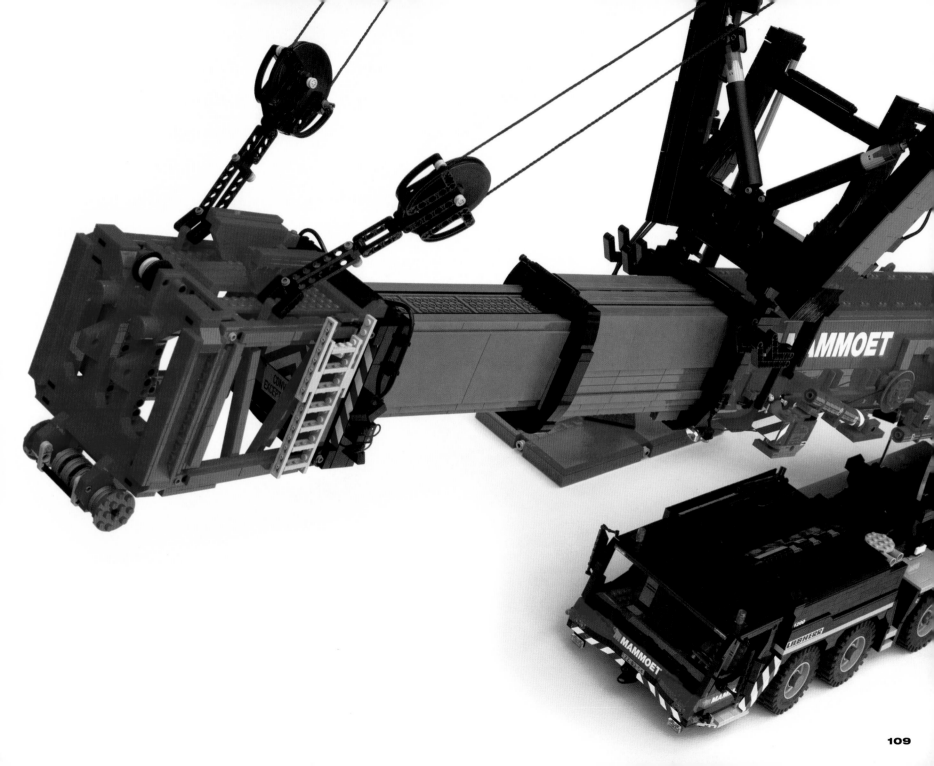

# Liebherr LTM 11200-9.1 & DAF Support Truck

Huib van der Hart & Nanko Klein Paste

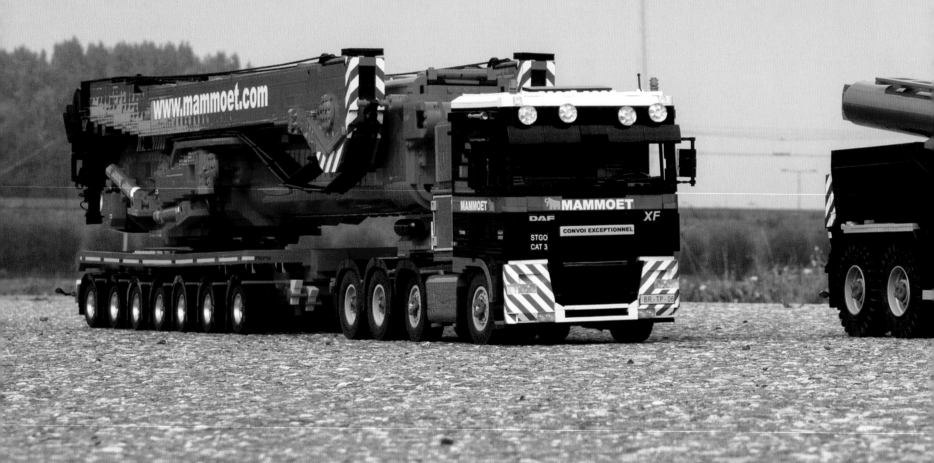

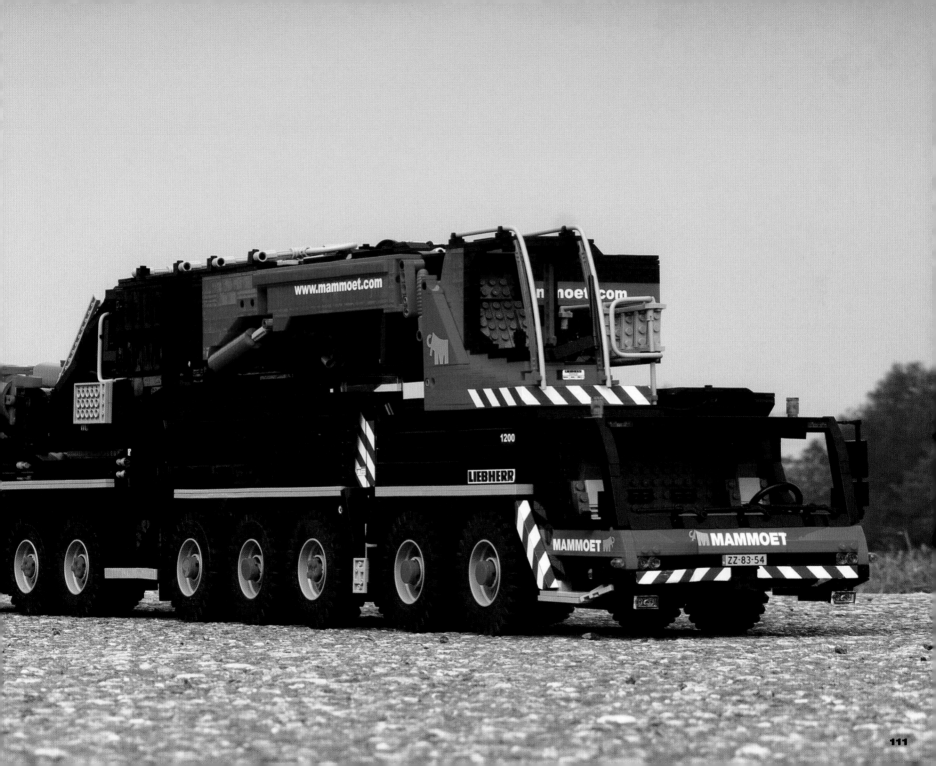

# Nooteboom Boom Carrier & DAF Support Truck
Huib van der Hart & Nanko Klein Paste

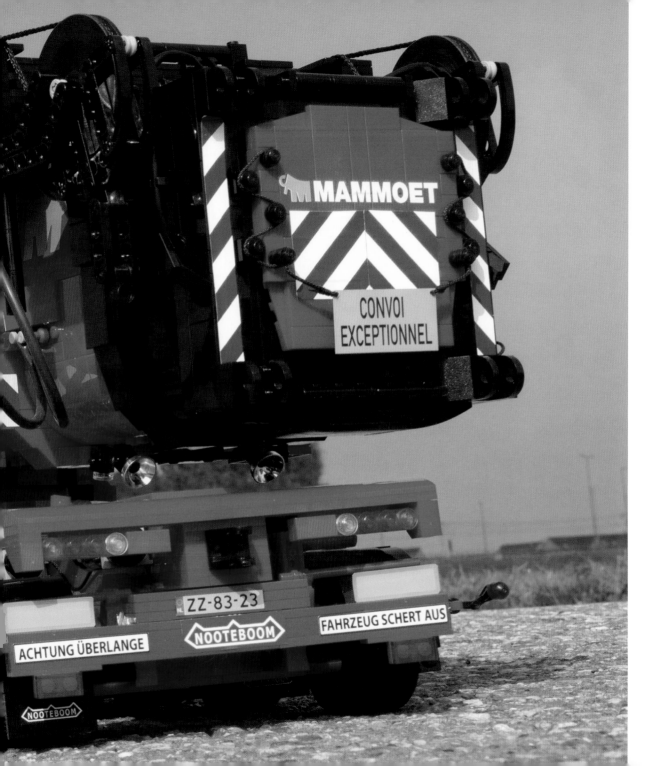

## Nooteboom Boom Carrier & DAF Support Truck

Although it is possible to drive the Liebherr LTM 11200 crane (see the previous pages) with its large boom mounted, it is often prohibited from traveling on public roads due to its weight.

For that reason, the crane's telescopic boom, which alone weighs 104 tons and is 62.3 feet (19 m) long, can be transported separately on a truck and trailer.

Dutch trailer manufacturer Nooteboom developed a seven-axle dolly especially for this purpose, keeping the total height less than 13.1 feet (4 m). Six of the dolly's axles are steered, making the trailer quite maneuverable despite its size. A four-axle tractor unit, in this case a 100-ton rated Dutch-built DAF XF105, is needed to pull the combo.

Like the crane boom it carries, the Nooteboom dolly was carefully replicated in LEGO to include all functionality, like the steerable axles.

# Atlas 1604 MK-ZW

Railroad maintenance requires versatile machines. In Europe, Terex Atlas is a leading developer of specialized railroad excavators. These small machines are easy to haul from one construction site to another and can easily operate on railroad tracks or off-road. This Atlas 1604 is manufactured in Germany.

This 1:13 scaled LEGO model includes all the functions of the real vehicle. The drivetrain is motorized using original LEGO motors, and the front axle features a realistic Ackermann steering geometry. The dollies at the front and rear of the frame are fitted to the tracks when operating on railroads. When even more stability is needed, support jacks can be lowered on either side of the machine.

The boom is operated by a pneumatic system built only of LEGO parts and includes several attachments.

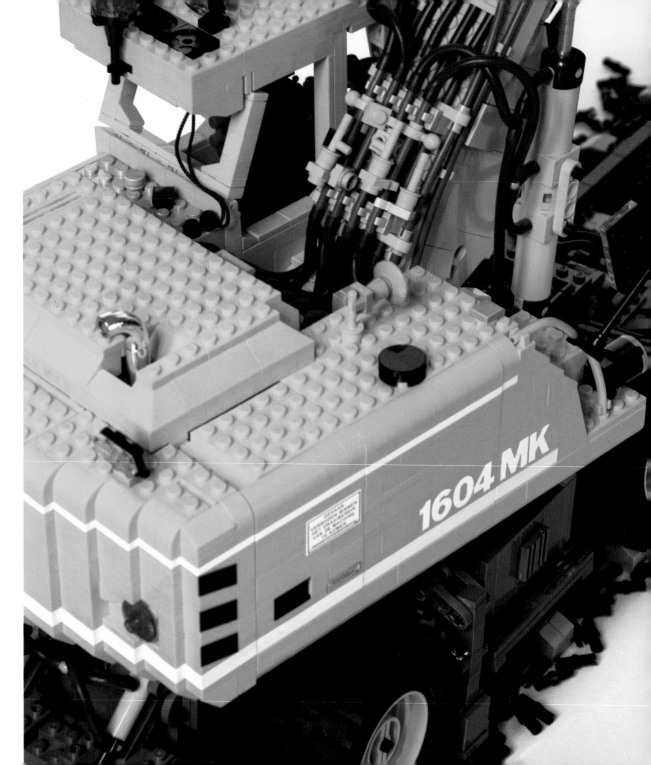

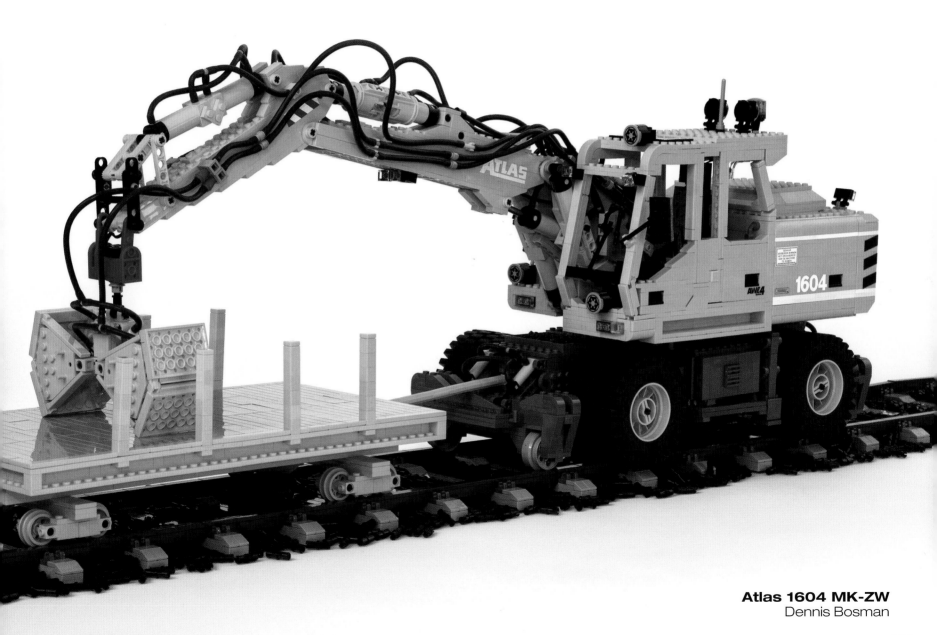

**Atlas 1604 MK-ZW**
Dennis Bosman

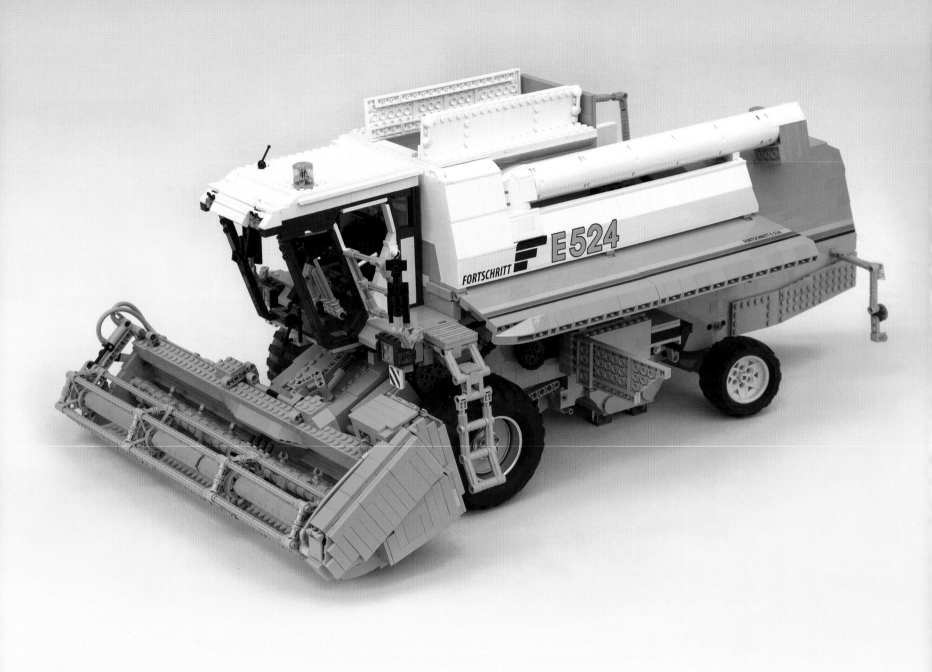

**MDW Fortschritt E524**
Kim Ebsen

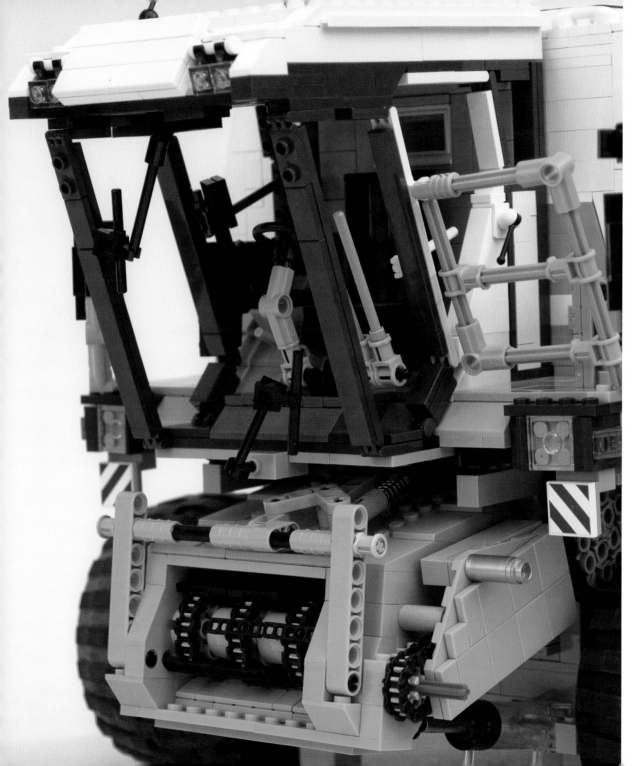

## MDW Fortschritt E524

MDW Fortschritt was one of the largest manufacturers of agricultural machinery in former East Germany. The state-owned company became a private business after the fall of the Berlin Wall in 1989 and was acquired by Case IH in 1997.

Built during the late 1980s and 1990s, the MDW Fortschritt E524 combine harvests and processes grain.

The LEGO E524 model was built to a scale of 1:13 and is equipped with a removable head. Just like its real-life counterpart, the combine features different heads to harvest particular crops.

Building a combine harvester that had been out of production for years was challenging. In particular, the model's lime green bricks and tiles, which match the color of the original combine, are quite rare and took time to collect.

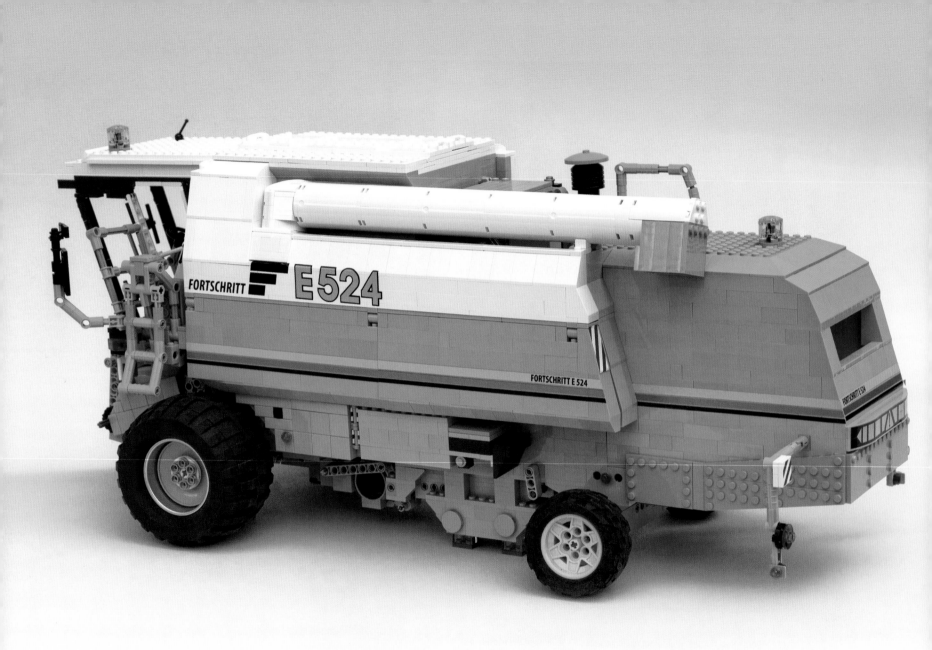

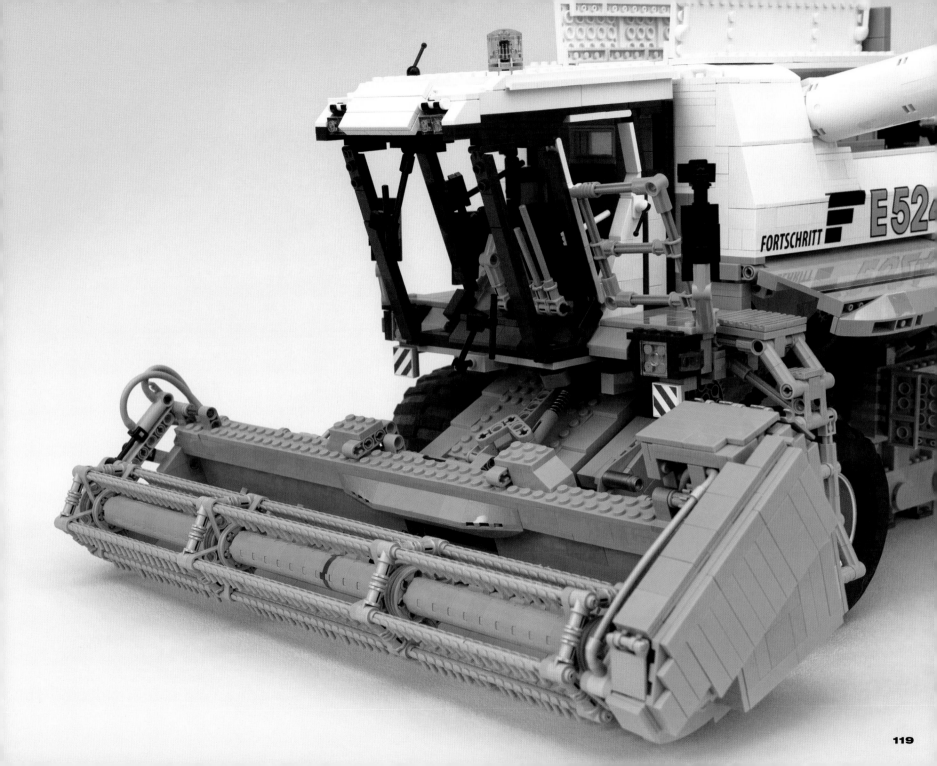

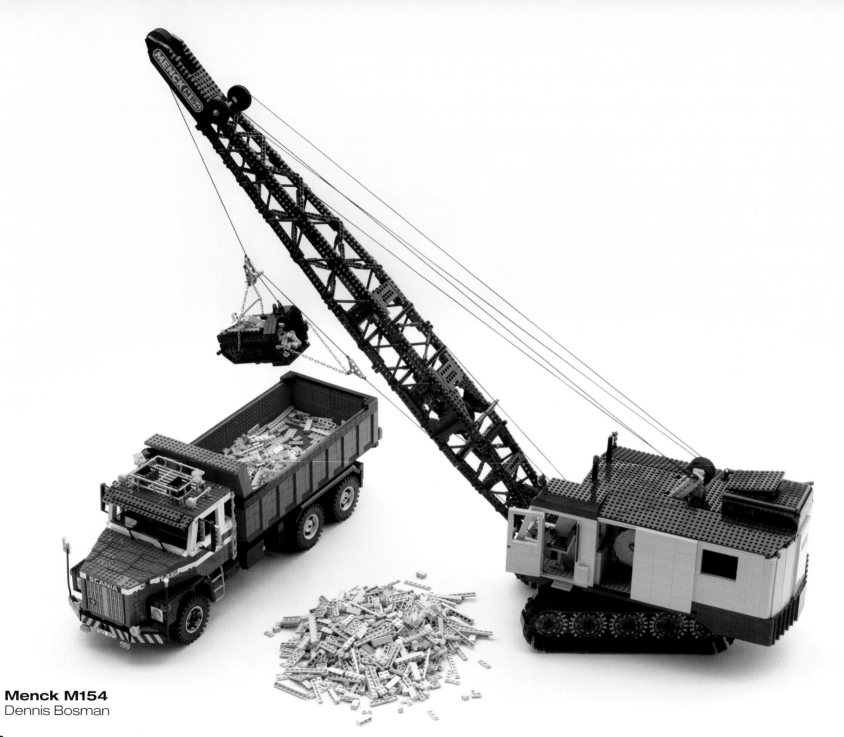

**Menck M154**
Dennis Bosman

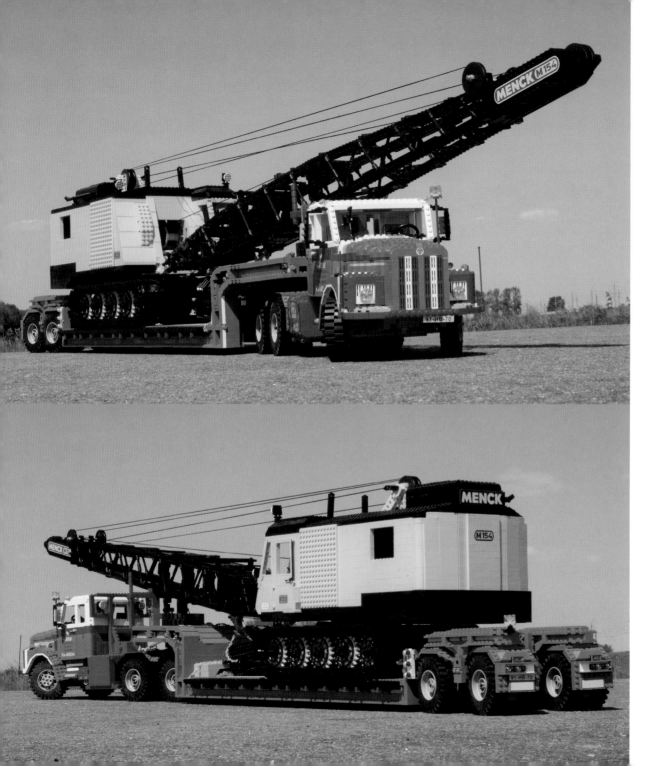

## Menck M154

Germany was home to many heavy equipment manufacturers in the 1950s and 1960s, including Menck, which was acquired by Liebherr during the 1980s. One of the most striking models the company built was the massive M154 dragline excavator.

Before hydraulically driven machines became standard on construction sites, dragline excavators like this Menck M154 were the norm. Its machine bay houses several winches that control the boom and bucket.

This LEGO model, built in 2003, is equipped with older LEGO motors no longer in production. The motors power the tracks, the boom, and even the bucket.

The tracks, as well as the yellow sprocket gears, were made using vintage LEGO parts from the early 1970s. This classic machine fits onto a lowboy trailer of the same era, making for an impressive combination.

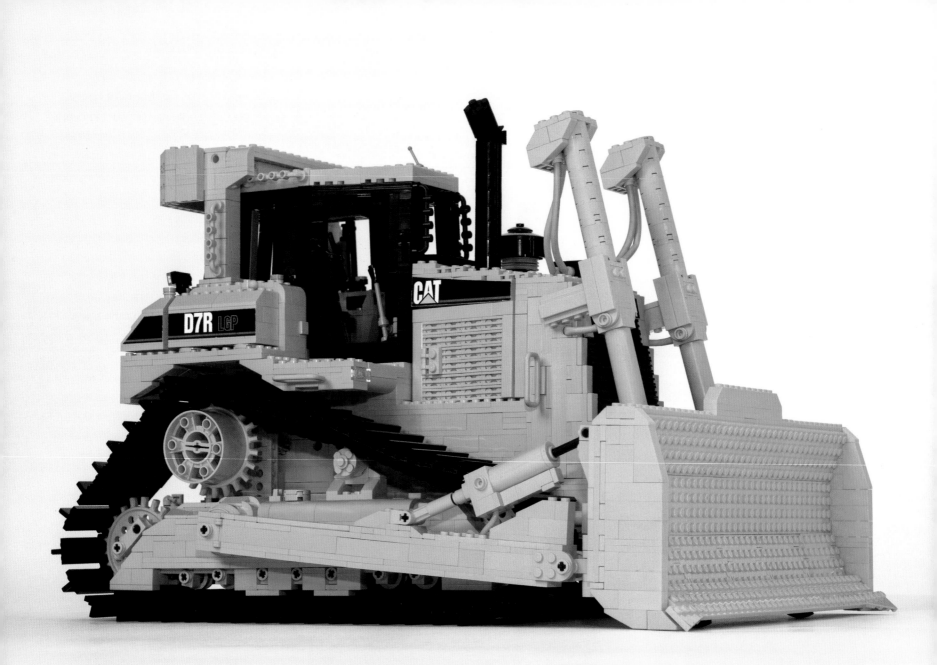

**Cat D7R LGP**
Dennis Bosman

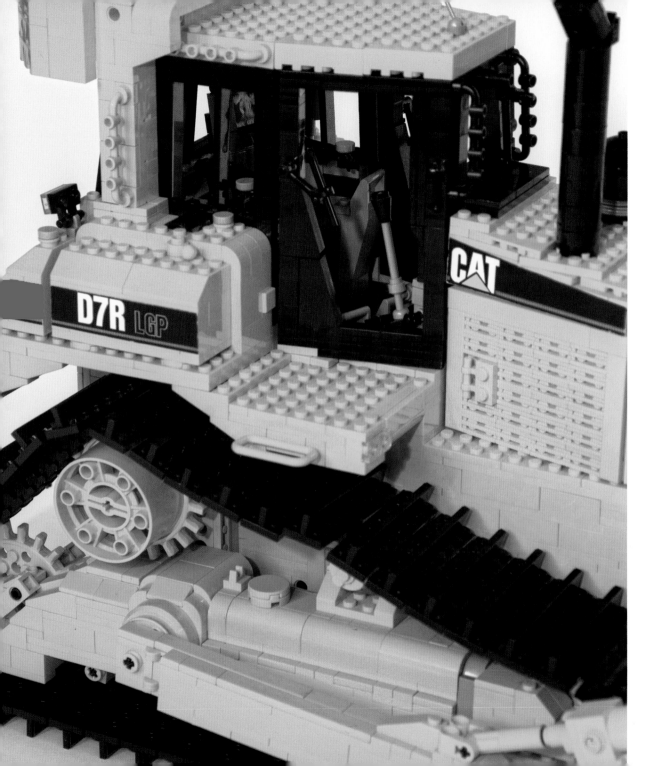

## Cat D7R LGP

The American company Caterpillar is one of the largest manufacturers of heavy equipment in the world, producing everything from small excavators to massive mining equipment.

This Cat D7R tracked bulldozer is a mid-size machine with an operating weight of 25 tons. Powered by a 240 hp 6-cylinder engine, it is mostly used to move material short distances or across challenging terrain. The D7R is badged as LGP, or Low Ground Pressure, meaning that it will not sink in sandy or muddy ground. Caterpillar also produces armored versions of this dozer for the US Army.

The powerful machine can be fitted with extra-wide tracks, as on this 1:13 scaled model. Each track of the LEGO model is independently driven by a motor, giving it a powerful drivetrain and allowing it to turn on a dime. The blade is raised and lowered by pneumatic pumps that are run by a remote. All of this functionality makes even this small LEGO version a real powerhouse.

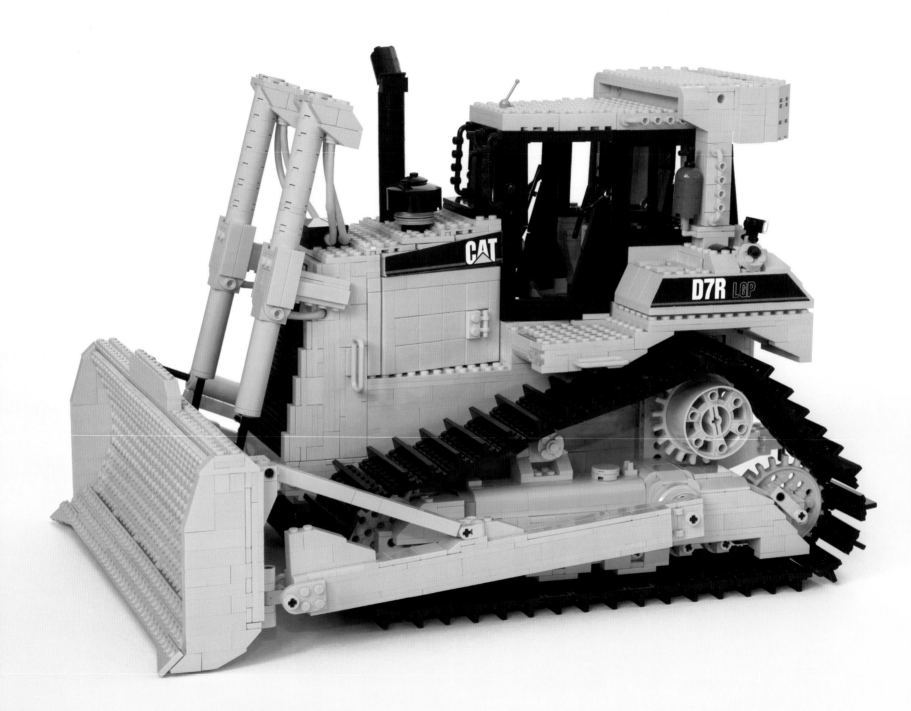

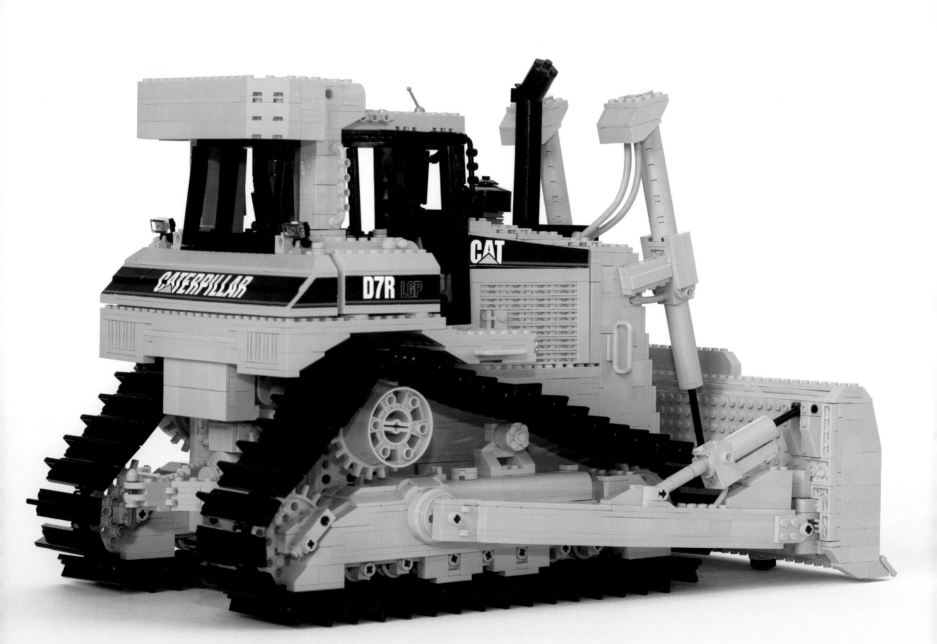

## Lida L-1300 TC

Lidagroprommash was founded in 1958 as an automobile repair plant. Many years later it became one of Belarus's major agricultural machinery manufacturers.

The Lida L-1300 TC combine is powered with a 250 hp engine, producing a maximum speed of 22.3 mph (36 km/h). It can harvest 12 to 13 tons of grain per hour, making it a very productive machine.

This combine's unique tracked undercarriage makes the machine more stable and comfortable and is less damaging to the soil than traditional wheels.

The entire model is made of about 6,500 LEGO elements, including the tracks, which were built using many small rubber bands.

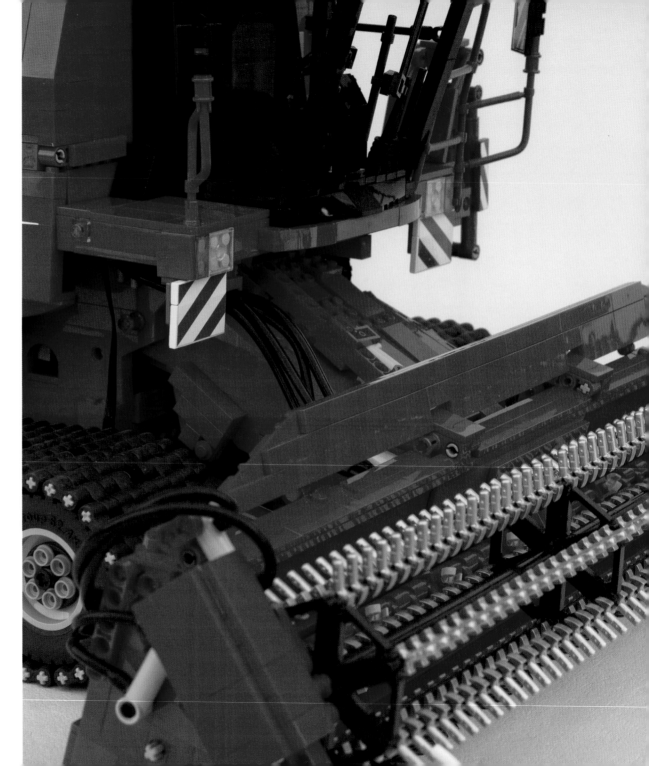

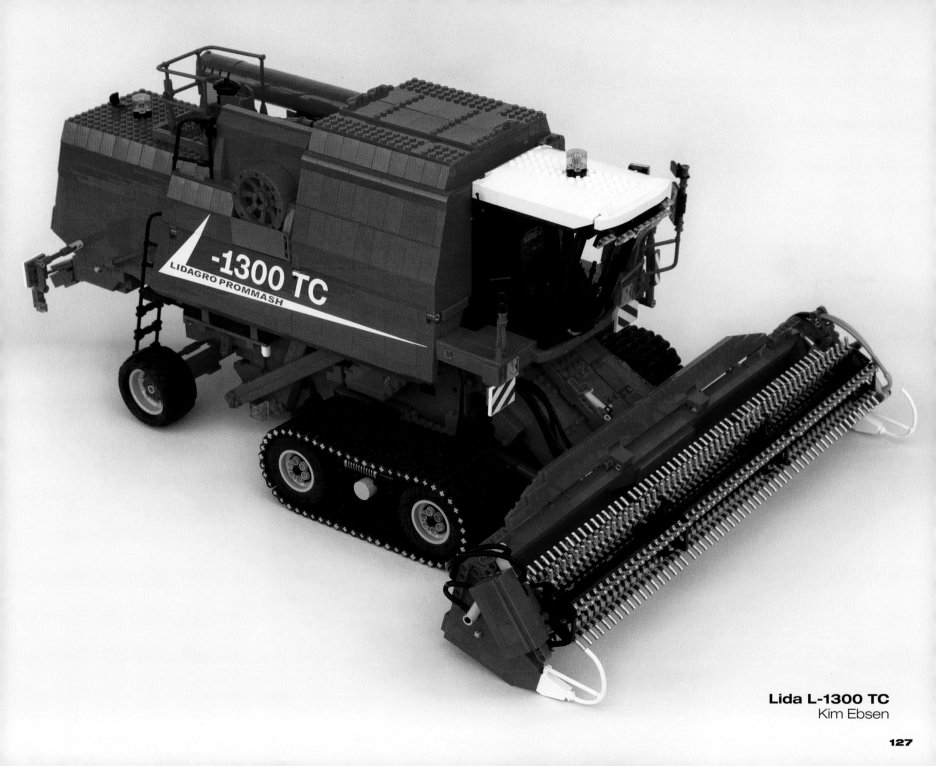

**Lida L-1300 TC**
Kim Ebsen

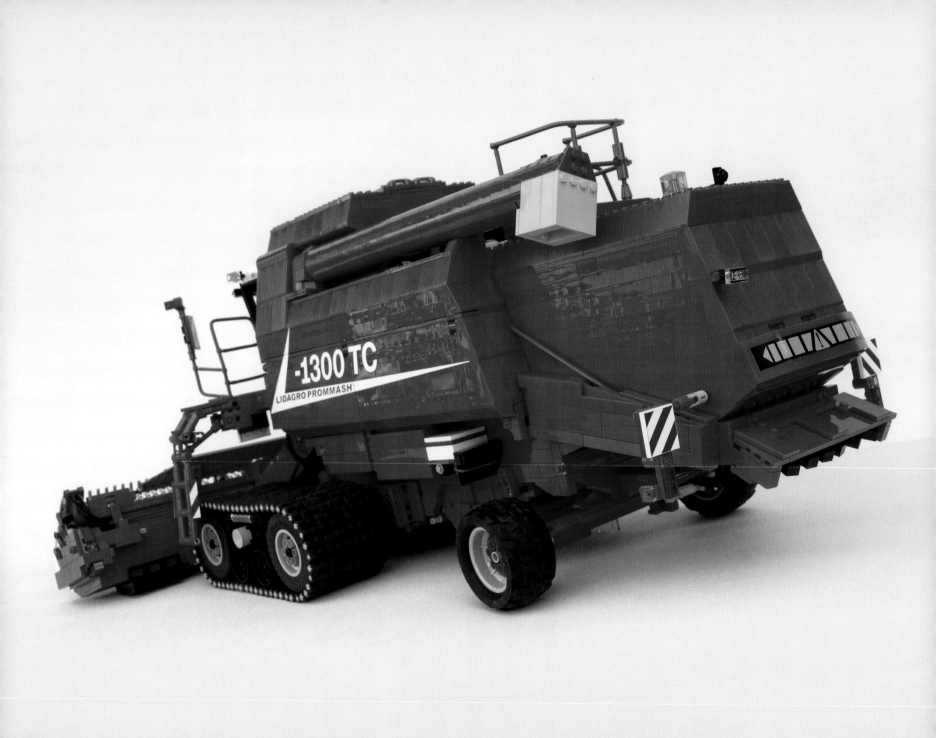

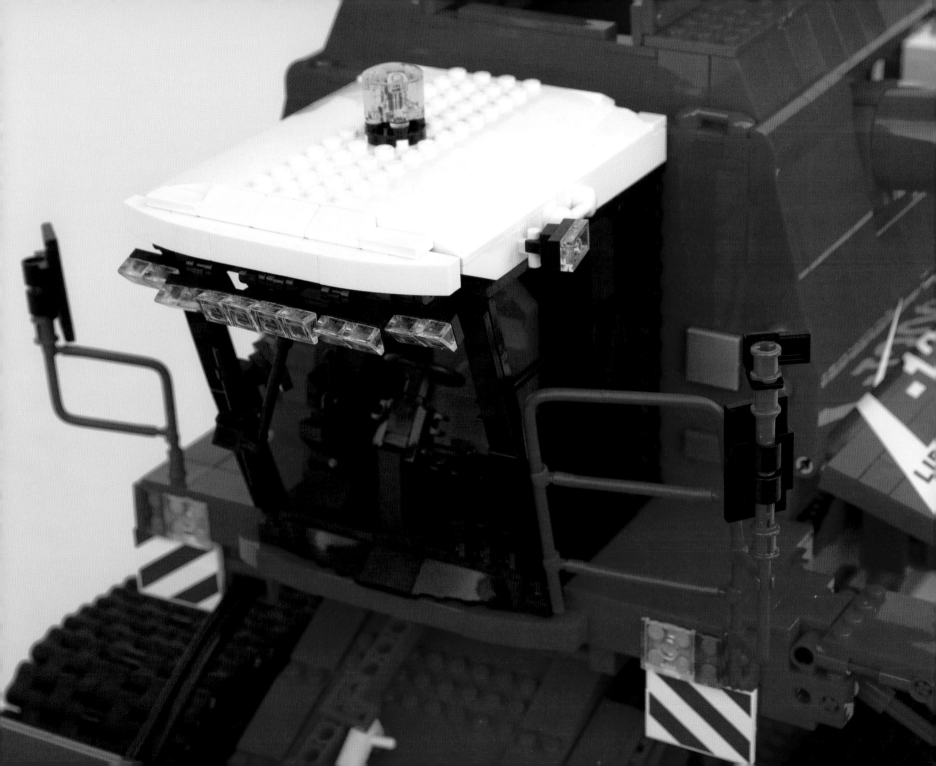

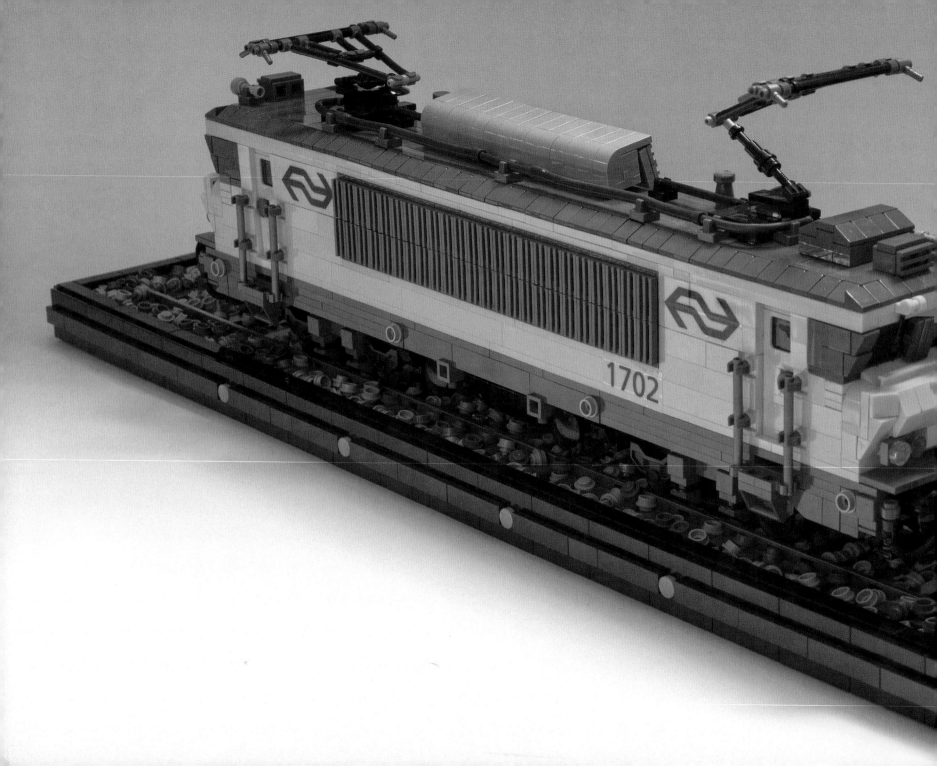

# Trains

Model railroading probably has the longest history of any scale modeling hobby. Scale model trains come in many gauges, and today most are motorized and remote controlled.

In 1966, the LEGO Group introduced a motorized train that was powered by batteries, and later models used electrified tracks. But these systems were discontinued in 2006 in favor of the LEGO Power Functions system.

Used in many LEGO themes, this system makes model railroading easier than ever before.

Many train enthusiasts design their own trains and lines using nothing but LEGO pieces. Steam engines, diesel and electric locomotives, and all kinds of freight cars and passenger wagons have been made to run on the standard LEGO rail track. Many modelers use LEGO to build much more than rolling stock,

creating detailed scenery and stations along the tracks. The popularity of this LEGO hobby has given rise to an entire community of LEGO train clubs, including dedicated websites and magazines.

Some modelers have built trains that are remarkably realistic, complete with lights, sound, and smoke effects.

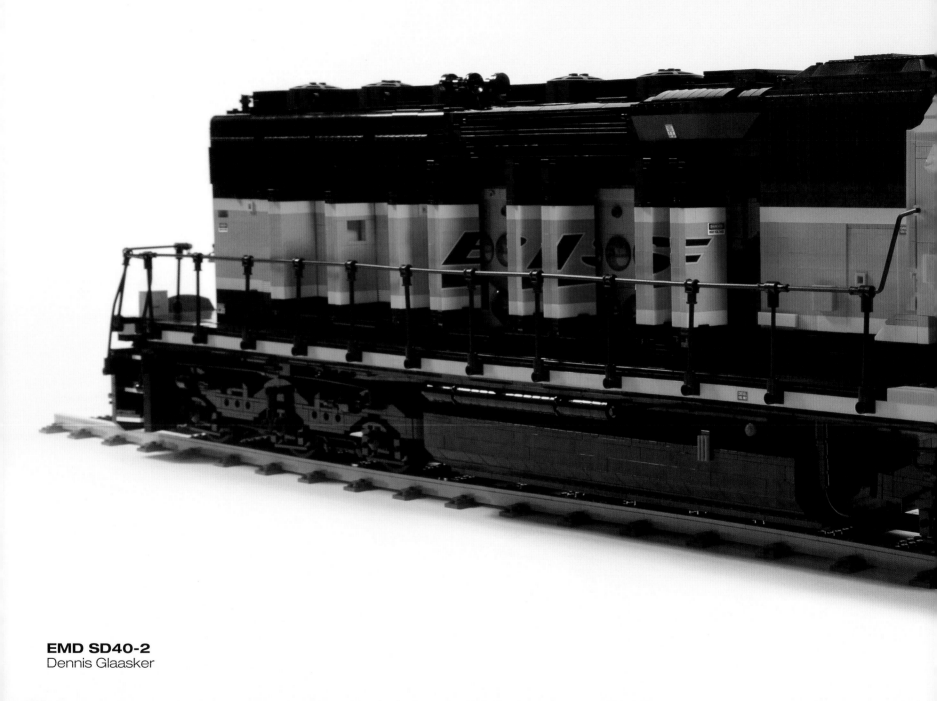

**EMD SD40-2**
Dennis Glaasker

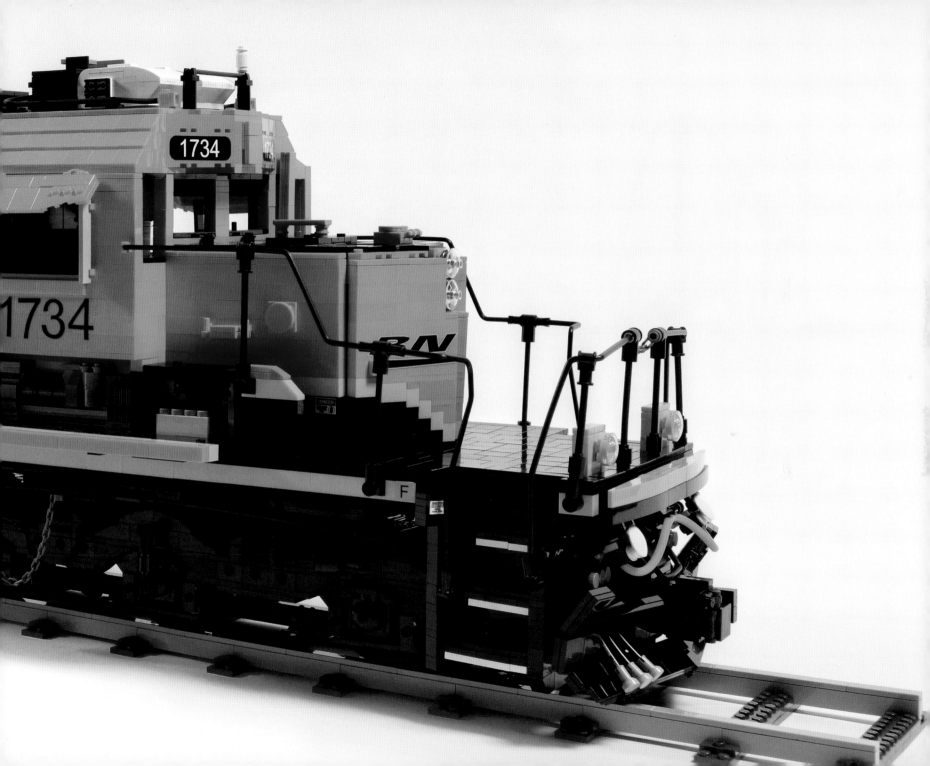

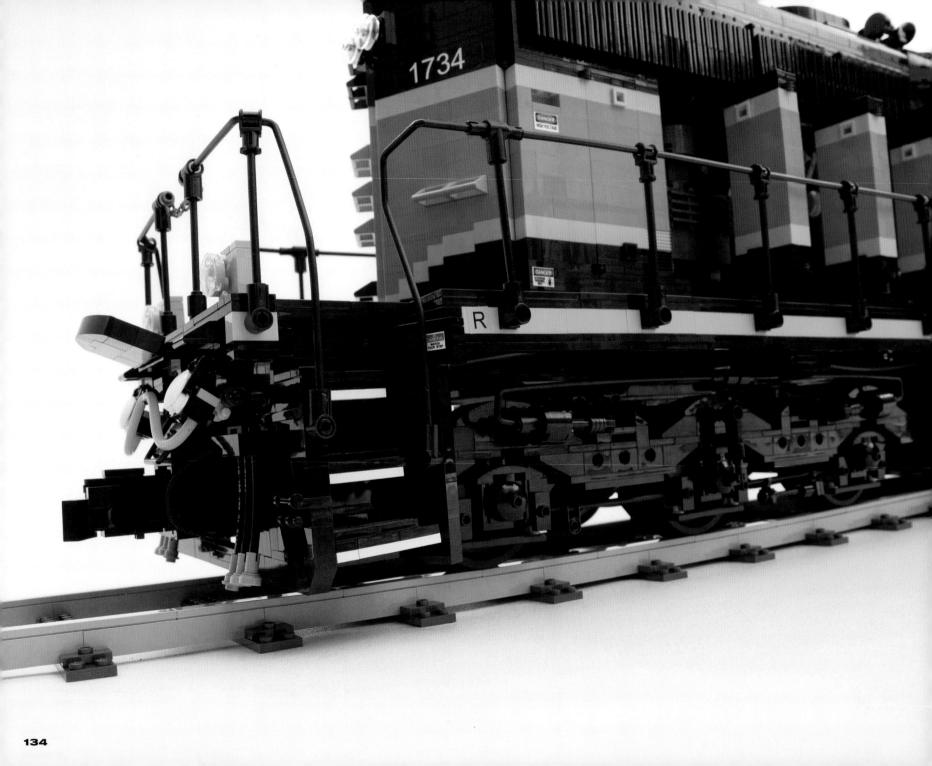

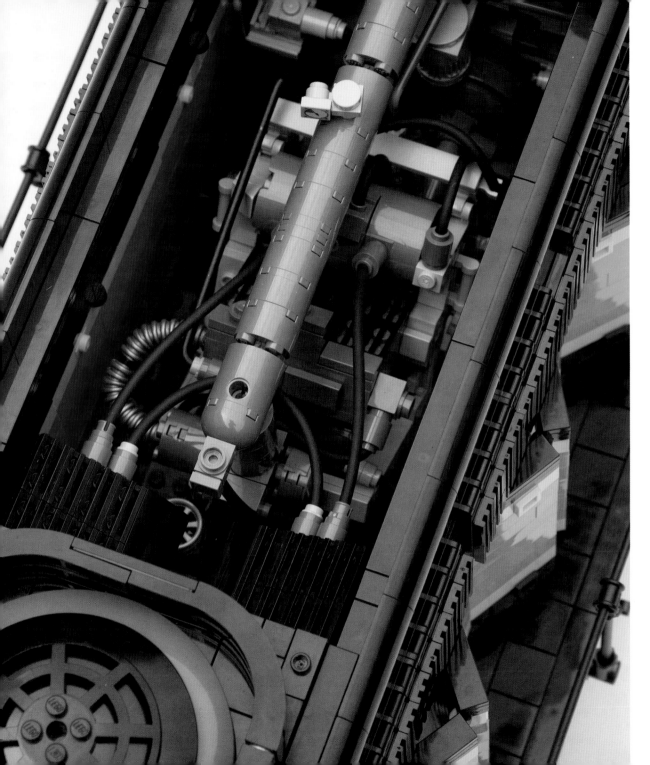

## EMD SD40-2

The EMD SD40-2 is one of the best-selling diesel locomotives in American history. Between 1972 and 1989, a total of 3,982 were built, and most of them are still in service today. The locomotive featured here is operated by BNSF, the second largest freight railroad network in North America.

While most LEGO trains are scaled to about 1:38, this unique model is scaled to 1:16, and it is about 4.3 feet long (130 cm). The locomotive is constructed of 22,000 original LEGO bricks and weighs about 44 pounds (20 kg).

The undercarriages, or trucks, are modeled accurately and include the traction motors. The engine is powered by the massive EMD 16-645 E3 turbocharged two-stroke diesel. All additional support systems, including electronics, are installed in this remarkable build. Operable doors allow access to the cabin and engine room, and both a toilet and a sandbox are mounted in the front of the cabin.

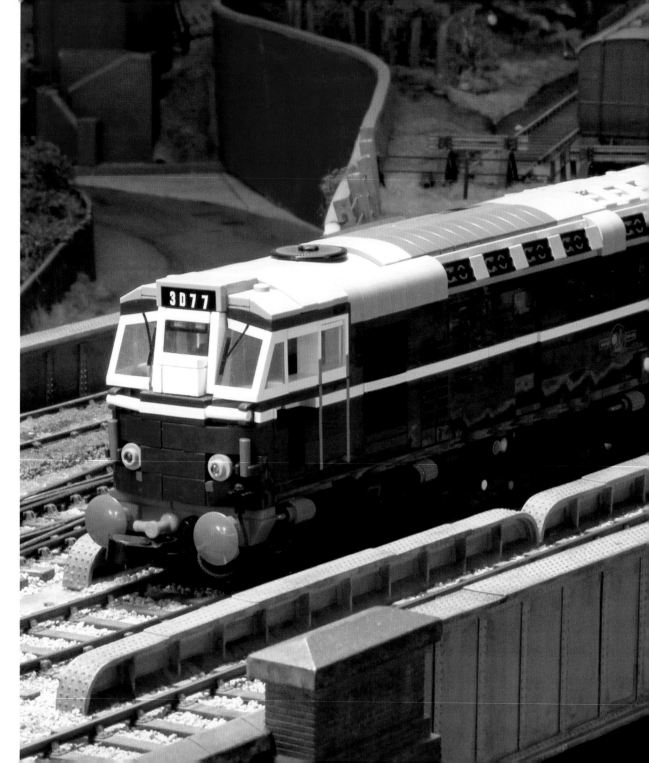

## British Rail Class 27

In 1961, British Rail ordered 69 Class 27 locomotives from the Smethwick-based Birmingham Railway Carriage and Wagon Company. The Swiss company Sulzer Brothers supplied the four traction motors used on this locomotive.

These locomotives also featured a steam boiler, which could be used to heat the passenger cars. For years, they serviced the famous West Highland Line in Scotland.

Class 27 was fully retired in 1987, but eight of these engines remain active on tourist heritage lines.

This LEGO locomotive can be run by the Digital Command Control (DCC) system, a standard model railway system that enables multiple trains to run on one track. This model includes a 9-volt traction motor, multiple lights, and a small sound system.

**Baldwin Locomotive Works Challenger**
Cale Leiphart

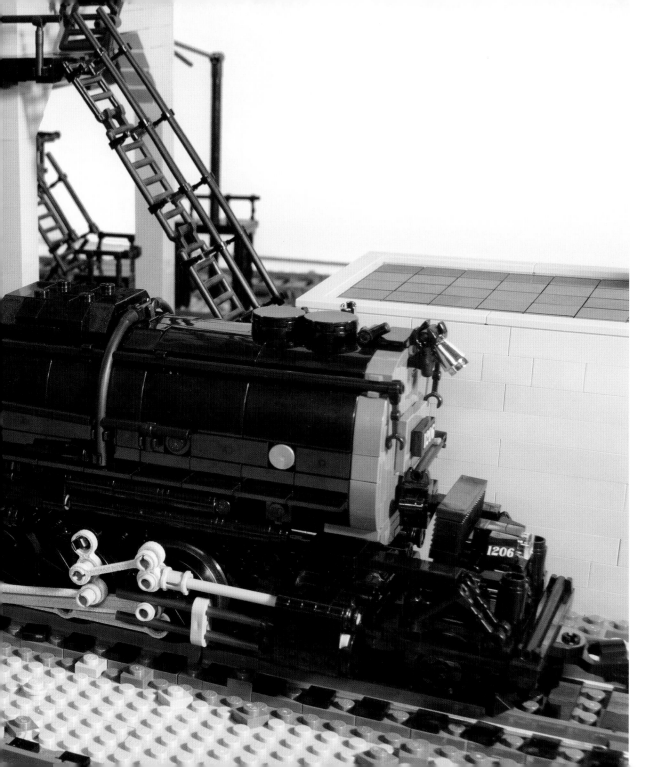

# Baldwin Locomotive Works Challenger

The Challenger is one of the most impressive steam locomotives ever built. It was developed during the 1930s, when demand for faster and more powerful freight trains grew rapidly in the United States.

As a so-called 4-6-6-4 articulated locomotive, the Challenger featured four leading wheels, two groups of six big driver wheels, and four trailing wheels. Boasting big numbers in every way, the entire locomotive, including tender, weighed close to 500 tons and exceeded a length of 121 feet (37 m). It cost about $130,000 in the 1930s, which translates to $1.7 million today. Expensive to operate, the Challenger consumed 6 tons of coal and 6,000 gallons (22,700 liters) of water every hour. In all, 252 Challengers were built between 1936 and 1947.

The eye-catching LEGO locomotive is shown in front of an equally detailed model of the York Coaling Tower. The model can be run by remote control and is powered by two LEGO Power Functions motors.

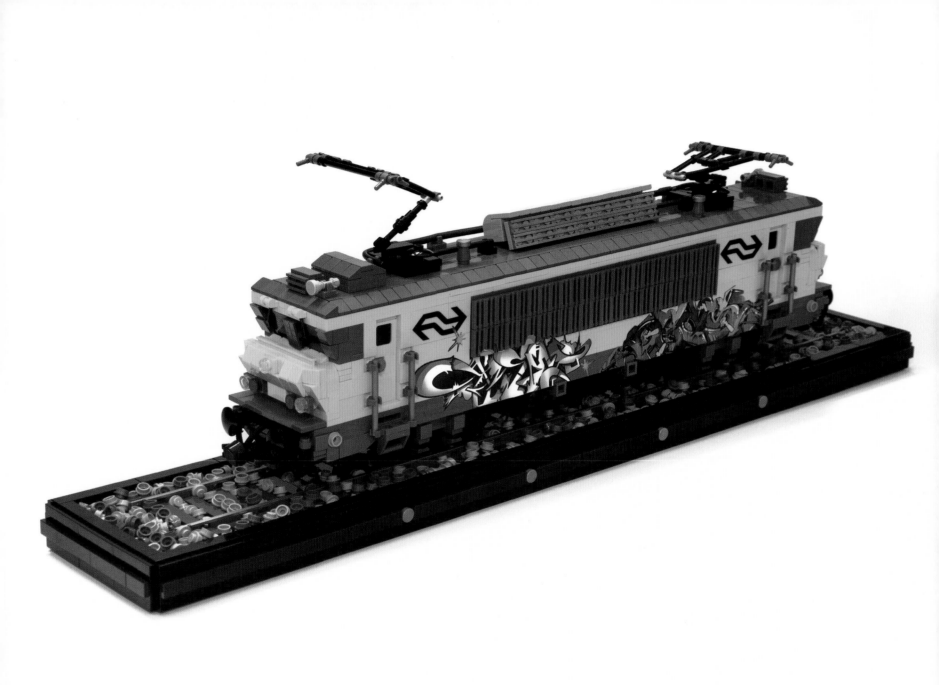

**GEC-Alsthom NS Class 1700**
Jebbo Bouhuijs

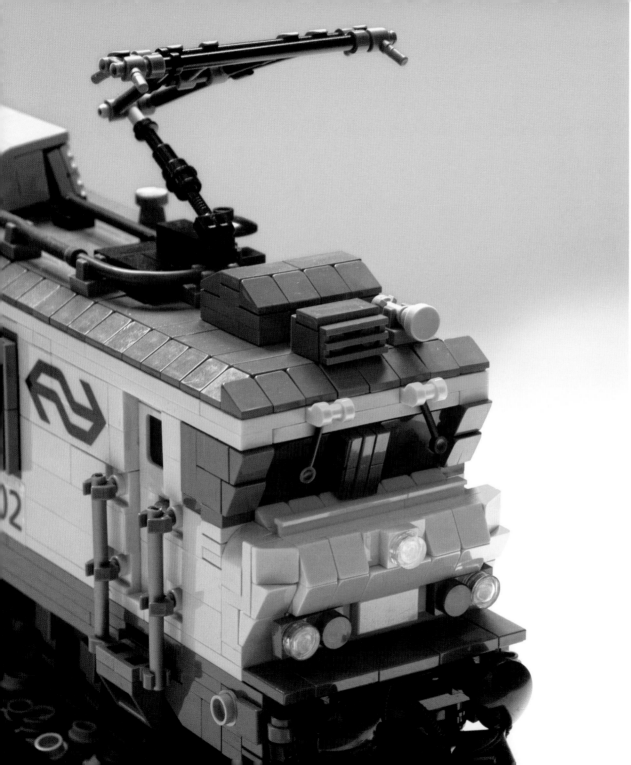

## GEC-Alsthom NS Class 1700

Dutch Railway NS started using the 1700 class locomotive in 1991. Built by the French company GEC-Alsthom, the 1700 weighs 86 tons and is powered by two electrical engines that provide a total of 6,255 hp (4,664 kW).

In official operation from 1993 to 2013, 81 of these locomotives were built for the NS, and some are still in active service in the Netherlands.

This 1702 LEGO model is built to the relatively small scale of 1:38, allowing it to fit a regular LEGO track. The model accurately reflects the geometry of the original.

This model features many lifelike details, including the pantographs (or pans) that connect the train to overhead electric wires, and the graffiti on the side of the locomotive, which was created with custom stickers.

# British Rail Class 55 Deltic

Built by English Electric between 1961 and 1962, this impressive diesel locomotive was designed for high-speed, express passenger service between London and Edinburgh. Twenty-two of these locomotives, named for a prototype with twin Napier Deltic engines, were built. At the time, it was the most powerful single-unit diesel locomotive in the world. After 20 years of service, all were retired, and today only six survive. Now fully restored, these trains provide tourist rides.

All Class 55 locomotives were named for famous racehorses or famous British Army regiments. The LEGO model shown here is named for Class 55 no. 22: Royal Scots Grey, which in turn took its name from a British cavalry regiment. The scaled version is about 2.5 inches (6.4 cm) wide and includes lights and small bass speakers mounted inside.

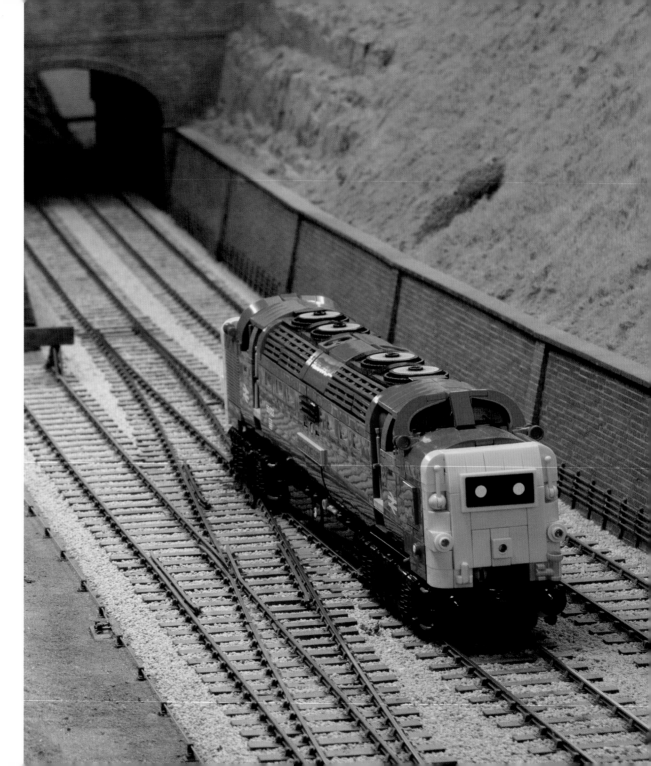

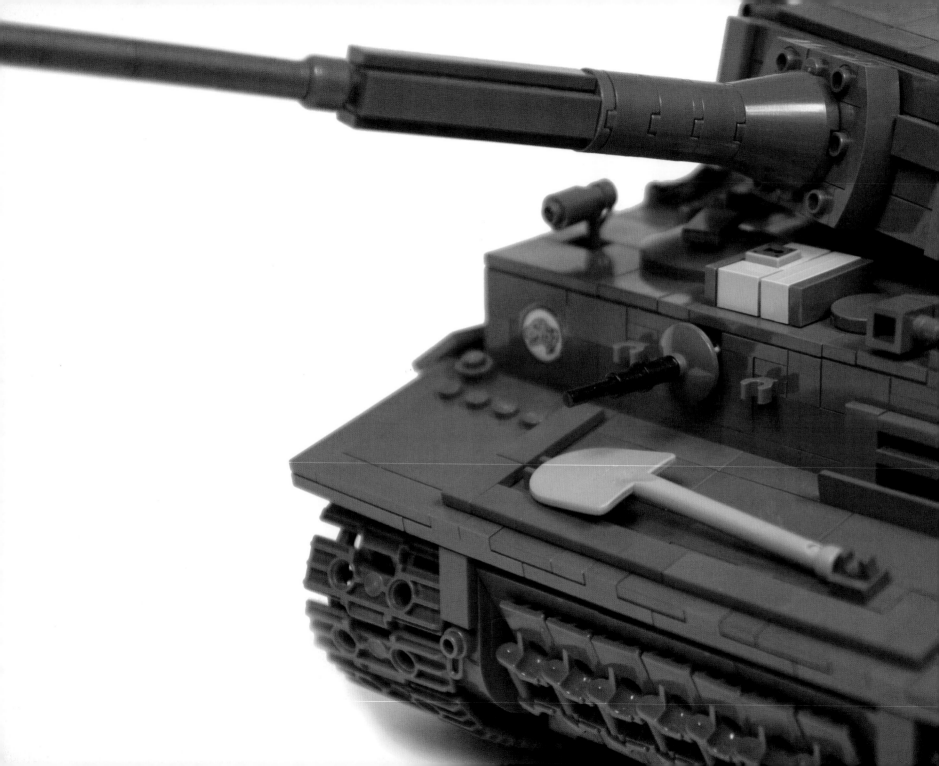

# Military

Military scale models have been around for many years. Countless kits are available in many scales, and the diversity from a historical perspective is wide-ranging. But most enthusiasts enjoy working with the World War II era and modern warfare models.

As a toy manufacturer, the LEGO Group has chosen not to sell realistic warfare kits, but LEGO fans design their own models. Many builders are inspired by real military vehicles and machines, constructing everything from jet fighters and artillery vehicles to combat layouts and sea frigates.

Bricks are available in many military colors, but the most popular are dark grey and camouflage green and tan. Builders also design and sell their own aftermarket products that can be added to genuine LEGO parts to create even more lifelike models.

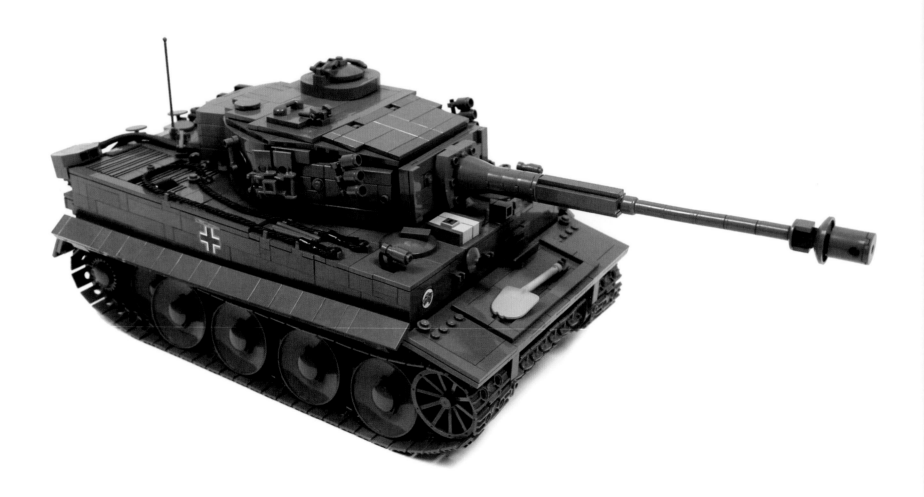

**Tiger I**
Paweł Kmieć

## Tiger I

Carrying powerful weapons, the Tiger was one of the most feared armaments during World War II. Developed in 1942, this large, heavily armored German tank was more advanced than others in the field and quickly earned a reputation for invincibility. But it had its problems as well, including an enormous price tag, heavy weight, and high fuel consumption. About 1,350 of these tanks were produced.

This 1:18 scaled LEGO model includes many realistic functions. Driven by LEGO Power Functions, the model includes nine motors for driving, steering, rotating the turret, elevating the main gun, panning and tilting the front machine gun, and rotating the radiator fans. Its oscillating suspension enables the model to traverse various kinds of terrain without damaging the tracks, and a motor-controlled hatch at the rear provides access to the engine. Construction of the model, which weighs 4.8 pounds (2.2 kg), took approximately three months.

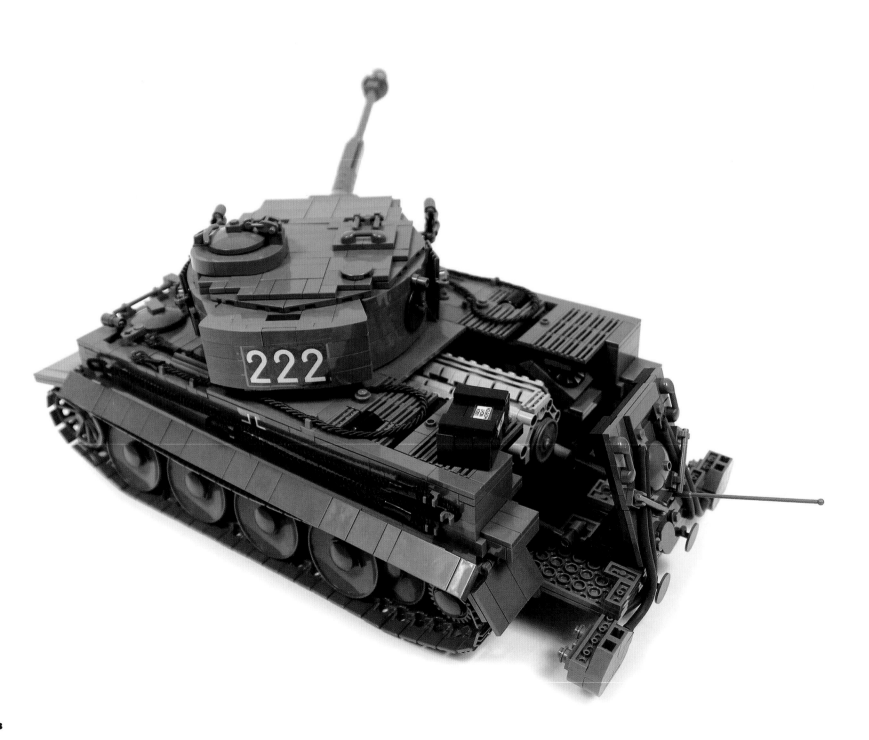

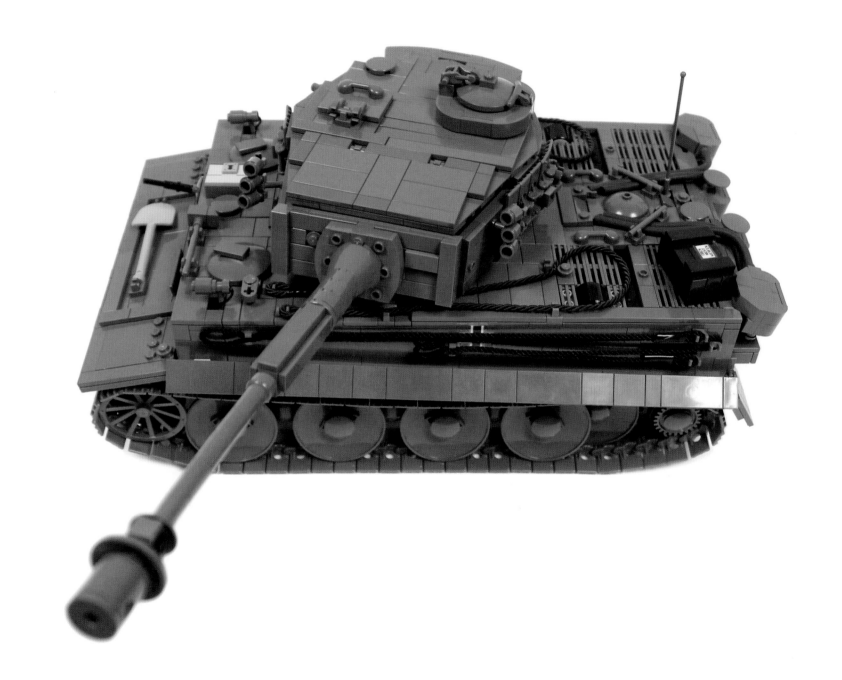

## 2A3 Kondensator 2P

The Soviet 2A3 Kondensator 2P is a 16-inch (406 mm), self-propelled howitzer, a mobile cannon used by artillery units. Developed during the Cold War, this machine was designed to fire nuclear weapons.

Only four 2A3 machines were built in the four years the Kondensator was in service. Experts questioned the practicality of the unit from the start, predicting that the howitzer's frame would break after a few shots from its enormous cannon. All four Kondensator howitzers were retired in the mid-1960s.

Only a few models of this rare machine exist, let alone in LEGO. This 2A3, built to 1:30 scale, includes a rolling chassis and tracks made with late 1970s gear chains.

The model also features stowable seats for the eight-man crew, as well as a working hoist and moveable breech loader on the right side. Custom stickers, handlebars, and other LEGO elements add realistic detail.

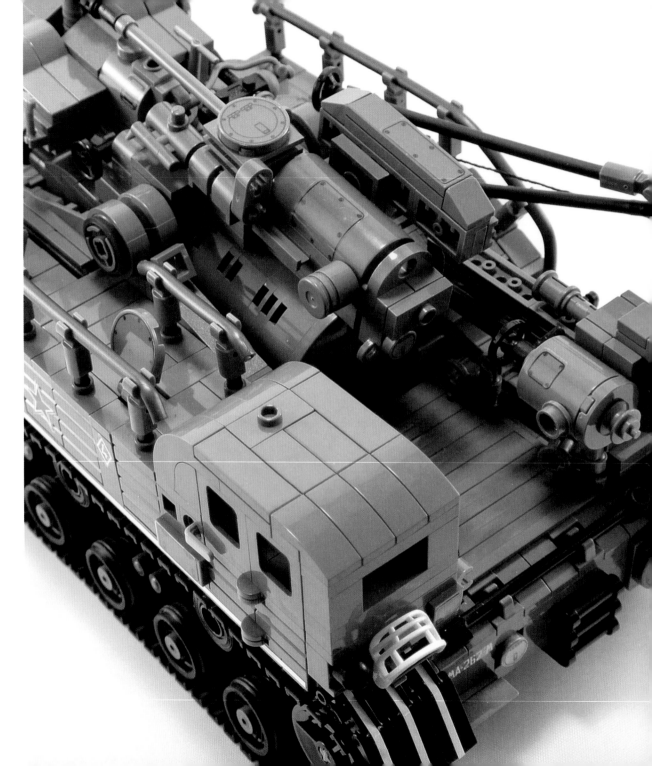

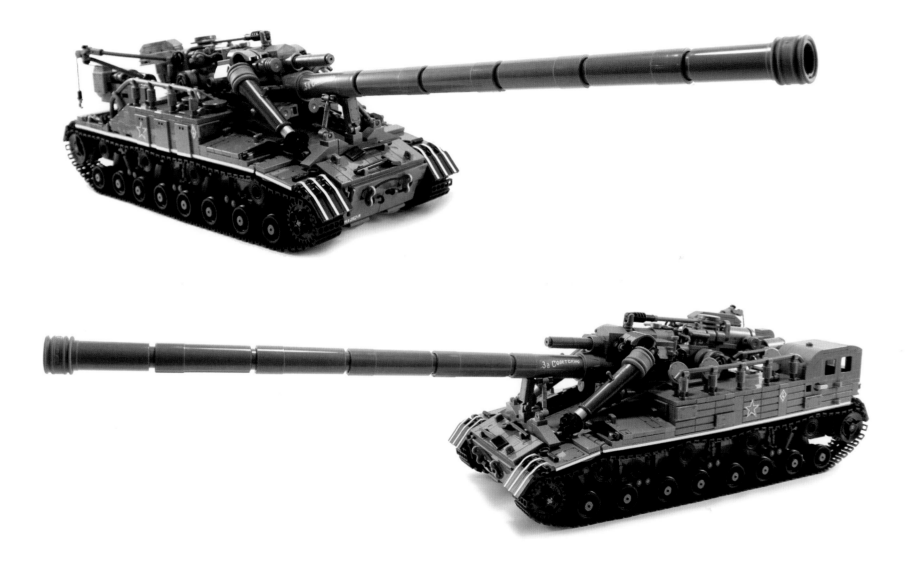

**2A3 Kondensator 2P**
Andy Baumgart

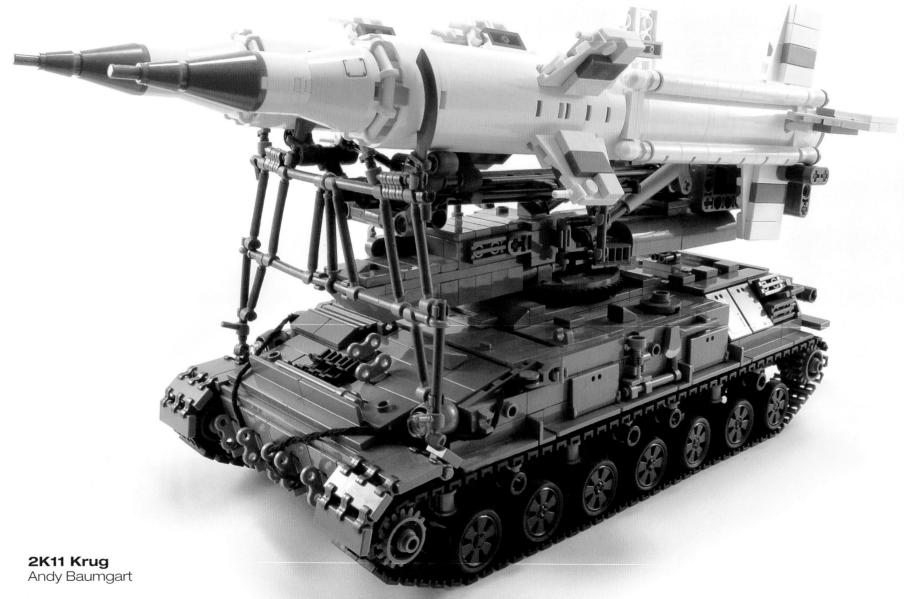

**2K11 Krug**
Andy Baumgart

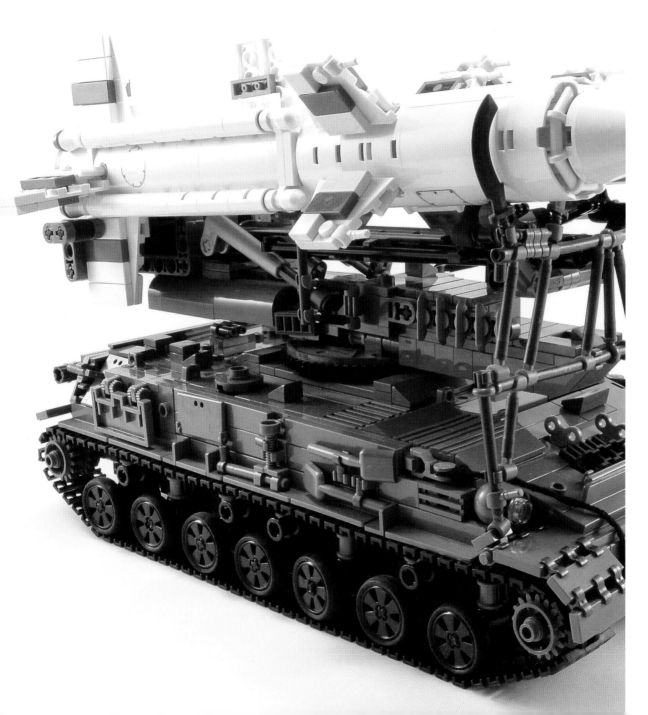

## 2K11 Krug

The 2K11 Krug is a Soviet surface-to-air missile launcher that entered service in the 1960s. A typical Cold War machine, it was displayed for the first time in a Moscow parade. Its two missiles are launched from an elevating turntable with solid-fuel rocket motors and can reach speeds up to Mach 4. It has an effective range of 31–34 miles (50–55 km).

Featuring a rolling chassis, the 1:28 scaled LEGO model uses 1970s LEGO gear chains for the tracks and black LEGO hockey pucks for the road wheels. Not only are the missiles removable, but the missile launcher rotates 360 degrees and elevates up to 80 degrees.

The travel lock can be engaged and disengaged, and secondary braces fold flat when the missile launcher is raised. Other features include a driver's hatch and commander hatches on both the left and right sides of the machine.

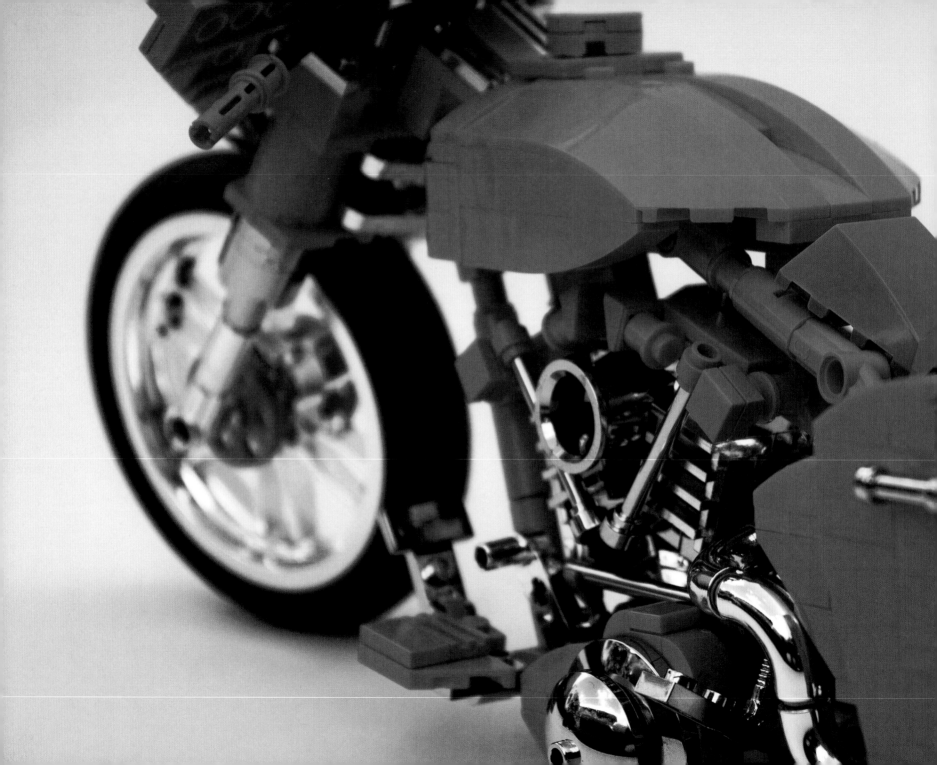

# Motorcycles

While much less common than other vehicles, like cars, trucks, and trains, LEGO motorcycles have been available for years in various themes and scales. The first official sets appeared in the mid-1970s, and the first large-scale bike was released in the Technic theme in 1979.

By the early 1990s, motorcycles were a regular sight in the LEGO Technic catalogue. Recent motorcycle sets include wheels that can be used on scratch-built LEGO bikes.

LEGO motorcycles require fewer pieces to build than cars and trucks do. Also, their larger scale and minimal bodywork leaves room for lots of details. Perhaps these models will encourage more LEGO enthusiasts to build their own bikes.

# Harley Davidson Road King Classic

Since its initial production in 1994, the Harley Davidson Road King has been *the* classic touring bike and one of the most famous American motorcycles. Inspired by the big-frame bikes that Harley Davidson launched in the 1940s, this bike offers all the classic style of its forebears.

Based on a custom 2006 Road King Classic fitted with a fully chromed Twin Cam 88-cubic-inch (1,450 cc) engine, the model shown here boasts a dual exhaust, larger front wheel, and special hard saddlebags that make it a true *bagger*.

This lifelike model also features a fully chromed frame and engine made with rare chromed LEGO pieces.

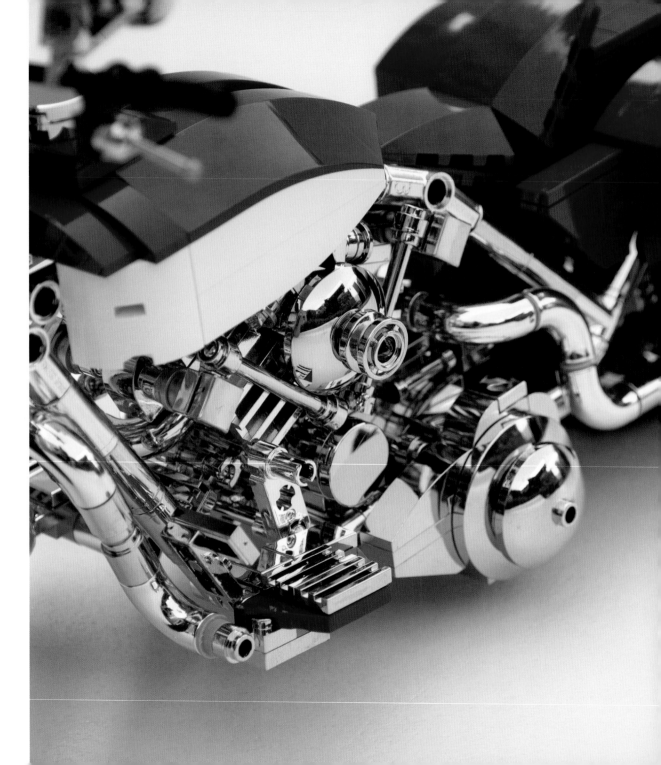

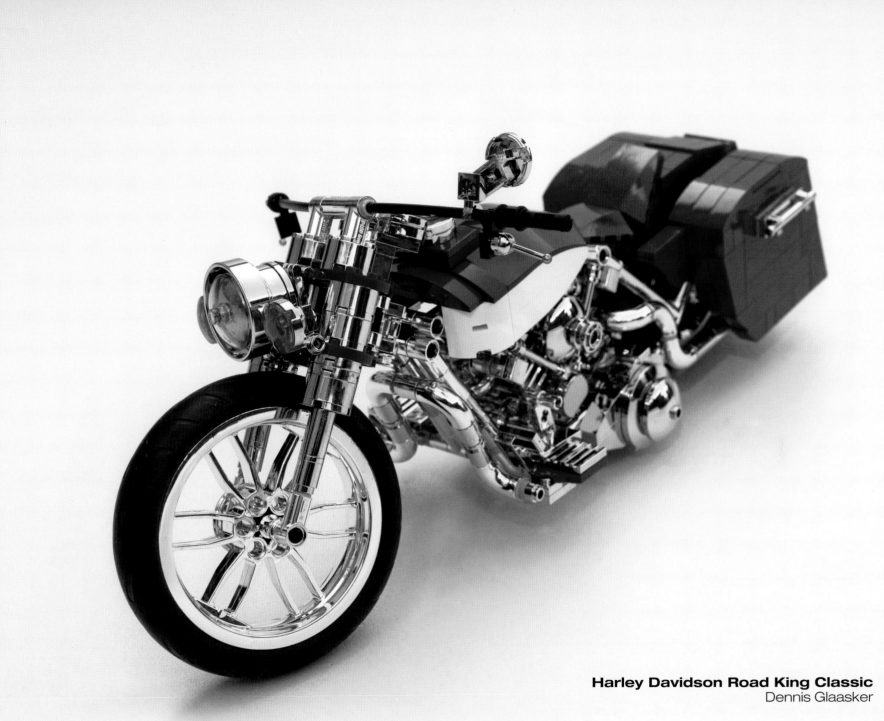

**Harley Davidson Road King Classic**
Dennis Glaasker

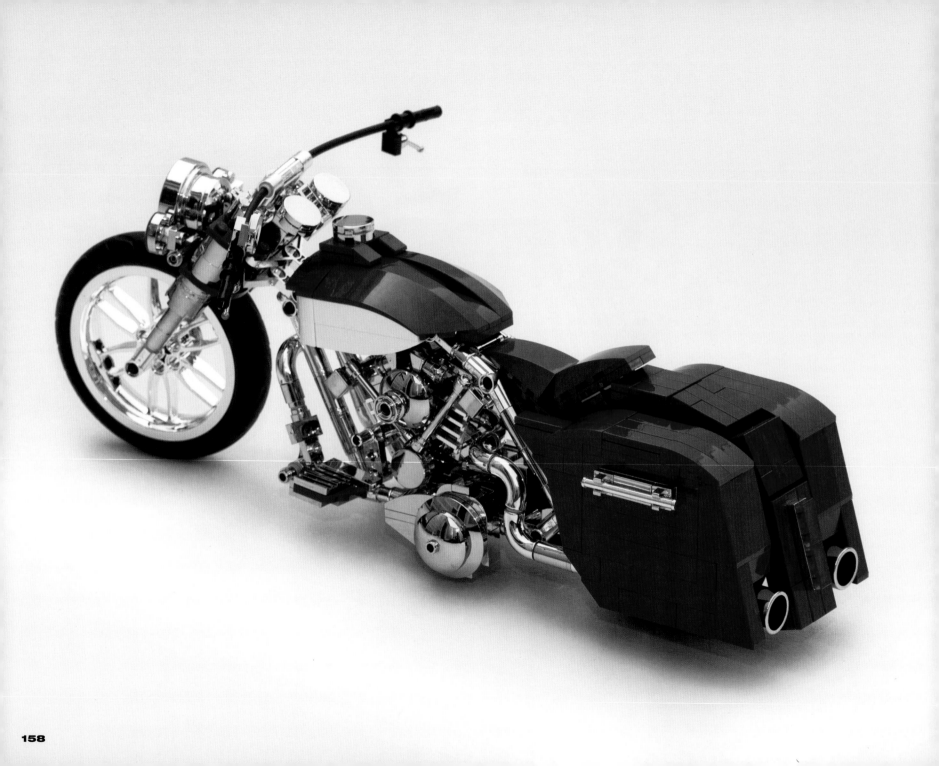

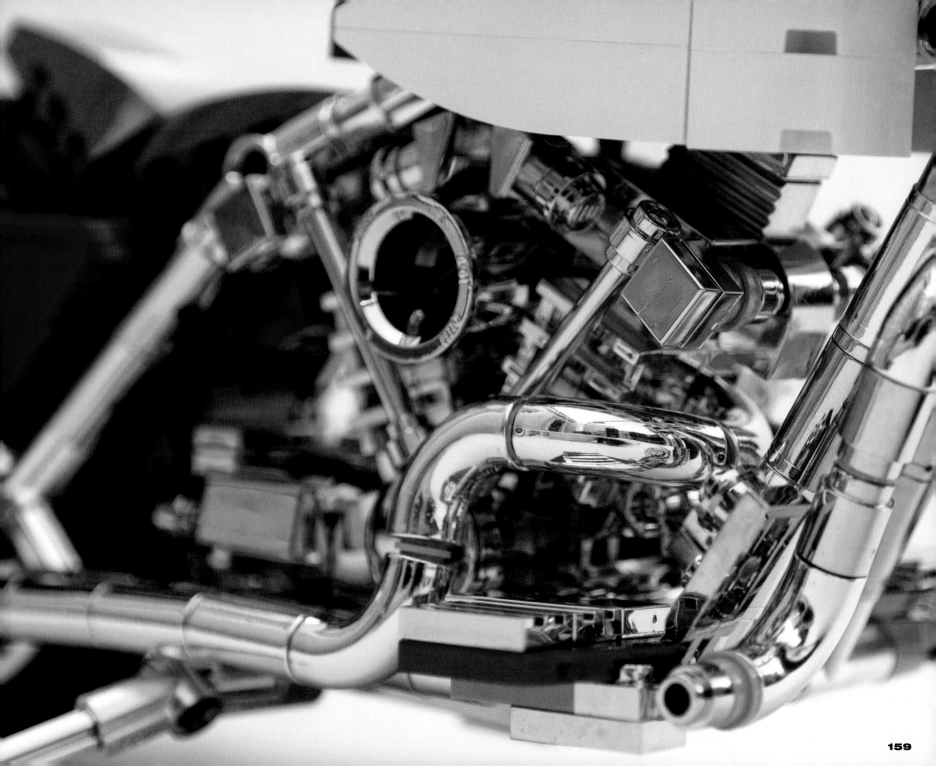

# Harley Davidson Street Glide

The Street Glide was introduced in 1984, at a time when Harley Davidson was in dire financial straits. Fortunately, the company survived, and the Street Glide remains in production today. Like the Road King, the Street Glide is a big-frame tourer, but it also includes a front fairing, which allows for audio equipment and protects the rider from bad weather.

With its orange design accents, this 1:10 scaled Street Glide is a sleek machine. Its frame consists mostly of orange LEGO Technic parts, while the fuel tank, fairing, hard saddlebags, and fenders are composed of traditional LEGO bricks.

Finished with chromed pieces, the model also features a scaled version of the original's custom 26-inch (66 cm) front wheel.

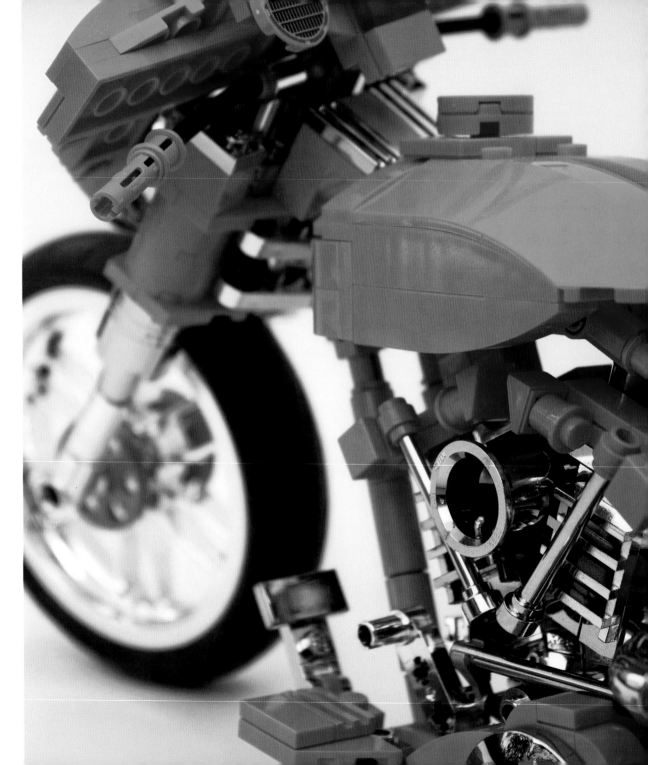

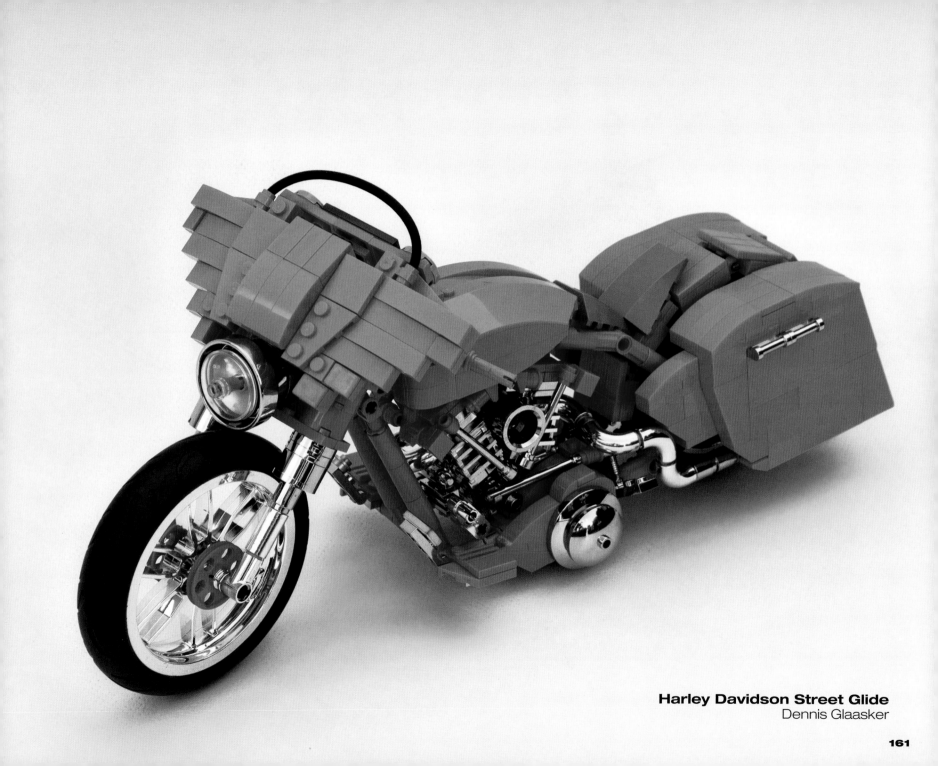

**Harley Davidson Street Glide**
Dennis Glaasker

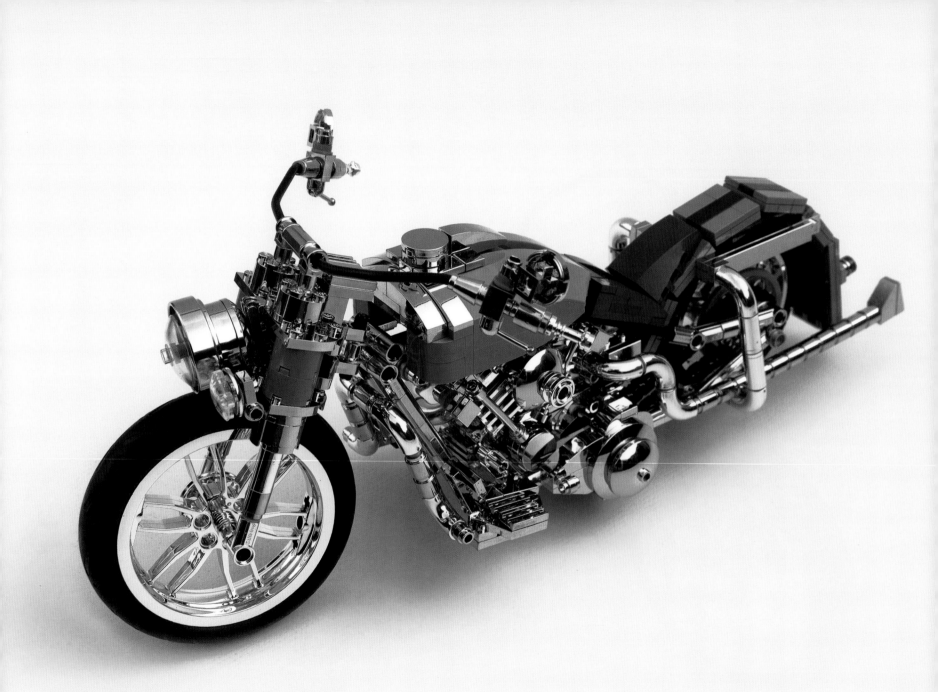

**Harley Davidson Cali Style Road King**
Dennis Glaasker

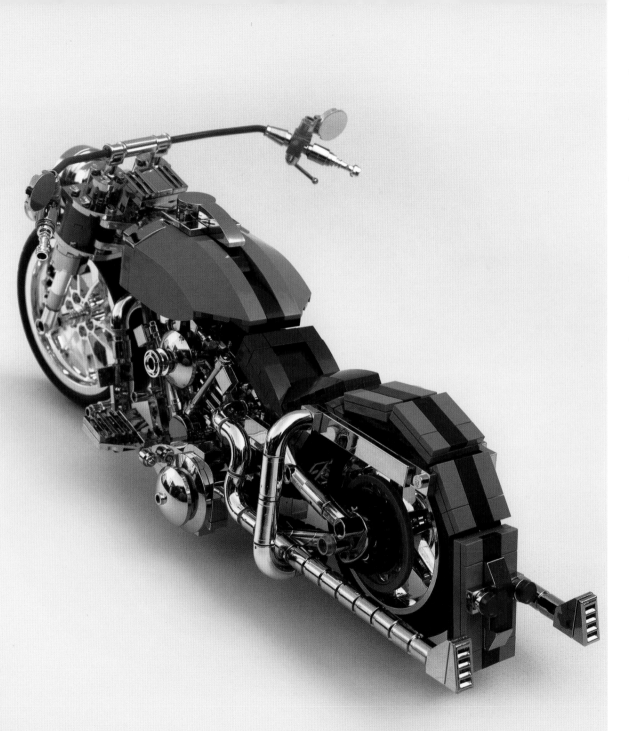

# Harley Davidson Cali Style Road King

California is home to many enthusiasts who own highly customized cars and motorcycles. American hot-rodding and customizing has deep roots in California, whose mix of cultures has had a major impact on the design of custom cars and bikes.

This Harley Davidson scale model is a typical example of the style. With its signature California look, the lowrider setup includes unique, stylish colors and long tailpipes, as well as custom chromed and gold-plated pieces.

# Harley Davidson Custom Chopper

The *chopper*, a bike modified from an original design, often includes characteristic features like extended forks, tall handlebars, and a hardtail frame. (As its name suggests, a hardtail frame has no rear suspension.)

A mix of various Harley Davidson styles, this custom chopper model includes a hardtail frame, big front forks taken from the Fat Boy, and a right-side chain setup culled from the Sportster.

This creation also features a wide rear wheel, which was fashioned by combining two rims with one tire, all found in the LEGO Racing theme.

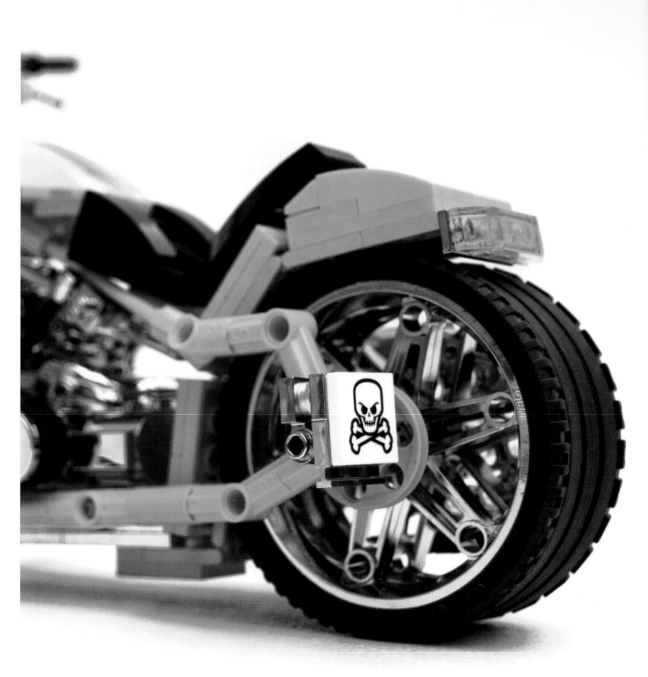

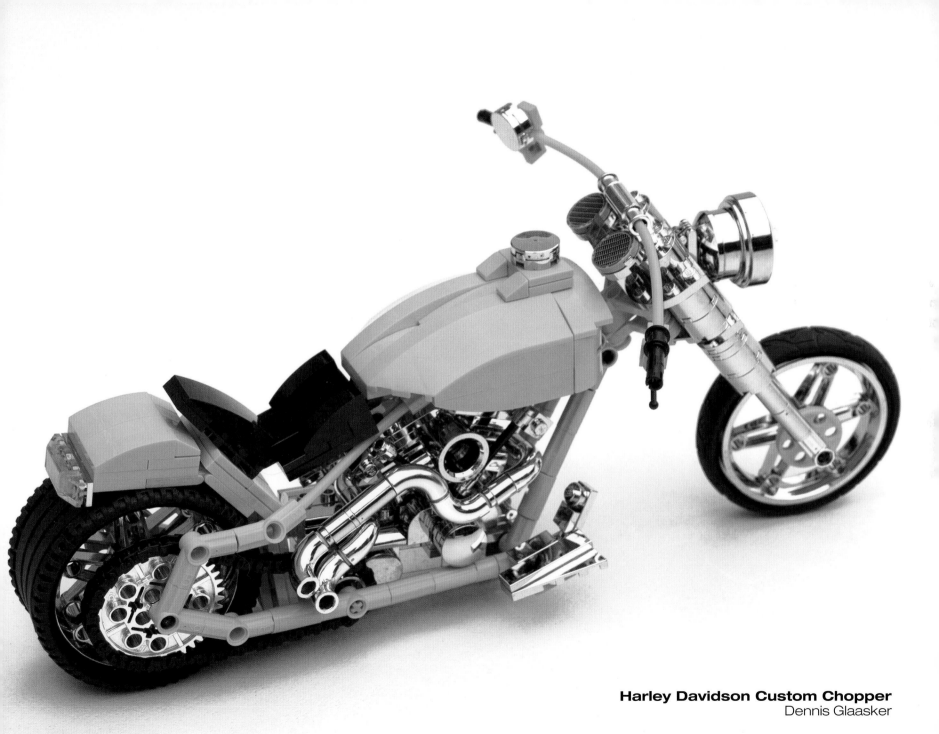

**Harley Davidson Custom Chopper**
Dennis Glaasker

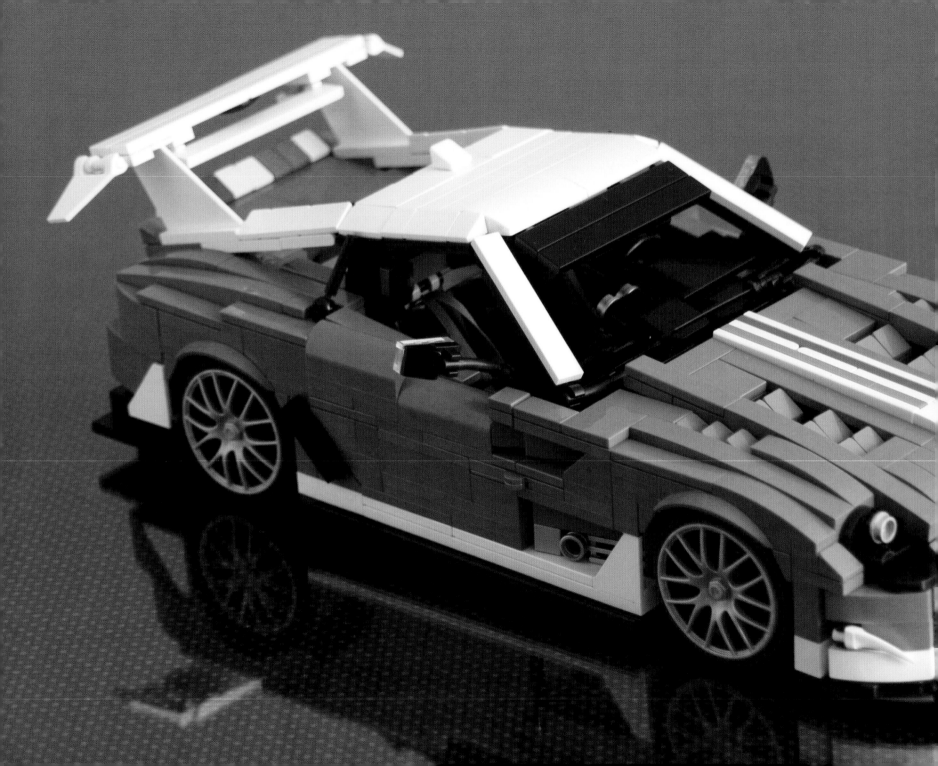

# Cars

Collecting and modeling cars has always been especially popular. Supercars, standard cars, vans—every kind of car has enthusiasts around the world. Some people focus on a specific brand, and others have a passion for a particular type, such as convertibles or sports cars. There are many scales and fabrication methods for stationary models, as well as a huge market for remote-controlled cars.

LEGO created molded cars in the early 1950s, and the first attachable wheels for the LEGO System were introduced in the 1960s. Cars have appeared in the LEGO catalogue ever since. The number of available car sets is immense, and the LEGO Group has become the world's largest tire manufacturer, producing more than 300 million annually.

The best modelers have the skills to build almost any car, from supercars and vintage cars to vans and lowriders— all out of LEGO pieces. New elements are making it possible to build ever more exact replicas, yielding results that modelers could only dream about years ago.

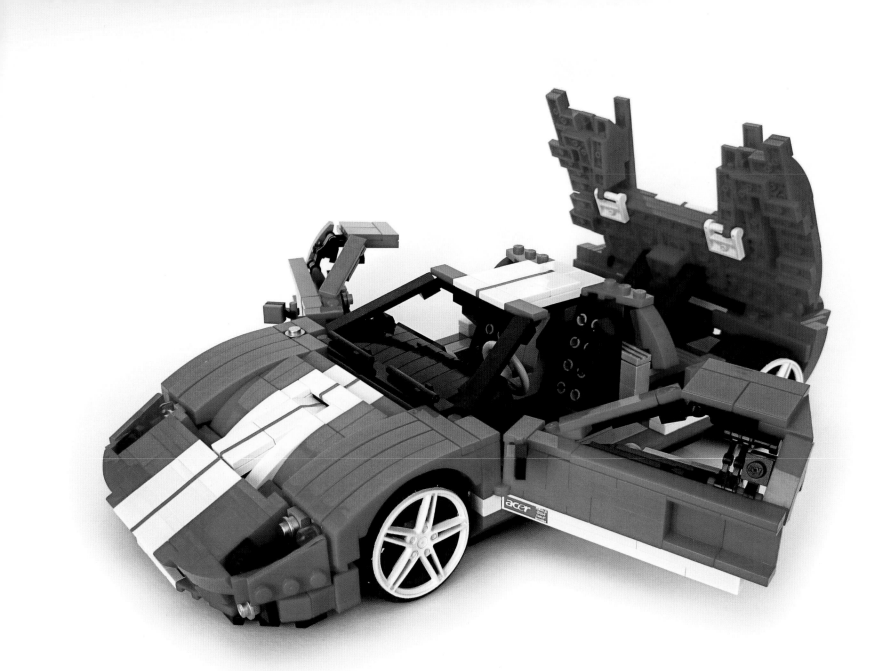

**Ford GT**
Firas Abu Jaber

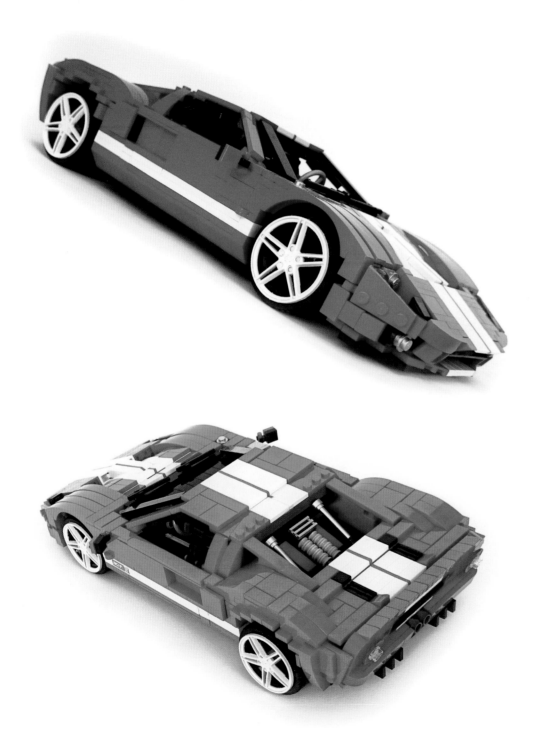

# Ford GT

The Ford GT is a modern-day version of the legendary GT40. During the 1960s, the GT40 won more prestigious races than any other race car type in history.

In honor of its centennial year in 2003, Ford revived notable names from its past, including the GT40. In total, 4,038 of the new GT were built. Though similar in looks to the original, the new Ford GT is bigger and incorporates more modern technology.

The 1:17 scaled LEGO Ford GT model features many lifelike details. The doors and hood open realistically, and the engine and interior are modeled accurately as well. Featured in magazines and blogs worldwide, this LEGO model even got the attention of the BBC's *Top Gear*.

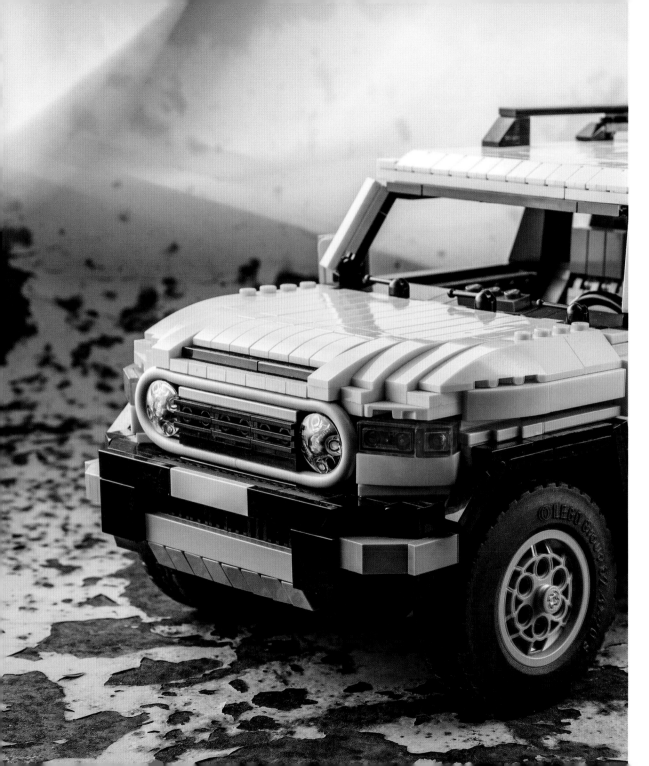

## Toyota FJ Cruiser

Incorporating elements from older Toyota models, notably the Land Cruiser 40 series, the FJ Cruiser is an iconic terrain car. Introduced at the 2003 Detroit Auto Show, this SUV reflects that decade's fondness for retro designs.

The five-passenger FJ Cruiser was built on the platform of the Toyota Tacoma pickup. Its 4.0-liter V6 produced about 240 hp and was available with two-wheel drive, as well as a four-wheel drive option for off-road aficionados. Toyota sold approximately 200,000 of this SUV, mostly in the United States and Canada, before it was discontinued in 2014.

Looking almost identical to its big brother, the LEGO model is scaled to 1:13. Modeled in a way that avoids visible studs, it also features a grille made of LEGO hose.

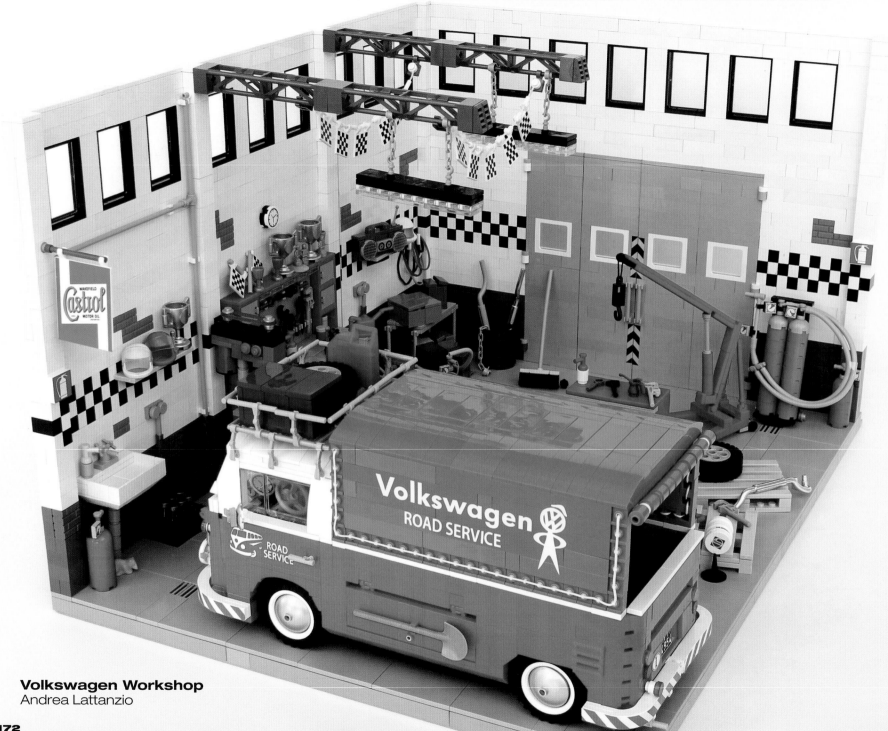

**Volkswagen Workshop**
Andrea Lattanzio

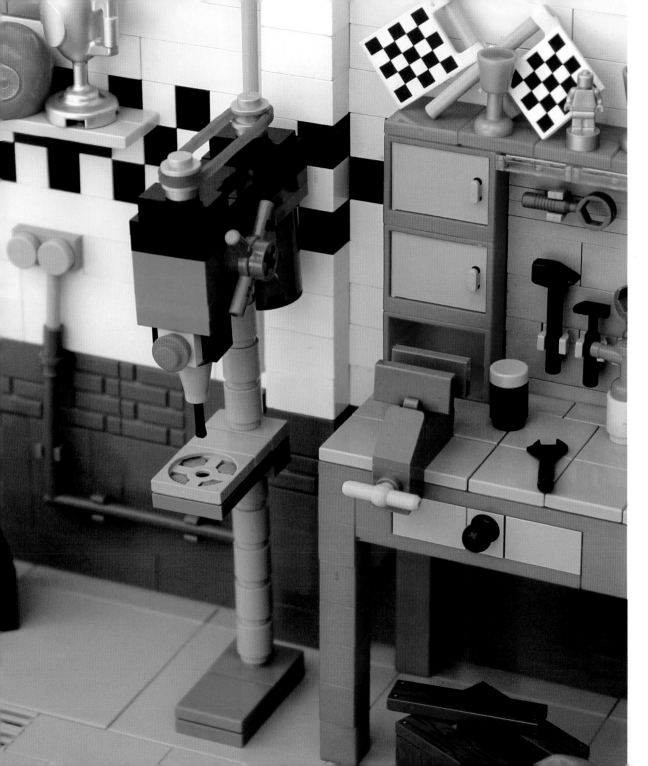

## Volkswagen Workshop

Car manufacturers are well aware of the value of their heritage, especially iconic brands like Volkswagen. VW's Beetle, campers, and buses have achieved cult status among vintage car fans, travelers, and free spirits of all types.

Many car makers have workshops dedicated to restoring classic vehicles, but enthusiasts often prefer to do the job themselves at home. This diorama was inspired by the modeler's own garage, which he uses to restore classic motorbikes. Included in the scene is a LEGO replica of a Volkswagen T1 service van.

Outfitted with many carefully modeled details, this workshop includes a workbench equipped with wrenches and a vise, a mobile roller cabinet, an air compressor, an oxyacetylene torch, and a small towing boom. Oil cans, hammers, and other tools give the impression of a small workshop in active use.

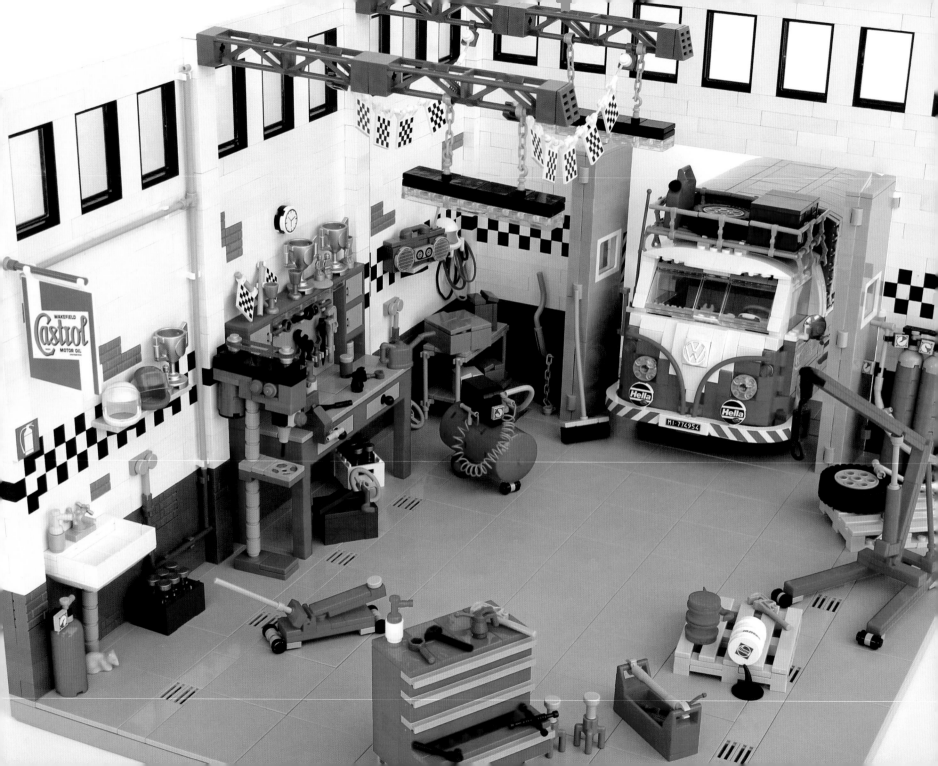

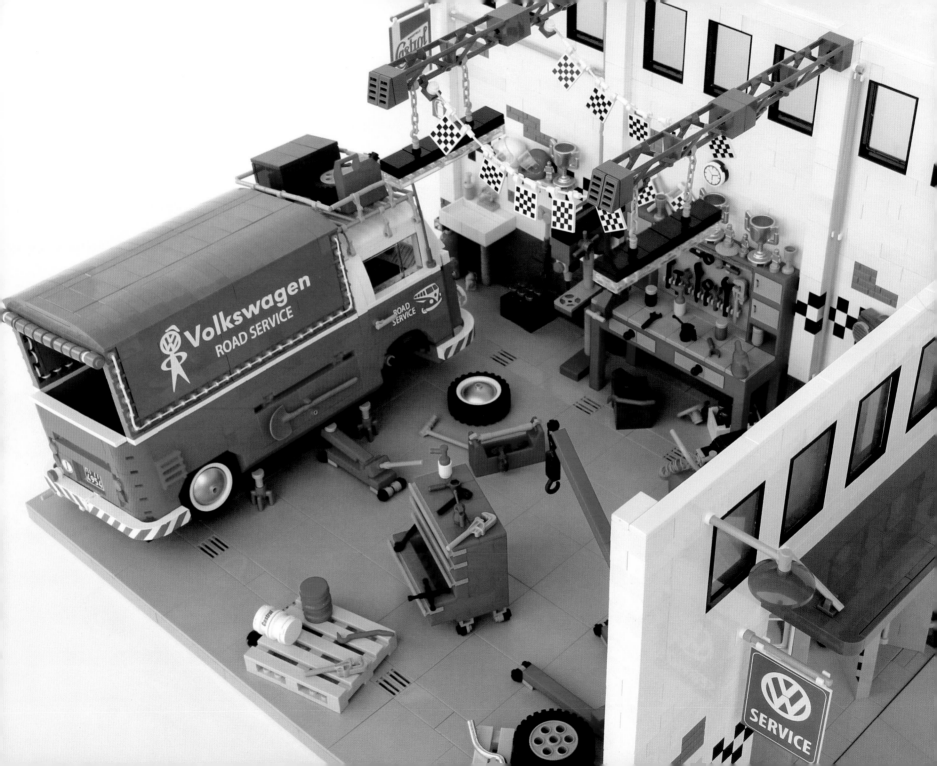

## Ferrari 599 XX Evo

Based on the 599 GTB Fiorano, the Ferrari 599 XX Evo was designed for Ferrari's Corse Clienti events, which allow racing enthusiasts to drive competition Ferraris.

As a track-only vehicle, the 599 XX is a technical powerhouse. Its unique technology is not street legal and doesn't fit in any official race class. The owner can drive it only at specially organized events and cannot even take it home.

This LEGO model 599 XX—the only one of its kind—is even more exclusive than the original, and it can be taken home! Its special blue color, inspired by Ferrari races at the Tour de France Automobile, mimics paint used on the 599 XX Evo from 2012.

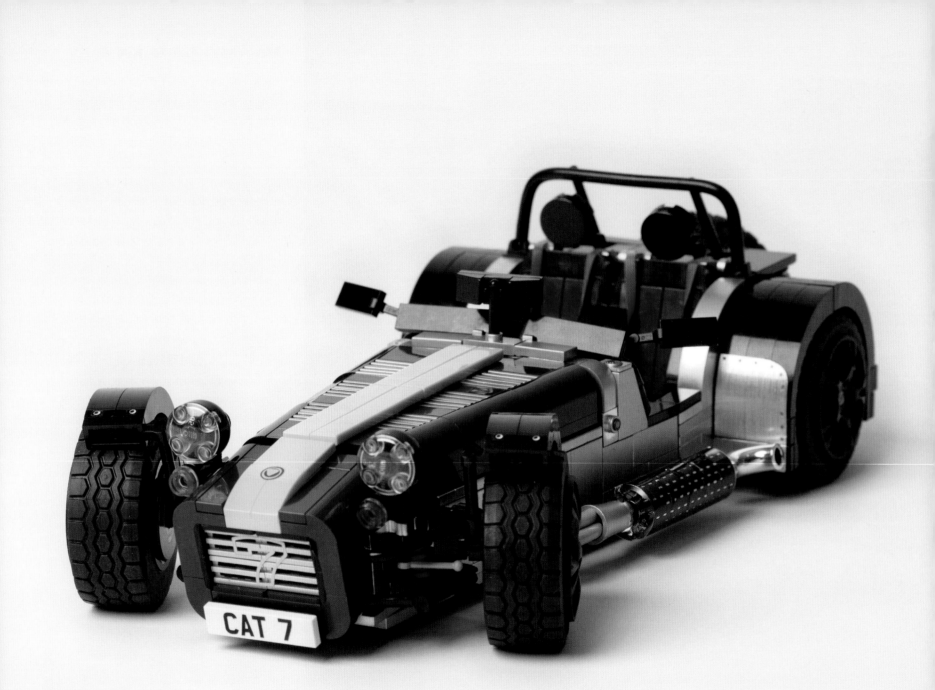

**Caterham Super 7**
Carl Greatrix

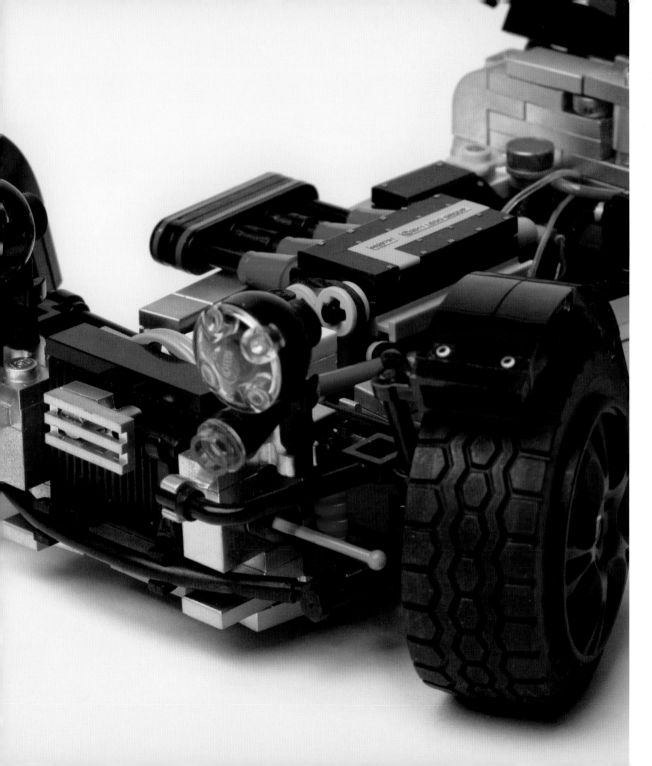

## Caterham Super 7

The British-built Caterham kit car, launched in 1973, is a lightweight two-seater sports car based on the Lotus Seven. Though it's a racer, it can also be driven on public roads.

Like the real-world kit car, this model features a snug interior and seats with harness brackets in the rear of the chassis, as well as a detailed dash and foot pedals. The engine, which can easily be reached when the hood is removed, re-creates all the rods and intakes of the original. The body panels have been painted metallic silver, and the decals are all custom made.

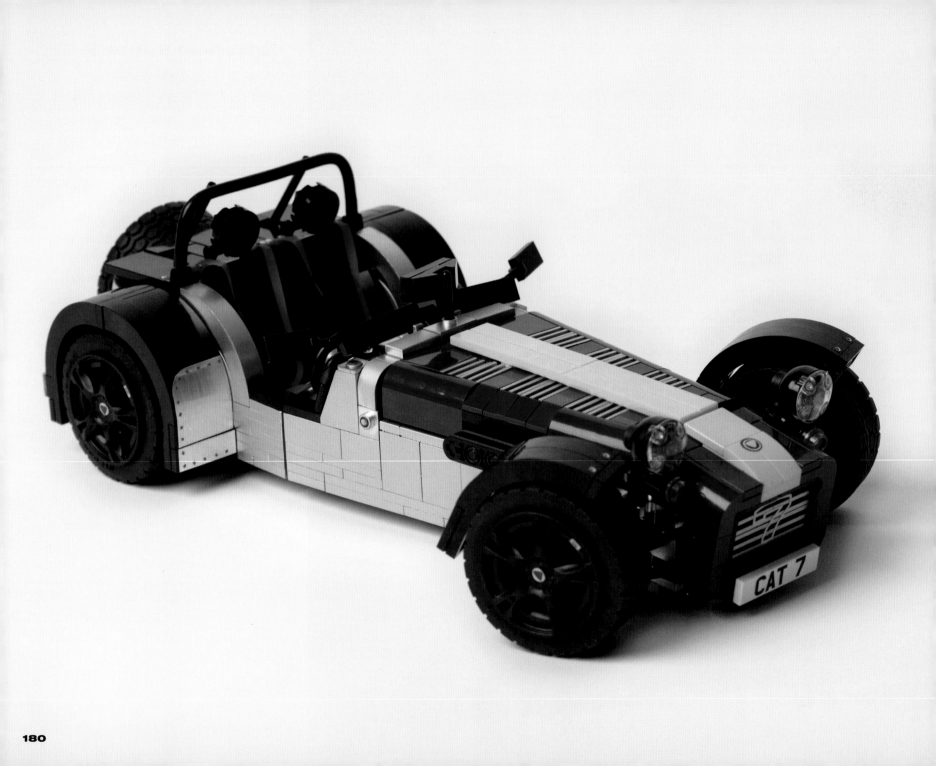

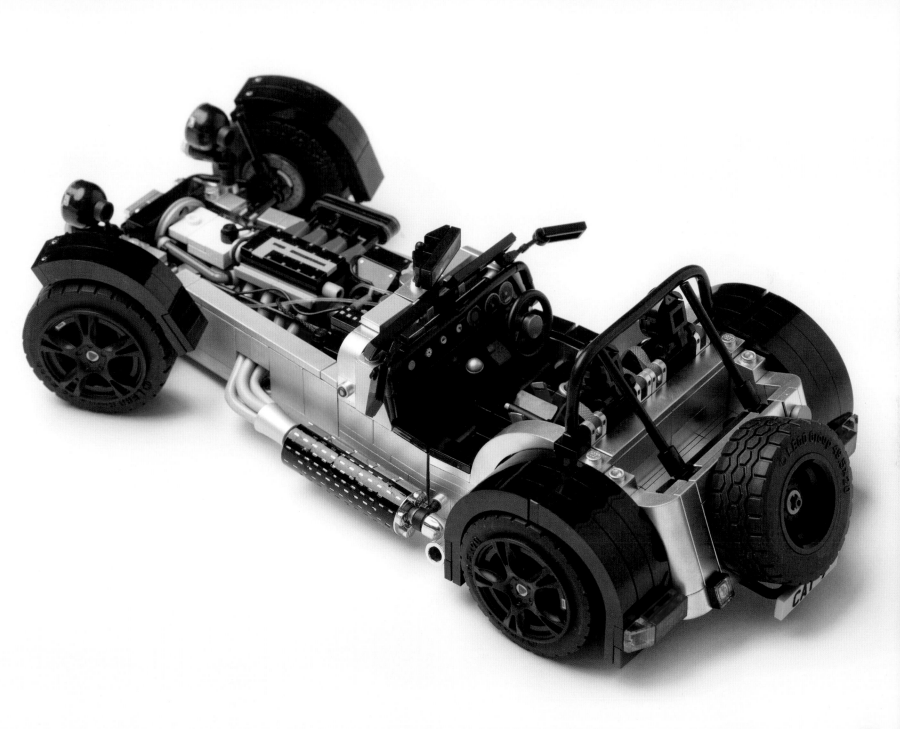

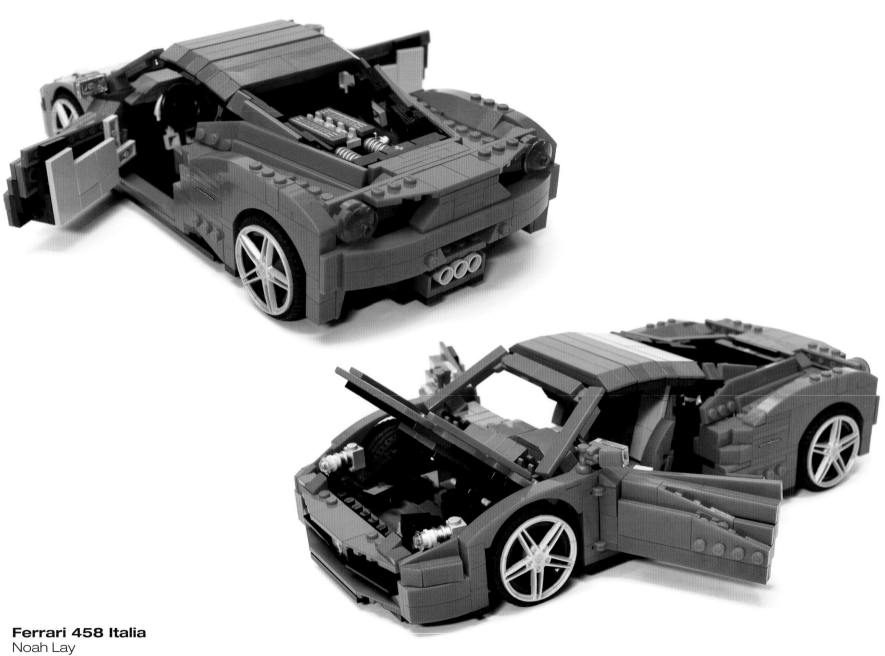

**Ferrari 458 Italia**
Noah Lay

## Ferrari 458 Italia

In 2009, the Ferrari 458 was unveiled at the Frankfurt Motor Show. As the successor of the F430, a model featured in a few official LEGO sets, the 458 Italia inspired many LEGO builders to build their own Ferrari models.

A traditional mid-engine Ferrari, the 458 Italia is powered by a 4.5-liter V8 engine—hence the type name 458. The 458 Italia is equipped with many high-tech features found in Ferrari's race cars, and it can be configured for driving on a racetrack as well as for daily driving. A full complement of electronic support systems help the 562 hp car drive in any conditions.

This 1:17 scaled Ferrari 458 Italia model started out as a Ferrari Spider. The modeler later adapted this design to reflect the curving lines of the Italia, paying careful attention to functional elements, like doors that can open.

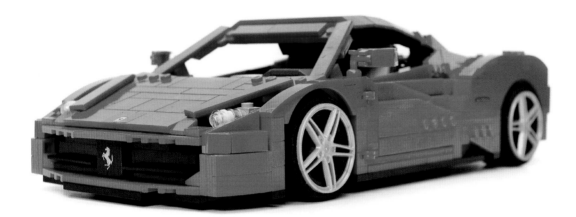

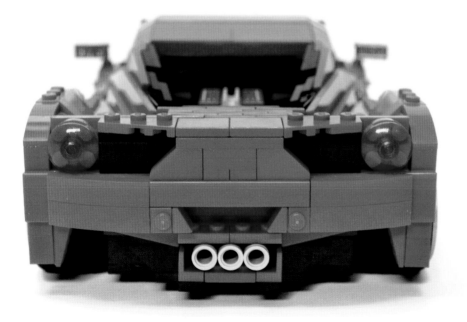

# Lamborghini Aventador

Italy is home to many of the most iconic supercar makers, including Ferrari, Maserati, and Lamborghini. The latter was founded by Ferruccio Lamborghini, the son of grape farmers, who started building his own sports cars after being disappointed by the quality of his Ferrari.

Like almost all Lamborghinis, the Aventador is named after a fighting bull. It showcases trademark Lamborghini design features, including scissor doors and a V12 engine. The engine delivers approximately 700 hp, giving the car a top speed of 217 mph (349 km/h).

This 1:17 scaled LEGO version is constructed using new curved slope pieces, giving it the elegant shape of the original. The model features a working rear spoiler and operational scissor doors.

The hood and headlights are two of the most important elements in any recognizable scale model. Here, the builder has made a curved hood from many small parts, adding to the replica's overall realism.

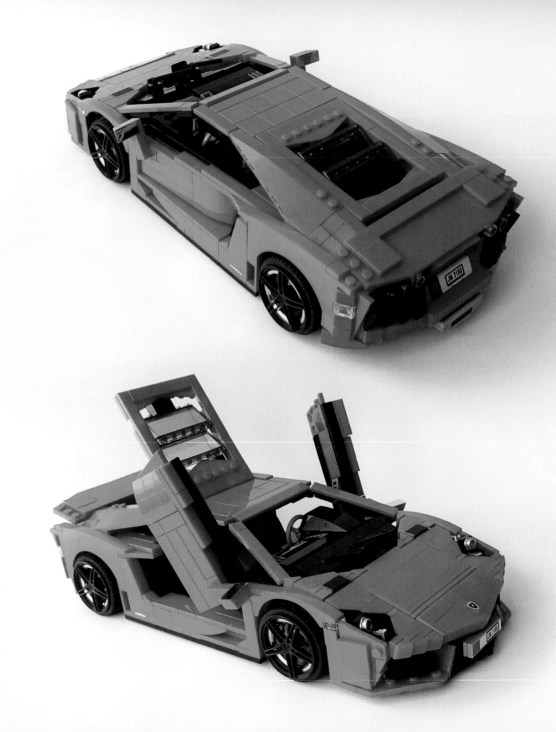

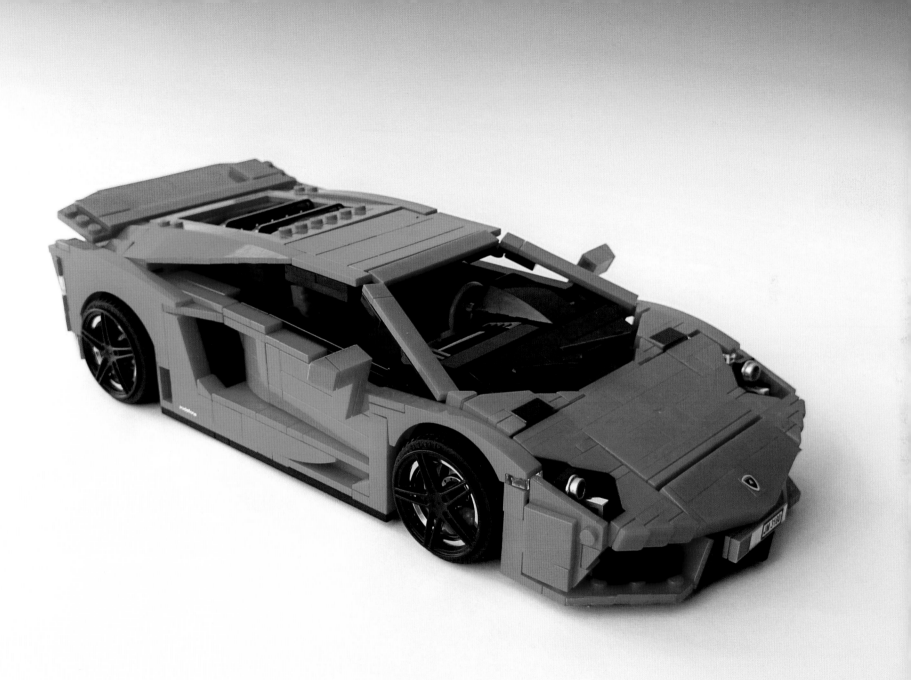

**Lamborghini Aventador**
Firas Abu Jaber

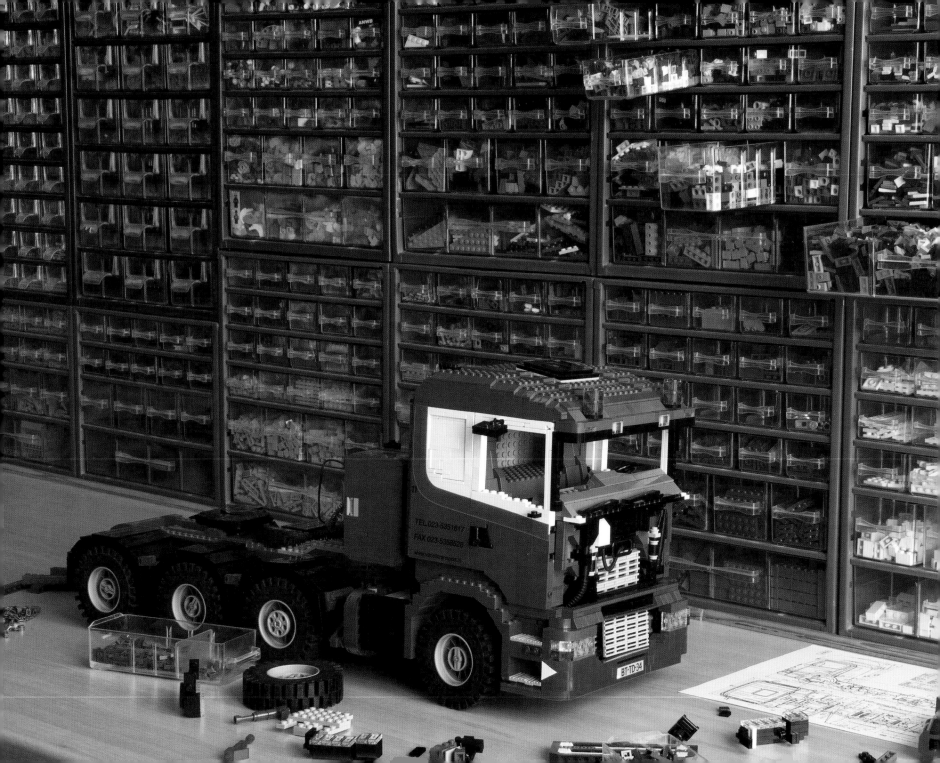

# How It's Done

As you were reading through the pages of this book, you might have wondered: *How'd they do that? How could I begin to create my own LEGO scale models?*

This chapter walks you through that process. You'll learn all the steps involved, including sketching designs, sourcing the LEGO pieces, and finalizing models with special stickers or custom parts.

You'll also see how to share your work and connect with other builders online and at LEGO shows. Sharing inspiration and techniques with others is a great way to learn, improve your designs, and make the most of a rewarding hobby.

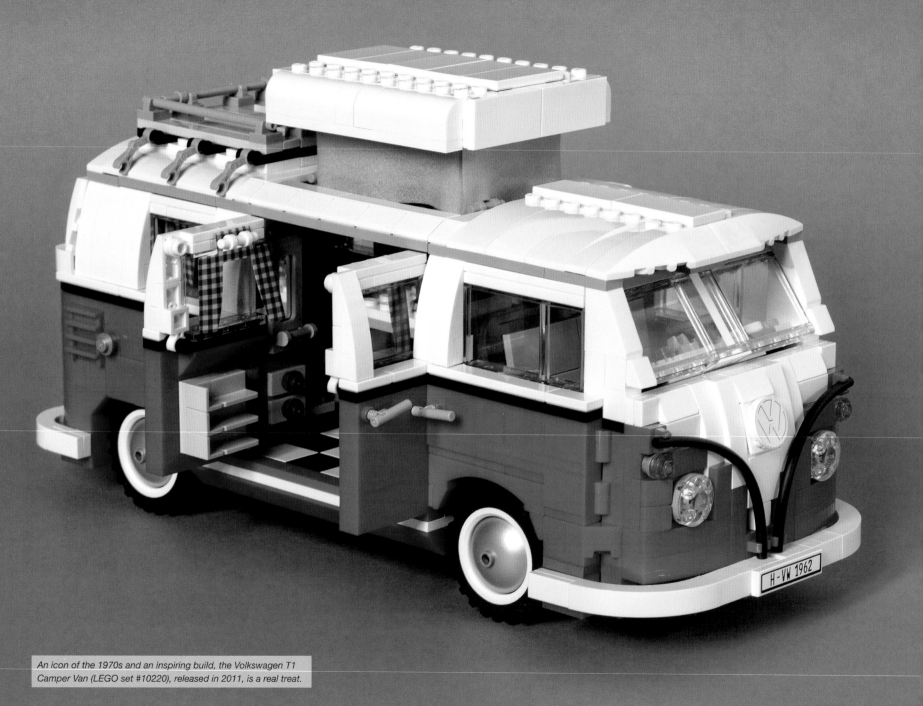

An icon of the 1970s and an inspiring build, the Volkswagen T1 Camper Van (LEGO set #10220), released in 2011, is a real treat.

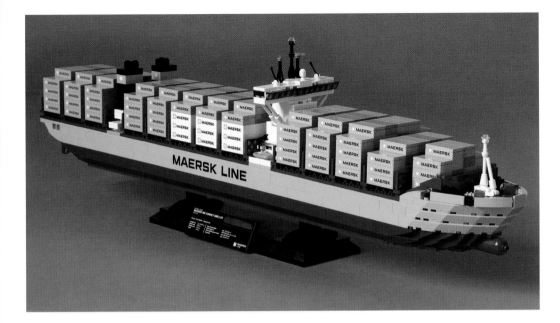

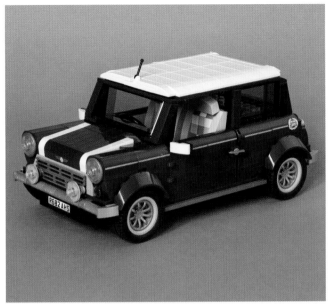

# Where to Start

As with any hobby, there are many ways to begin. If you're feeling intimidated by the models in this book, don't worry. Most of the builders featured here have years of experience working with LEGO. Of course, they started with official LEGO sets and later decided to make their own models based on their interests.

If you've never built with LEGO before, LEGO sets are a great way to learn. The Exclusives, the Creator sets, and the Technic sets are fun to build and give you hands-on experience with various parts and functions. Any sets you buy can also be used as raw materials for your custom builds later on.

It's important to start with a project you can finish, even if it's smaller than some of the massive models shown in this book. Keep in mind that it's more rewarding to *complete* a model than to simply dream about that one perfect design.

Don't forget, too, that LEGO is a reusable medium! After you finish a model, take some photos and then reuse your bricks on another project to build something even better and boost your skills. Modelers often say that their most recent work is the best, because they learn from every new model.

**Left:** *The Maersk "Triple-E" (set #10241) has inspired many LEGO scale modelers, and it includes several exciting colors.*

**Right:** *The Mini Cooper (set #10242) was launched as part of the LEGO Creator theme in 2014. With close to 1,100 pieces, this realistic model showcases great building techniques. Featuring operable doors, hood, and trunk, it's the perfect set to practice modeling real-life details.*

**Right:** *Glaasker: "I had never built a locomotive before attempting to build an American diesel. This photo of a BNSF SD40-2 became my inspiration. As soon I posted some "work in progress" photos online, I was contacted by a few railroad engineers who work on the engines. They supplied me with many detailed photos that I couldn't have found elsewhere. It was fun to share the build publicly as it progressed, and by the time I finished the locomotive, a whole community of enthusiasts was cheering me on."*

**Below:** *The result after months of work*

## Design

Designing your own models requires some groundwork. You should start your design by finding something you are passionate about. You'll be spending lots of time thinking about whatever you build, so be sure to choose a subject that appeals to you.

Then start thinking about the scale of the model, because deciding on the scale is a crucial starting point for every new design. The scale you choose might be limited by the number of pieces you have, or by the availability of certain parts.

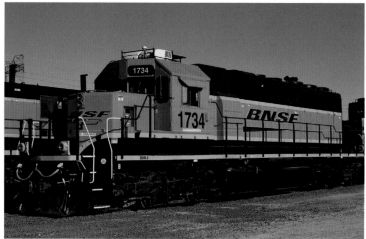

CREDIT: CHARLES H. BIEL

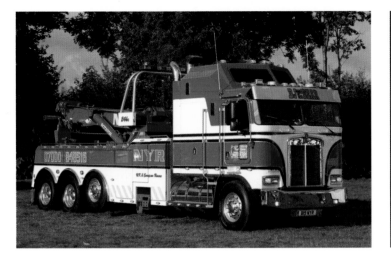 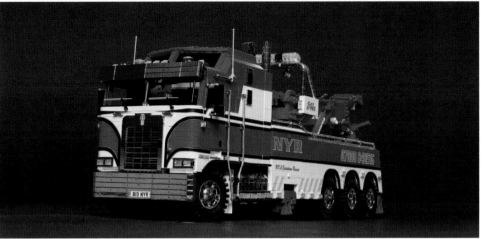

Often, a vital part will determine the scale of a model. For example, LEGO wheels aren't available in every diameter that would fit a certain scale, so you'll need to start with the wheels you want to use and work backward from there. Many of the models in this book were designed this way. The Kenworth K100 (this page; page 10) is scaled to 1:13 and uses one of the bigger classic LEGO wheels, yet the same wheel is also used for the massive Liebherr LTM 11200 (page 106), which is scaled to 1:16.

Wheels aren't the only component that can force design decisions on scale. The yacht *Kiss* (page 48) is scaled to 1:54 because of the dimensions of a specific LEGO window type. Unusual scales like this are common in the LEGO design world.

Once you have decided on your scale, the next step is to do some research. Manufacturers often offer technical specifications or blueprints online that provide accurate dimensions and can easily be scaled to your model. Measure as many of the dimensions as possible, and then round each dimension to the nearest *stud*, the LEGO unit of measurement.

Many modelers create a spreadsheet of key information about LEGO piece geometry and use this to make basic calculations. Others prefer using dedicated software for the job.

Once you have your measurements worked out, the next step is usually to choose the color. Just be aware that not every part is available in every LEGO color and that some parts are rare. Online libraries like BrickLink.com and Peeron.com will show you which parts are available in which color.

Some builders prefer to construct their models digitally using computer-aided design software like the LEGO Group's LEGO Digital Designer (LDD) and the fan-created LDraw. LDraw, which is an open standard for LEGO CAD programs, allows for more complexity and "illegal joins." It also allows you to create 3D renderings of your models, but it's more complicated to use. Both products can also generate lists of parts.

**Left:** *Bosman: "I chose this Kenworth K100E Rotator as my subject because I thought it would be a nice challenge at 1:13. I love tow trucks, and I took endless photos of the original to guide me. The driver of the real Kenworth also helped me by sending some additional information."*

**Right:** *The end result*

## Sourcing Your Parts

Now that your design is ready, you need pieces to start building. LEGO.com offers a Pick a Brick service where you can order almost any element in many colors. Bricklink.com is another great source for new and used bricks.

## Building and Detailing

Obviously, when you start building your custom model, you won't have the guidance of step-by-step instructions. This means you might encounter problems you've never seen before if you've only built official sets. For example, it can be quite challenging to find a balance between structural rigidity (strength) and space for detail.

Experienced builders think ahead to create strong structural skeletons that can support a more fragile shell of details. They sometimes use unusual methods to connect different LEGO elements, angling pieces or turning them every which way to get the desired result.

Beginners are often tempted to start by building the part of the model that they like most. This is understandable, but it is not always beneficial for the model's rigidity. It's best to start at the center of the model or at a spot that lets you maintain an overview of the construction. For example, working with the chassis of a truck or the frame of a bike gives you a bird's-eye view of the model's skeleton.

When a build goes wrong, you can easily disassemble a model and start again. Don't be afraid to make mistakes. Most builders have had to revise their models during the building process, often many times.

While you're building your model, keep an eye out for opportunities to add extra detail, like gas caps, rims, hosing, wiring, or other elements that might enhance your model's realism. Creations like the Brabham BT44B (page 78), are a perfect example of this kind of attention to detail. Although the use of different colors and wiring on the engine require more time to complete, the result is unparalleled.

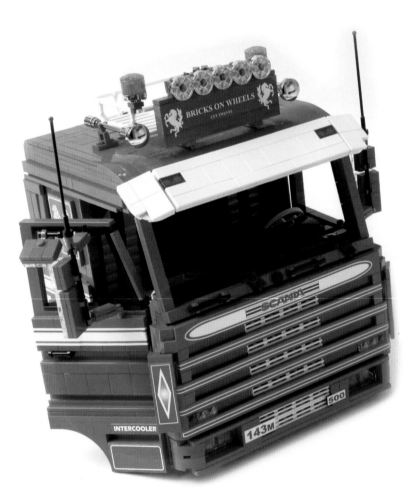

*This is the cabin of the Scania 143 featured on page 34. Just like the original truck, it has working doors and a detailed interior. Custom stickers finish this design.*

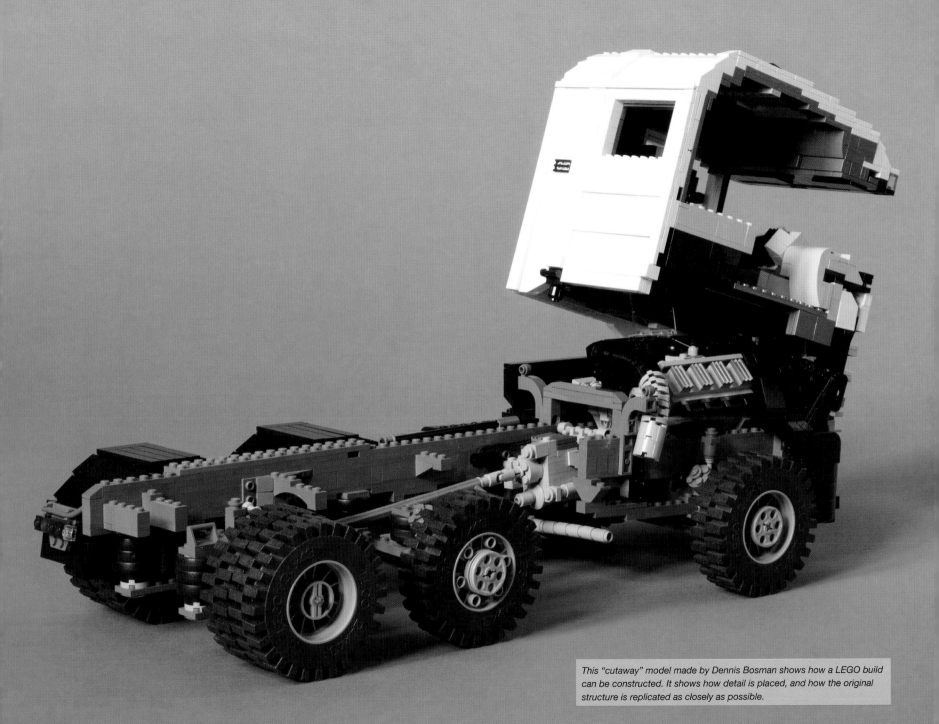

This "cutaway" model made by Dennis Bosman shows how a LEGO build can be constructed. It shows how detail is placed, and how the original structure is replicated as closely as possible.

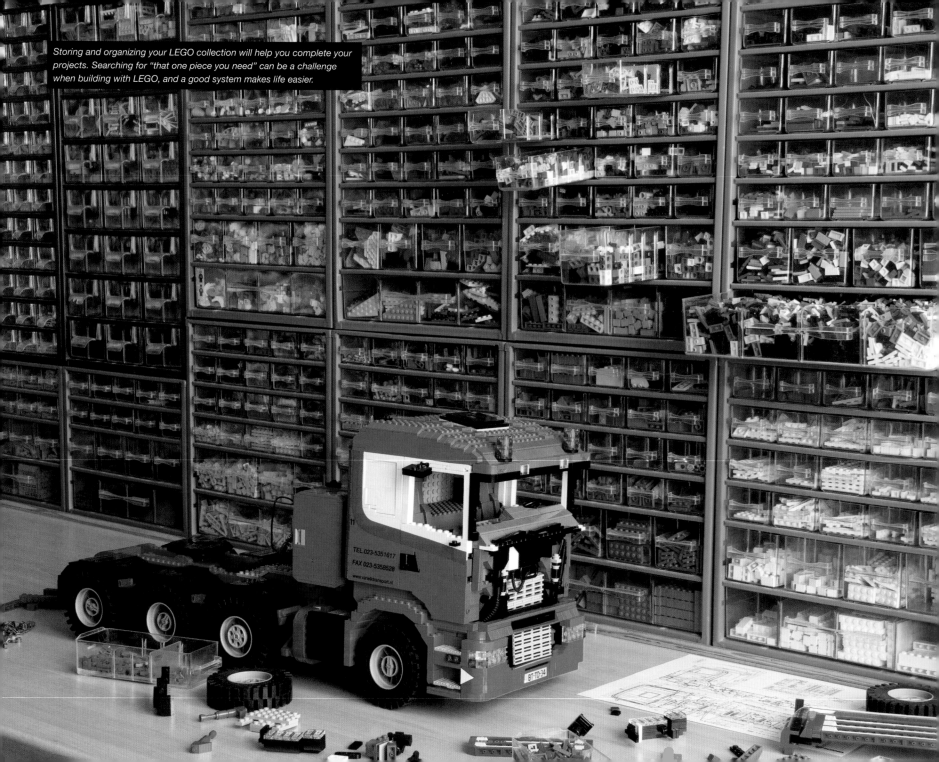

Storing and organizing your LEGO collection will help you complete your projects. Searching for "that one piece you need" can be a challenge when building with LEGO, and a good system makes life easier.

TEL.023-5351617
FAX 023-5350528
www.vanadetransport.nl

BT-TD-34

CREDIT: AURELIUSZ FALOWSKI, CHROME BLOCK CITY

## Customization

Customization can add another layer of realism to your model. Some very effective techniques are available, including chroming, stickers and decals, engraving, and 3D printing.

Chroming takes regular LEGO bricks and applies an industrial process called *electroplating* or a special paint. The LEGO Group also offers a limited selection of chrome parts. Different processes can produce different colors of chrome, as well as gold. Clearly, you cannot do this easily on your own, but you can purchase these retro-chromed bricks online.

Stickers and decals can add realistic detail to models. If no decals or stickers for your model are available at the scale you need, you'll need to make your own.

Some modelers choose to engrave LEGO parts with logos or other details and sometimes fill the engraved area with paint. This is less common than stickers, as it makes a permanent change to the piece, but it can create dramatic results.

3D printing technology is also allowing modelers to create parts with a geometry or function that is not available in existing LEGO pieces. Enthusiasts are generating many new developments in this area.

## Storing Parts

Using a container or storage system to organize and sort your LEGO bricks is helpful when you're building, but it also helps to prevent damage to your bricks. Every builder uses a different storage system, so find one that works best for you.

**Left:** *Pretty much any LEGO brick can be chromed. There are many different colors and chroming techniques to choose from.*

**Right:** *A motorcycle offers many opportunities to use custom parts. This 1:10 Harley Davidson motorcycle engine has been completely chromed. You might have to look twice to notice each element is actually a LEGO piece.*

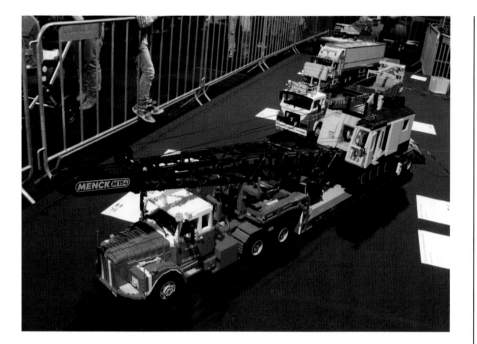

**Above:** *LEGO shows, like LEGO World in the Netherlands (shown here), are a great place to find fellow scale modeling enthusiasts of all ages. There are dozens of large LEGO events worldwide, both official and unofficial, that attract thousands of visitors.*

**Opposite:** *Sand and railroad tracks add to the atmosphere.*

## Photography

Good photography is important when you're presenting a model. Using a neutral background helps produce a strong composition: a large piece of thick paper might be enough for a small model. You'll also have to control the lighting. A flash is not always necessary; you may get better results with diffuse light from a softbox or a light tent.

Depending on the model you build, consider photographing it outside in its "natural environment." An outdoor photo shoot requires special attention to detail. Make sure the model matches the scale of the objects around it. Avoid placing it on the grass or near other plants. Choose surroundings that will help make the model look accurate at the right scale; for example, when photographing a vehicle, find some smooth asphalt to represent the road.

## Presenting Your Work

After many hours of concentration and hard work, sharing your model with others is exciting! Many modelers display their work on a Facebook or Flickr page, and some even have their own websites. The Internet has been helping builders find and contact each other for years. In fact, most of the models in this book were collected via the Internet.

LEGO scale modeling is loved by people of all ages. Many LEGO modelers are involved in communities and show their work at model shows or LEGO-related events. No matter where you live, there is probably a LEGO or scale modeling meetup, conference, or show somewhere nearby. Nothing is more satisfying than watching lots of people enjoy your models. Plus, the camaraderie among builders and the thrill of exhibiting your models publicly will likely encourage you to build new work every year.

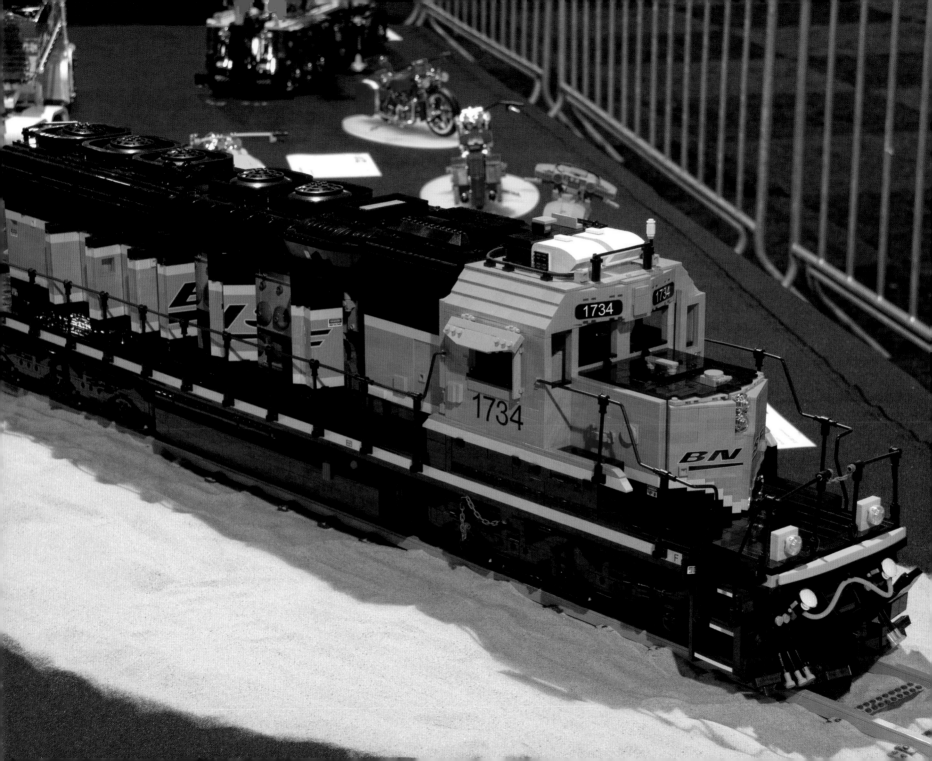

## Vrachtwagens van LEGO

# 'Geen kwestie van stenen stapelen'

Tekst en foto's: Dennis Bosman

Voor iemand die er niet bekend mee is, is LEGO niet het meest voor de hand liggende middel om een schaalmodel te bouwen. Maar diegene die af en toe naar modelbouwbeurzen in Nederland gaat, zal het niet vreemd in de oren klinken. Zeker op het gebied van voertuigen is in Nederland aardig wat te vinden, vrachtwagens in het bijzonder.

*De Scania LS141 waar de Holmes 750 oorspronkelijk op stond. Dit model voltooide ik begin 2006 en later heb ik de bomen van de Holmes verlengd. De Scania is gebouwd zoals hij in de jaren negentig bij Pillen in Winterswijk reed.*

### Diepladers en speciale voertuigen

'Het is beslist geen kwestie van stenen stapelen. De LEGO-elementen hebben een bepaalde geometrie en zo hebben wij 'plates' op elkaar gestapeld dezelfde hoogte als die van één 1×2 blokje.

*De Scania R500 van Van Elk met Faymonville dieplader. Het model is ruim twee meter lang.*

---

DG: This is one of my favorites. A while ago I brought a truck about custom trucks in the USA. Normally I tend to build tractors only, but in the book was a feature on a very nice dump truck, and it caught my attention. I start a MOC by browsing the web for exact dimensions and reference pictures. These I store on my laptop, which always is on to the custom when building. I also use an Excel sheet for scaled dimensions.

---

Vol. 3 #5/2013

# 2017 ENGLISH EDITION

It all started out back in the 1970s when he was a kid. Dennis was one of those boys with a big passion for cars and trucks. Back then, he could spend hours watching the old Scania and Volvo trucks roaring though his hometown in The Netherlands, Europe, on their way to Germany or Scandinavia. Being a creative guy, he started drawing trucks, and then building scale models from standard plastic kits that were available in the stores. He also had some nice Lego sets his parents gave him as gifts, and soon he started to build his own creations with them, trying to copy the trucks he saw in town and in the European truck magazines. Around this same time, truckers in Europe started dressing up their rigs with loads of accessories and some

sorts of ver...
types of ver...
found the ultimate c...
is Dennis Glaasker, mo...
his internationally-recognizable a...
Wheels" on the web. Dennis' hobby is...
scale models of cars and bikes, but mostly by
trucks – and he is good!

Nowadays, the Lego community worldwide is huge, and there are many very talented Lego builders who make the most beautiful things. It is something that everybody likes – from kids to grandparents. But, Dennis is one of the few builders that specialize in custom big rig trucks. Websites like ours (www.tenfourmagazine.com)

The first step in building a new "crea... is to surf the internet for inspiration. Sometimes Dennis builds a replica of an existing truck, but often he makes a Kenworth or Peterbilt of his own design. Dennis likes to build American trucks, but living in The Netherlands makes that hard because there are not many of them in Europe. Once he is inspired, he begins by scaling the dimensions to his common sizes of 1:13 or 1:16 (these scales are based on the fixed sizes of available Lego wheels).

Once the dimensions of the chassis are set, he often makes a sketch of what he thinks it should look like when done. At this point, he then checks to see if he has all the desired Lego bricks needed, and that he has the right colors. This can be a challenge, because not every color is available in Lego bricks, and some essential parts are only available in even fewer colors. Nowadays, you can buy whatever single color on the web, so you need in any available color on the web, so that has made Dennis' job a little easier.

The next step is the actual building of the truck, which typically takes around 6 to 8 weeks. Making a rigid Lego chassis with single bricks without making it too bulky requires some plastic construction engineering, as Dennis really aims to make it as close to the real thing as possible.

Not only have some builders become popular artists on the Internet, but their work has also been featured in magazines, in books, and on television programs, proving that interest in LEGO extends beyond the LEGO communities. LEGO is not just a toy.

When you share your own innovative models, you're reminding people of some of their best childhood memories. Your work might even inspire others to rescue their LEGO collection from the attic and start building again. Happy building!

**Opposite:** *It's satisfying to see your work in print! Magazines give you the opportunity to reach a larger audience.*

**Top:** *Photography is crucial to presenting your models. Shown here is a photo shoot for a massive B-52.*

**Bottom:** *Video is another way to capture your work. Author Dennis Bosman was even featured in an episode of a weekly Dutch transportation television show in 2005. In this photo, a cameraman zooms in on the Scania L111.*

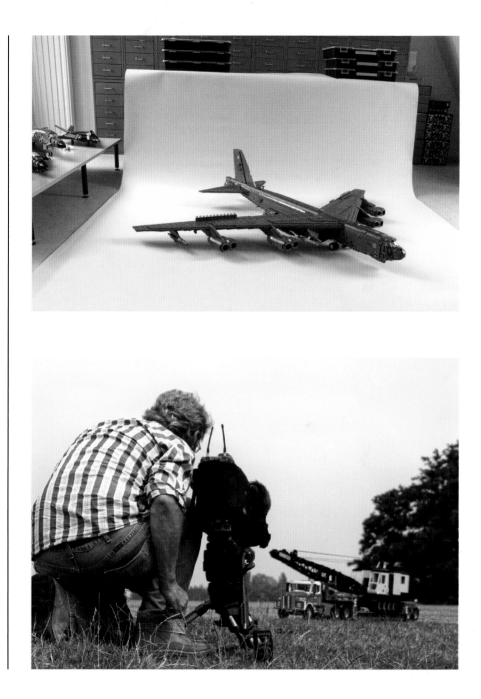

# About the Builders

### Firas Abu Jaber

Firas Abu Jaber, who works as an event manager, is also a dedicated model builder with a focus on exotic cars. His fabulous model cars have been featured in the media, including the BBC's *Top Gear*. (Jordan, b. 1979)

*Ford GT; Lamborghini Aventador*

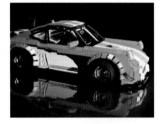

### Malte Dorowski

Malte Dorowski is trained as a digital designer and works in marketing management for a large web portal in Germany. He has two big hobbies: LEGO and cars, especially Porsches. You can see the marriage of these two passions in his models. (Germany, b. 1981)

*Porsche 962C; Porsche 911 GT3-R Hybrid*

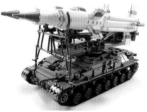

### Bob Alexander

Bob Alexander works as an assistant professor of architecture at California Polytechnic State University. He is also a principal at the environmental design firm bobCAT. His fabulous sports car models have been featured on many websites and in many magazines, including *Road and Track*. (USA, b. 1977)

*Alfa Romeo 8C 2600*

### Kim Ebsen

Because he grew up so close to the LEGO factories, it is no surprise that Kim Ebsen has been building models from a young age. Kim works as a construction engineer on farm and forest machines. Besides his LEGO hobby, he also enjoys motorsports. (Denmark, b. 1966)

*MDW Fortschritt E524; Lida L-1300 TC*

### Andy Baumgart

Andy Baumgart, a UPS delivery driver and dad, has been interested in LEGO for as long as he can remember. When he was young, Cold War military vehicles caught his attention, and they have become a favorite modeling theme. (USA, b. 1974)

*2A3 Kondensator 2P; 2K11 Krug*

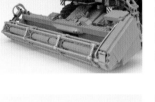

### Carl Greatrix

Carl Greatrix is a senior model designer for TT Games and Warner Brothers, a group that produces official LEGO video games. He also makes beautiful scale models of aircraft, cars, and trains. (Great Britain, b. 1968)

*McDonnell Douglas F-4E & F-4B Phantom II; Brabham BT44B; Ferrari 312T4; Renault RE20; British Rail Class 27 and Class 55 Deltic; Caterham Super 7*

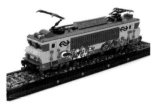

### Jebbo Bouhuijs

As a car mechanic, Jebbo Bouhuijs knows about automotive technology. He started building LEGO models a couple of years ago. Since reviving his old hobby, his specialties have been small-scale models and dioramas. (The Netherlands, b. 1980)

*GEC-Alsthom NS Class 1700*

### Hoang Huy Dang

Hoang Huy Dang began work in Detroit's automotive industry after obtaining his bachelor's degree in transportation design. Hoang was born in Vietnam. (USA, b. 1989)

*Vietnamese Fishing Boat*

### Nanko Klein Paste

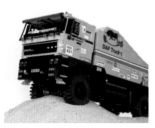

Nanko Klein Paste works as a project manager handling complex renovations at a housing corporation. Nanko's specialty is building trucks, often from the Dutch brand DAF. Nanko also enjoys cycling. (The Netherlands, b. 1971)

*DAF 3300, "The Bull"; DAF Support Truck*

### Paweł Kmieć

Paweł Kmieć is a graphic designer and the author of *Incredible LEGO Technic* and *The Unofficial LEGO Technic Builder's Guide*. He's an official LEGO Technic reviewer and former LEGO ambassador. (Poland, b. 1982)

*Tiger I*

### Edwin Korstanje

Edwin Korstanje is a family man with a passion for ships. He runs his own automotive windshield repair service but is also actively taking commissions for designing and building LEGO ships for customers such as large shipyards. (The Netherlands, b. 1971)

*Kiss*

### Andrea Lattanzio

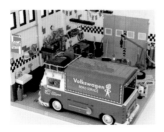

Andrea Lattanzio works in the communications department of an Italian nonprofit organization and has been a LEGO fan since childhood. He also spends a lot of time restoring vintage motorcycles and bicycles. (Italy, b. 1974)

*Volkswagen Workshop*

### Noah Lay

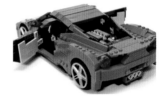

Noah Lay is a skilled young modeler. Inspired by the official LEGO Ferrari Enzo set (#8653), he started building his own work, mostly focusing on sports cars. He also has a passion for car photography and classical music. (USA, b. 1998)

*Ferrari 458 Italia*

### Cale Leiphart

Cale Leiphart specializes in building LEGO trains. He started building at an early age and has never stopped. He is a cofounder of the Pennsylvania LEGO Users Group (PennLUG). Other hobbies include photography and working on vintage cars and machinery. (USA, b. 1977)

*Baldwin Locomotive Works Challenger*

### Jens Matuschek

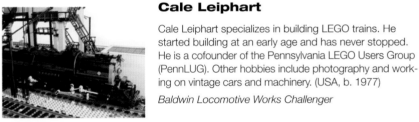

Jens Matuschek studied social anthropology, focusing on North American Native cultures, and he works in the museum field. In addition to making fabulous sports cars out of LEGO bricks, Jens also re-creates Native American objects. (Germany, b. 1978)

*Ferrari 599 XX Evo*

### Arjan Oude Kotte

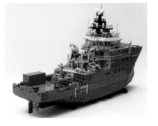

Family man Arjan Oude Kotte has a day job at a bicycle store. He also established his own company, Konajra.com, which builds custom LEGO models. His specialty is 1:40 scaled ships, but he has built beautiful heavy machinery as well. (The Netherlands, b. 1974)

*Tyr Viking; Dutch Coaster Fiona; Grampian Don*

### Luca Rusconi

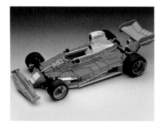

Luca Rusconi works as an engineering manager and has a keen interest in the history and technological development of Formula 1 cars. Before building his LEGO models, he first designs them in MLCad. He is also a LEGO ambassador. (Italy b. 1970)

*Ferrari 312T; Tyrrell P34*

### Ralph Savelsberg

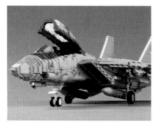

Ralph Savelsberg is a physicist working for the Dutch Ministry of Defense. He has been building with LEGO bricks for most of his life and is a regular contributor to the blog *The Brothers Brick*. (The Netherlands, b. 1975)

*Mercedes-Benz 2536 Actros Car Carrier; Westland Lynx SH-14D; Grumman F-14A Tomcat; Rockwell B-1B Lancer; FM-2 Wildcat*

### Ingmar Spijkhoven

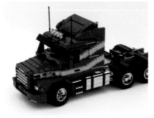

Ingmar Spijkhoven works as a building engineer. He didn't touch LEGO for 20 years but picked up his hobby again a few years ago. Ingmar also creates building instructions for most of his models. (The Netherlands, b. 1971)

*Scania T143M 500*

### Peteris Sprogis

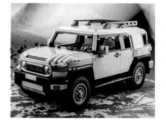

The models of Peteris Sprogis are not only beautifully crafted but also beautifully photographed, so it comes as no surprise that Peteris is a professional photographer. He cherishes the countryside of Latvia and counts himself lucky to be living so close to a big forest. (Latvia, b. 1975)

*Toyota FJ Cruiser*

### Huib van der Hart

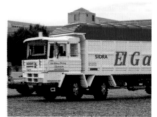

Huib van der Hart is a truck driver and father from the Netherlands. He built an impressive custom LEGO crane as a teenager, and then rebuilt the project 15 years later, producing a very big Liebherr crane. (The Netherlands, b. 1978)

*Liebherr LTM 11200-9.1; Nooteboom Boom Carrier*

### Iván Vázquez

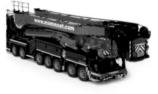

Iván Vázquez is a mechanical engineer. Since childhood he has been fascinated by trucks, specifically vintage Spanish trucks. Iván started building with LEGO only a few years ago, when he saw creations from other LEGO builders online. (Spain, b. 1966)

*Pegaso 1083 & Z-701*

# Credits

Credits are listed here by model name. All copyrights are retained by the individual copyright holders. All photographs have been provided by the builders of their respective models, except for those noted otherwise below. All photographs in "How It's Done" are by Dennis Bosman, except where noted.

2A3 Kondensator 2P, p. 150–151
Builder: Andy Baumgart

2K11 Krug, p. 152–153
Builder: Andy Baumgart

Alfa Romeo 8C 2600, p. 100–101
Builder: Bob Alexander

Atlas 1604 MK-ZW, p. 114–115
Builder: Dennis Bosman

Baldwin Locomotive Works Challenger, p. 138–139
Builder: Cale Leiphart

Brabham BT44B, p. 78–79
Builder: Carl Greatrix
Photo Credits: Mike Hatton and Will Fuller

British Rail Class 27, p. 136–137
Builder: Carl Greatrix
Photo Credits: Mike Hatton and Will Fuller

British Rail Class 55 Deltic, p. 142–143
Builder: Carl Greatrix
Photo Credits: Mike Hatton and Will Fuller

Cat D7R LGP, p. 122–125
Builder: Dennis Bosman

Caterham Super 7, p. 178–181
Builder: Carl Greatrix
Photo Credits: Mike Hatton and Will Fuller

DAF 3300, "The Bull," p. 82–85
Builder: Nanko Klein Paste
Photo Credits: Dennis Bosman

DAF Support Truck, p. 110–113
Builder: Nanko Klein Paste
Photo Credits: Dennis Bosman

Dutch Coaster *Fiona*, p. 44–47
Builder: Arjan Oude Kotte
Photo Credits: Dennis Bosman

EMD SD40-2, p. 132–135, p. 190
Builder: Dennis Glaasker
Photo Credits: Edwin Meijnen and Dennis Glaasker

Ferrari 312T, p. 96–99
Builder: Luca Rusconi
Photo Credits: Marco Angeretti

Ferrari 312T4, p. 86–89
Builder: Carl Greatrix
Photo Credits: Mike Hatton and Will Fuller

Ferrari 458 Italia, p. 182–183
Builder: Noah Lay

Ferrari 599 XX Evo, p. 176–177
Builder: Jens Matuschek

FM-2 Wildcat, p. 72–75
Builder: Ralph Savelsberg
Photo Credits: Dennis Bosman

Ford GT, p. 168–169
Builder: Firas Abu Jaber

FTF F-8.8 20D & Floor Trailer, p. 28–29
Builder: Dennis Bosman

GEC-Alsthom NS Class 1700, p. 140–141
Builder: Jebbo Bouhuijs
Photo Credits: Dennis Bosman

*Grampian Don*, p. 50–53
Builder: Arjan Oude Kotte
Photo Credits: Dennis Bosman

Grumman F-14A Tomcat, p. 64–67
Builder: Ralph Savelsberg
Photo Credits: Dennis Bosman

Harley Davidson Cali Style Road King, p. 6, p. 162–163
Builder: Dennis Glaasker
Photo Credits: Kayleigh Glaasker (p. 6)

Harley Davidson Custom Chopper, p. 164–165
Builder: Dennis Glaasker

Harley Davidson Road King Classic, p. 6, p. 156–159
Builder: Dennis Glaasker
Photo Credits: Kayleigh Glaasker (p. 6)

Harley Davidson Street Glide, p. 160–161
Builder: Dennis Glaasker

Kenworth K100E Century 1140 Rotator, p. 10–13, p. 191
Builder: Dennis Bosman

*Kiss*, p. 48–49
Builder: Edwin Korstanje
Photo Credits: Dennis Bosman

Lamborghini Aventador, p. 184–185
Builder: Firas Abu Jaber

Lida L-1300 TC, p. 126–129
Builder: Kim Ebsen
Photo Credits: Dennis Bosman

Liebherr LTM 11200-9.1, p. 106–113
Builder: Huib van der Hart
Photo Credits: Dennis Bosman

McDonnell Douglas F-4E & F-4B Phantom II, p. 58–63
Builder: Carl Greatrix
Photo Credits: Mark Nicholson

MDW Fortschritt E524, p. 116–119
Builder: Kim Ebsen
Photo Credits: Dennis Bosman

Menck M154, p. 120–121
Builder: Dennis Bosman

Mercedes-Benz 2536 Actros Car Carrier, p. 22–25
Builder: Ralph Savelsberg
Photo Credits: Dennis Bosman

Nooteboom Boom Carrier, p. 112–113
Builder: Huib van der Hart
Photo Credits: Dennis Bosman

Pegaso 1083 & Z-701, p. 14–15
Builder: Iván Vázquez
Photo Credits: Jorge Carlos Castañón Hevia

Peterbilt 379 Century Rotator, p. 26–27
Builder: Dennis Glaasker

Peterbilt 379 & MAC End Dump, p. 18–19, p. 204
Builder: Dennis Glaasker

Porsche 911 GT3-R Hybrid, p. 94–95
Builder: Malte Dorowski

Porsche 962C, p. 80–81
Builder: Malte Dorowski

Renault Magnum & Floor Lowboy, p. 32–33
Builder: Dennis Bosman

Renault RE20, p. 90–93
Builder: Carl Greatrix
Photo Credits: Mike Hatton and Will Fuller

Rockwell B-1B Lancer, p. 68–71
Builder: Ralph Savelsberg
Photo Credits: Dennis Bosman

Scania L111 & Nooteboom Lowloader, p. 16–17
Builder: Dennis Bosman

Scania R143M 500 Streamline, p. 34–35, p. 192
Builder: Dennis Glaasker

Scania R500, p. 20–21
Builder: Dennis Bosman

Scania T143M 500, p. 30–31
Builder: Ingmar Spijkhoven
Photo Credits: Dennis Glaasker

Tiger I, p. 146–149
Builder: Paweł Kmieć

Toyota FJ Cruiser, p. 170–171
Builder: Peteris Sprogis

Tyrrell P34, p. 102–103
Builder: Luca Rusconi
Photo Credits: Marco Angeretti

*Tyr Viking*, p. 38–41
Builder: Arjan Oude Kotte
Photo Credits: Dennis Bosman

Vietnamese Fishing Boat, p. 42–43
Builder: Hoang Huy Dang

Volkswagen Workshop, p. 172–175
Builder: Andrea Lattanzio

Westland Lynx SH-14D, p. 56–57
Builder: Ralph Savelsberg
Photo Credits: Dennis Bosman

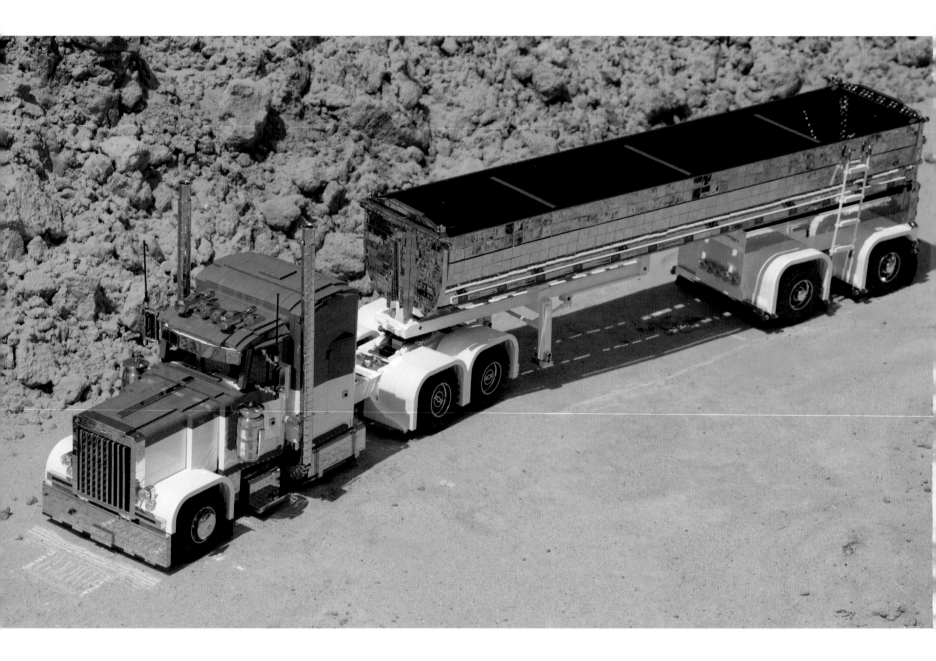